The New York Agent Book

Get the Agent you need for the career you want

D0107897

K CALLAN

Eighth Edition 2008

Other Editions 1987, 1990, 1993, 1995, 1998, 2001, 2004
ISBN 1-878355-19-8
ISSN 1058-1928

Illustrations: Katie Maratta
Map: Kelly Callan
Photography: Don Williams
Editor: Denton Heaney

K Callan Can Make Your Career

I hope that got your attention. Because *this very second* you have the chance to do one thing that will instantly increase your chances of "making it."

Buy. This. Book.

Within the pages of the eighth (the Eighth!) edition of *The New York Agent Book*, you will find everything you need to succeed in the Biz's first and most intimidating hurdle: How to get an agent.

Who are these strange creatures called agents? What do they like? What do they hate? What is it that makes them so important to an actor's career? What is it that they do that makes them worth the magical 10%?

K tells you. And just as importantly, K gets the actual agents themselves to tell you. No fluff, no cheerleading, just the honest, unvarnished truth.

I first met K when I had just been promoted to an agent at DGRW, one of New York's finest agencies. Like many beginning agents, I was making the rounds of the various seminar companies in NYC. If you're reading this book you probably already know the drill. Pay your money and get to audition for a real live (fill in the blank) agent, casting director, or manager.

I was astonished by how little these beginning actors knew about the business. As talented as some of them were, they were as far from being able to take the necessary professional steps to success as I was from being able to sing "Bring Him Home."

I did what little I could to pass on what I knew, but one day at our daily meeting, I mentioned how frustrated I was about how little people seemed to know. "Isn't there some book they could read?"

And that's when I met K the author. I think it was my colleague Flo Rothaker reminded me of *The New York Agent Book*. She had a copy (I say "had" because I promptly stole it, sorry Flo) which became my Bible.

And what a Bible it is. All the questions you might have, and just as importantly, all the questions *you should have* are brought up and discussed.

How should you dress for a meeting?

Covered.

What do agents look for (the twenty dollar question)?

Covered.

When is it time to look for a new agent? (The ten dollar question – since ten will go to the old agent. Sorry. Agent humor).

Covered. Covered. Covered.

Unlike most authors of books for actors, K speaks from experience as a successful working actress in an increasingly difficult and complex

business. You've seen her a Ma Kent on *Lois and Clark*, as Edie's evil mom on *Desperate Housewives*, Lily's unsuspecting grandmother on *How I Met Your Mother*, and as the heart-rending Okie in HBO's *Carnivale*.

She's lived the actor's life to the utmost. And when she chose to share what she had learned, she made it that much easier for the rest of you.

Don't take my word for it. Try this simple test. Close the book. Open it randomly three times. I guarantee you'll learn three things not only that you didn't know before, but that *you need to know*. Try it. I'll wait.

Done? Okay. One more thing.

Buy. This. Book.

K Callan can make your career.

It's as simple as that.

Andy Lawler

◅ Introduction ▻

Directors, producers, agents and civilians (people not in the business) frequently comment to me that my books about the entertainment industry follow a circuitous route. Actors never say that. They know the business *is* a circuitous route. You enter the circle anyplace and usually don't get to choose where. It is possible to spend twenty years at this occupation and still feel like a beginner, depending on what phase of the career you are experiencing.

The periods of heat in a career make an actor think he will never be unemployed again (no matter what he has witnessed or experienced before) and the periods of unemployment produce only a different agitated state: *I'll never work again. It was all an accident. Now, they know I can't act. I just fooled them before.*

Some young actors waltz in, get attention, an agent, and a job, and aren't seriously unemployed for ten or twenty years. When things inevitably slow down, they have to learn the business skills that other less fortunate actors began to learn on day one. As it turns out, no steps can be skipped. We all just take them at different times.

Though business skills are essential, you're not going to work without self-knowledge. Although some actors never have to find a niche for themselves, most of us spend several years figuring out just what it is we have to sell. If you weigh 500 pounds, it doesn't take a master's degree to figure out that you're going to play the fat one. If you go on a diet and become a more average size, casting directors will have a harder time perceiving who you are. You might, too. This is not to say that if you are easily typed that your life is a bed of roses, but it can be a lot easier.

So, *Self-Knowledge* could be the first chapter for one actor and the end of the book for another. While an actor who already has an agent might feel justified in starting with chapter fourteen because he wants to change agents, a newcomer in town might feel that divorce is not his current problem. All he wants is an agent — any agent.

In fact, a beginning actor would gain real insight from the chapter on divorce. That information could alert him to potential warning signs when he *is* meeting with an agent and chapter six might prompt the seasoned actor to reexamine all the things his agent does do for him.

This book deals with all aspects of actor/agent relationships at various stages of one's career: the first agent, the freelance alliance, the exclusive relationship, confronting the agent with problems, salvaging the bond, and if need be, leaving the partnership.

You will find information for the newcomer, help for the seasoned

actor and encouragement for everybody. Interviewing hundreds of agents in New York and Los Angeles was, just like every other part of the business, sometimes scary, sometimes wonderful, and sometimes painful, but always a challenge.

Mostly the agents were funny, interesting, dynamic, warm, and not nearly as unapproachable as they seem when you are outside the office looking in.

Regardless of the circuitous nature of the business and this book, I advise you to read *straight through* and not skip around. The first fourteen chapters give you an informed foundation from which to view the agency profiles.

Fight the urge to run to the agency listings and read about this agent or that. Until you digest more criteria regarding evaluating agents, you may find yourself just as confused as before.

If you read the agents' words with some perception, you will gain insights, not only into their character, but also into how the business really runs. You will notice whose philosophy coincides with yours. Taken by themselves the quotations might only be interesting, but considered in context and played against the insights of other agents, they are revealing and educational.

I have quoted a few agents that you will not find listed here because they are either from Los Angeles (Ken Kaplan, Tim Angle), out of the business (Joanna Ross, Lynn Moore Oliver), or deceased (Michael Kingman, Barry Douglas, Beverly Anderson, Fifi Oscard). Even though you won't be able to consider them as possible business partners, I felt their insights were particularly valuable.

Always check all names and addresses before mailing. Every effort has been made to provide accurate and current addresses and phone numbers, but agents move and computers goof. Call the office and verify the address, and make sure the agent you want to contact is still there.

It's been a gratifying experience to come in contact with all the agents and all the actors I have met as a result of my books. Because I am asking the questions for all of us, if I've missed something you deem important, tell me and I'll include it in my next book. Write to me at *Kcallan@swedenpress.com* or c/o Sweden Press at the address on the back of the book. Be sure to write something in the reference line that identifies you as a reader; I dump a lot of junk mail.

K Callan

Los Angeles, California

⚓ Table of Contents ⚓

⟫ 1 ⟪

Forewarned

As this 8ᵗʰ edition goes to press, technology continues to redefine methods of distribution in film and television, action films and sequels dominate the big screen, even more reality shows crowd the small screen, and the New York theatre continues to prefer lavish musicals and revivals.

Agents increasingly want to act like managers and produce. Screen Actors Guild and AFTRA still haven't worked out their jurisdictional issues and SAG and the Association of Talent Agents still have no agreement. Managers continue to sign actors with no union oversight and/or licensing from the state.

So the sky is officially falling.

But is it?

Our unions will work out ways of compensation regardless of the distribution system, and while the thirst for reality shows may never diminish for a certain segment of the population, history shows that the pendulum swings both directions and scripted shows will always be relevant.

It takes time for change, but Broadway is increasingly inhabited by performer/creators like Quiara Alegria Hudes and Lin-Manuel Miranda (*In the Heights*), Heidi Rodewald and Stew (*Passing Strange*), and Bob Martin and Dan McKellar (*Drowsy Chaperone*) whose projects continue to inspire us to get out our word processors, stop waiting to be discovered and start creating.

As with any business, the way to survive and prosper is to see how you can manipulate the energy of the marketplace to your advantage. If you were a saddle maker when automobiles were invented, you could whine and ask for a subsidy or you could figure out how to adapt your business to the new world.

That's what actors have to do now. Perhaps you'll be lucky and find a place in the marketplace without adapting, but maybe there is a way for you to create a show that will fit into the current climate.

Oprah Winfrey studied to be an actress, switched to media and began a career as a broadcaster which, among countless other showbiz accomplishments, led to an Academy Award nomination for *The Color*

Purple. During the hiatus of *How I Met Your Mother* scripts written by Josh Radnor and Jason Segal were in production while Neil Patrick Harris was directing a play reading of material destined for Broadway. And these are people who already *have* jobs.

You never know where your entrepreneurial talents will take you. The one thing we know is true, however, is that an investment of positive energy always pays off.

With that in mind, whether you're just starting in the business and trying to figure out your first step, or whether you find yourself suddenly agent-free, take heart and take a big breath. Anything is possible.

Let's begin.

Wrap Up

Change Continues

✓ sink or swim, it's up to you

◁ 2 ▷
Before You Leave Home

The more tools and experience you have before assaulting one of the major production centers, the better, so begin to sharpen your job-getting skills while you are still at home in a protected environment.

Get involved in any acting related ventures, whether it's singing at the Lion's Club or doing local television and radio commercials or independent films. Scour the newspaper and internet looking for productions filming locally looking for help. Even working as a gofer will yield a wealth of information about the business.

Once you've exhausted the local scene and are ready for training, if you are contemplating undergraduate or graduate studies in the Fine Arts, you should know about the connected theatre schools.

Some schools are not only significantly superior to others, but are universally accepted as the most comprehensive training for young actors, whose name on a resume instantly alerts the antennae of buyers (CDs, agents, producers, directors, etc.). This is where the creme de la creme of new young actors, the next Meryl Streep or Paul Newman, are coming from.

These schools formed a collective referred to at one time as "the leagues." Though the collective no longer exists, "league school" is still shorthand for the prestigious connected school of the moment.

An undergrad degree from one of these schools is not as prized as a grad school credit, but any degree from one of the connected schools on your resume gains instant respect.

Since the competition is so fierce at these schools and they are so expensive, maybe it makes more sense to go somewhere where you might have more chance playing great parts and won't have such a massive debt when you graduate. Then take time to work before applying to the cool grad school.

✦ *"There is indeed a predisposition to take people who have been out working,"* *Gister said. "They understand what the profession is about and understand why*

they want to come here."
Siobhan Peiffer, *Yale Herald*[1]

Check out *www.yaleherald.com/archive/xxii/10.4.96/ae/drama.html*
for the complete article.

Web Pages for Information

All universities have web pages where you can check out their grads
and curriculum. Some are more user friendly than others, so be patient.
Whether or not a school should be included in the connected list
depends on who you talk to. No one wants to take responsibility for
saying who belongs and who doesn't.

Andy Lawler was an still an agent at DGRW when he fearlessly
spoke these words of wisdom on schools,

✦ *The two best musical theatre programs in the country belong to the Cincinnati
Conservatory of Music and the Boston Conservatory of Music. Each year, these
schools' industry showcases attract almost every agent and casting director in New
York City. Their graduates probably have the highest employment percentage of
ANY drama school, musical or otherwise, graduate or undergraduate.*

*Juilliard is, of course, one of the two or three best drama programs in the
country, but does not specialize in musicals. Nonetheless many Broadway musical
stars have gotten their start there, including Patti LuPone and Kevin Kline.*

*A number of other schools offer good programs as well, although they lack the
prestige of the above mentioned three: Carnegie Mellon, Northwestern, and, to a
lesser extent, Michigan and NYU. Questions you need to ask are:*

*Does it offer a Bachelor of Fine Arts or a Bachelor of Arts degree? Aim for the
BFA, as that's the sign of an actual professional training program. Does it offer
a showcase in NYC or LA? There's little point investing in a degree if the industry
doesn't see you at the end of it. What sort of performance options do you have?
How recently have the faculty actually been participating in the biz?*

*A note of caution to close. Remember that everyone auditioning for these
programs has been the star of their schools. Stature at your high school rarely
guarantees success beyond. However, don't be intimidated by a lackluster resume
either. What gets people into these schools is their audition and their look, and
nothing else will really matter.*
Andy Lawler

The Cool Schools

Here is a list of other schools, based on hearsay and research that are thought to be the chosen schools at this moment in time. The best way to judge is to check out the curriculum as well as the track record of graduates via their web pages.

American Conservatory Theatre, Carey Perloff
30 Grant Avenue, 6th Floor
San Francisco, CA 94108
415-834-3200
www.act-sfbay.org/conservatory/index.html

Carnegie Mellon, Drama Department/Elizabeth Bradley
College of Fine Arts/School of Drama
5000 Forbes Avenue, Room #108
Pittsburgh, PA 15213
412-268-2392
www.cmu.edu/cfa/drama

Columbia University in the City of New York, Kristin Linklater
305 Dodge Hall, Mail Code 1808/2960 Broadway
New York, NY 10027-6902
212-854-2875
www.columbia.edu/cu/arts

Harvard University, Richard Orchard
American Repertory Theatre/Loeb Drama Center
64 Brattle Street
Cambridge, MA 02138
617-495-2668
www.amrep.org

Juilliard School, Kathy Hood, Director of Admissions
60 Lincoln Center Plaza
New York, NY 10023
212-799-5000 Ext. 4
www.juilliard.edu/splash.html

New York University/Drama Department
Arthur Bartow, Artistic Director
721 Broadway, 3rd Floor
New York, NY 10003
212-998-1850
www.nyu.edu/tisch

North Carolina School of the Arts, Gerald Freedman
Post Office Box 12189, 1533 Main Street
Winston-Salem, NC 27117-2189
336-770-3235
www.ncarts.edu

Northwestern School of Communications, Dean Barbara O'Keefe
Frances Searle Building
2240 Campus Drive
Evanston, IL 60208
847-491-7023
www.communication.northwestern.edu

State University of New York (at Purchase), Dean Irby
735 Anderson Hill Road
Purchase, NY 10577
914-251-6360
www.purchase.edu/academics/taf

Yale School of Drama, Yale University, Lloyd Richards
Post Office Box 208325
New Haven, CT 06520-8325
203-432-1505
www.yale.edu/drama

Don't forgo your education just because you can't afford it or can't get into Yale or Juilliard or any of the other status schools. But if you can gain admittance, you are already in a select group seemingly bound for success. This article from *Yale Herald* is over ten years old but I see nothing that makes me think things have changed.

✦ *Last year, 1,270 hopefuls applied to the Yale School of Drama. Sixty-eight got in. That's a five percent acceptance rate. And you thought getting into Yale*

College was hard.

A look at the bare facts of Drama School admissions is daunting: Out of the thousands of hopefuls who request information, out of the hundreds who actually apply, out of the dozens who are granted interviews or auditions, a mere fraction actually make it past the final cut and spend three years learning in what is arguably the finest Master of Fine Arts (MFA) program in the country.

Admissions is "an enormously difficult process," Earle Gister, director of the acting department, said. Gister sees approximately 900 actors every year, in New Haven, Chicago, and San Francisco. He picks 16. Gister has been teaching and auditioning actors for 34 years, 17 at Yale, and his criteria haven't changed.

Siobhan Peiffer, *Yale Herald*[2]

Actors from these programs are courted by agents and some have agents as early as freshman year. The career boost by the annual showcase of graduating students, produced specifically for an audience of agents and casting directors in New York and Los Angeles, can be priceless.

✦ *Although the leagues may sometimes lead to auditions for immediate employment on a soap opera, in summer stock, in an off-roadway play, more often it serves as a casting director's mental Rolodex of actors to use in future projects.*
Jill Gerston, *New York Times*[3]

Conservatory education requires a big commitment of time and money. Choose the school that is right for you.

Even if you are educated at the best schools and arrive highly touted with interest from agents, ex-William Morris agent Joanna Ross told me there is still a period of adjustment.

✦ *When you come out of school, you gotta freak out for a while. Actors in high-powered training programs working night and day doing seven different things at once get out of school and suddenly there is no demand for their energy. It takes a year, at least, to learn to be unemployed. And they have to learn to deal with that. It happens to everybody. It's not just you.*
Joanna Ross

Even if you can't make it to a league school, all is not lost.

✦ *The truth is, a great performance in the leagues can jump-start a career, but if*

these kids have talent, they'll get noticed. They just won't be as fast out of the starting gate...they just have to do it the old-fashioned way by pounding the pavements, reading "Back Stage," calling up friends, going to see directors they know and knocking on agents' doors.

Jill Gerston, *New York Times*

And maybe faster out of the gate isn't the best way to go anyway. Success in any business takes a toll on the persona. The more maturity you can gain first, the better your chance of weathering the shock of lots of money, instant friends, and visibility. It's easier to deal with success when it comes gradually so you can adapt. Too much too soon is too much too soon. No matter who you are, the career ebbs and flows. Stardom is just unemployment at a higher rate of pay.

Wrap Up

Connected Schools

✓ 5% acceptance rate

✓ very expensive

✓ can jumpstart your career

☑ 3 ☒
Welcome to the Big Apple

Now that you've exhausted all the opportunities at home, gotten yourself trained, saved your money (I hope), you are finally ready to tackle Manhattan. As training for the impossible challenge of making a living as an actor, your first task will be to get acquainted with the city and get a place to live in New York.

Getting to Know the City

It's easy to get around the island of Manhattan. If you are directionally challenged, this is your chance to finally understand about north, south, east, and west. The Hudson River is west and guess where the East River is?

As you travel uptown (north), the numbers get larger and as you go downtown toward Wall Street, Chinatown, and the Statue of Liberty (south), the numbers get smaller. The numbers stop at Houston (pronounced "how-ston"). Then you have to deal with street names.

The quickest way to get anywhere is on a bicycle, if you have the courage. That's too scary for me, so I walk. Cabs are expensive and frequently very slow; the fastest transportation is the subway. Many people don't like it, but I've personally never had any trouble. Subways now require MetroCards which can also be used on buses. It makes sense to buy a MetroCard with many rides on it. You can buy MetroCards at banks, some newsstands, and in machines at most subway stations. Many stations don't have manned token booths at all times, so have appropriate bills or a credit card, and don't expect directions.

Look online for a free subway map and guides to New York theatres.

There are subways that only go up and down the East Side (Lexington Avenue) and some that only go up and down the West Side (7th Avenue) and some (the E & F) that do both. There are some that

only go crosstown (14th Street, 42nd Street and 59th Street). Buses are great for shorter hops, but, like the subway, you must have exact change or a MetroCard.

I can walk across town in about twenty minutes; you probably can too. Crosstown blocks go east and west and are about three times as long as downtown blocks which go north and south. It takes about the same amount of time to walk from 42nd to 59th Streets as it takes to go from Lexington Avenue to Broadway.

www.ny.com/locator is a guide to cross streets, e.g. if you are at 1501 Broadway, you are between 43rd and 44th Streets. For general transportation info, *www.travel.howstuffworks.com/new-york-city-guide1*.

I've included a map to give you an overview of Manhattan. I have marked the Broadway theatre district, the Public Theatre, the theatre library at Lincoln Center, the TKTS Booth (half-price tickets to Broadway and off-Broadway shows), the various television networks, bookstores, etc. Here's the key:

1. ABC Television
 77 West 66th Street

2. Actors' Equity Association (AEA)
 165 West 46th Street, East of Broadway

3. Actors' Studio
 432 West 44th Street btwn 9th & 10th Avenues

4. AFTRA/American Federation of Television & Radio Artists
 260 Madison Avenue at 38th Street

5. American Academy of Dramatic Arts
 120 Madison Avenue at 32nd Street

6. Applause Theatre Books
 211 West 71st Street btwn Broadway & West End Avenue

7. Carnegie Hall
 881 7th Avenue at 57th Street

8. CBS Television Studios

524 West 57th Street btwn 10th & 11th Avenues

9. City Center
131 West 55th Street btwn 6th & 7th Avenues

10. The Drama Book Shop
250 West 40th Street

11. HB Studios
120 Bank Street in the Village, West of Hudson Street

12. Lincoln Center
64th Street at Columbus Avenue

13. The Lincoln Center Library of Performing Arts
40 Lincoln Center Plaza at 66th Street

13. NBC Television
30 Rockefeller Plaza at 5th Avenue & 49th Street

14. Manhattan Plaza
43rd Street btwn 9th & 10th Avenues

15. The Public Theatre
425 Lafayette Street at 8th Street, one block East of Broadway

16. Screen Actors Guild
360 Madison Avenue btwn 45th and 46th Streets

17. TKTS (Half-Price Theatre Tickets)
Duffy Square/North End of Times Square at 47th Street

18. Theatre District (Broadway)
42nd to 57th Streets and 6th to 9th Avenues

19. Theatre Row
42nd Street btwn 9th & 11th Avenues

Another way to get a handful of excellent Manhattan information

is to pick up *The Official City Guide*, available at most hotels and/or online at *www.cityguideny.com*. I don't think I've seen a better source of maps and information about what's going on in Manhattan. It includes useful phone numbers and a reference page detailing cross streets relative to the address. Another useful link is *www.newyorkcity.com*.

Get a Place to Live

Even though it's New York, the problem is not unsolvable. The Drama Book Shop (250 West 40th Street), most acting schools and the acting unions all have bulletin boards listing sublets that might give you temporary housing while you get your bearings. Another good housing resource is *Craig's List*. The show business newspapers *Back Stage* and *Show Business* also offer opportunities to plug into the grapevine on many levels.

There are actor-friendly neighborhoods in the City: West Beth (downtown in the West Village) and The Manhattan Plaza (midtown on the West Side) are both artistic communities with subsidized housing and long waiting lists, but since actors are frequently out of town for jobs, sublets are available. Both of these artists' havens offer classes and are plugged into the creative forces of the city.

Areas in which rents are cheaper are the Lower East Side, below Wall Street, Chinatown, and some areas of what used to be called Hell's Kitchen in the far West 40s.

Some churches and YMCA/YWCAs have a limited amount of relatively inexpensive housing available on a temporary basis. There is also a youth hostel. For information consult the NY Convention and Visitors Bureau, Two Columbus Circle, New York, NY 10019.

There are those fabled $75 per month apartments that keep us all salivating but they have been occupied for hundreds of years by the same tenant. Don't allow yourself to keep from finding suitable housing because you are waiting for one of those fabulous deals. You don't want to use up all your good luck getting a swell apartment for 35¢. Save your luck for your big break and you'll be able to afford to pay full price.

More and more people are finding housing in Brooklyn, Queens, New Jersey and Staten Island. When I first arrived in New York, I

Manhattan Street Map

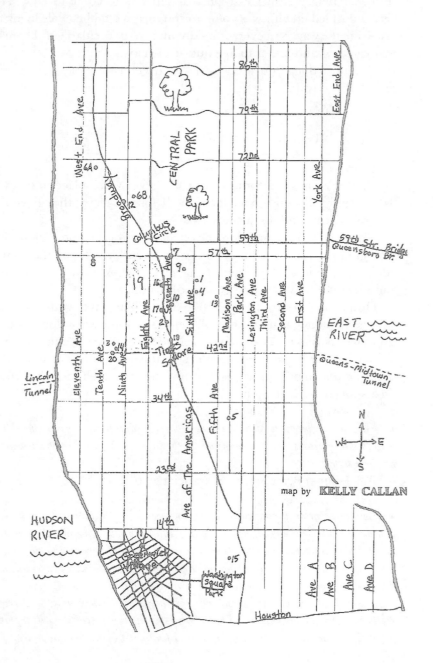

map by **KELLY CALLAN**

briefly considered New Jersey (since I had children), but after much soul-searching, I realized that my dream was to come to New York City. I decided that if I was going to starve, it would be while living my dream all the way. Not everyone's dream is so particularized. There are many actors who prefer to live out of the city.

The next thing you need to do is to get a job, and not just for financial survival .

A Job Gives Form to Your Life

Having a job gives form to your life, gives you a place to go every day, a family of people to relate to, and helps you feel as though you are part of the City and not just a tourist.

Nothing feeds depression more than sitting at home alone in a strange city. Even if you know your way around, you'll find that as time goes on, activity is the friend of the actor. Depression feeds on itself and must not be allowed to get out of hand.

Don't allow yourself to be broke or you'll just drag yourself down. This is something you can control. Being a starving actor doesn't work. What works is to take care of yourself so that you are healthy and have money in your pocket. You don't have to suffer to be an actor. Most of us did that in our early lives, it's time now to have fun even if you're on a shoestring. Get a job.

✦ *As soon as you get to town, get a survival job. You must have income. You'll need to have pictures, resumes, audition clothes, classes. You need to have money to do these things.*
Bill Timms/Peter Strain & Associates, Inc.

✦ *Before an actor begins to look for an agent, he should establish a secure foundation. He or she needs a place to live and/or a job, some friends to talk to, and pictures or at least a facsimile of pictures. It's very important that they have a comfortable place to go to during the day and be settled so they don't carry any more anxiety than necessary into an agent or manager's office.*

Some actors think an agent or a manager will turn into a surrogate mother-father-teacher-confessor. That really isn't his role. Actors get disappointed when they aren't taken care of right away. I think it's better to come in as a fully

secure person so you can be sold that way. Otherwise, too much development time is wasted.

Gary Krasny/The Krasny Office

I know you are itching to get an agent and become a working actor, but first things first, get situated, meet some people, fill up your energy/good feelings and financial bank accounts. You will need them all.

Wrap Up

Geographical Resources

✓ phone books
✓ maps
✓ NYC Convention Bureau

Finding a Place to Live

✓ Drama Book Shop bulletin boards
✓ union bulletin boards
✓ acting class grapevine
✓ Craig's List

Your Day Job

✓ gives form to your life
✓ a family
✓ a place to go every day

4

Your First Agent & His tools

There's good news and bad news. First the bad news: you're probably going to have to be your own first agent. Now the good news: nobody cares more about your career than you do, so your first agent is going to be incredibly motivated.

In order to attract an agent, you have to have something to sell. No matter how talented you are, if you don't have some way to show what you've got, you're all talk. Working up a scene for the agent's office will work for a few agents, but it's not enough.

Your focus should be to amass credits by appearing onstage and in student and independent films so an agent can find you — and so you can put together a professional audition DVD.

This book is focused on actors who are already entrepreneurial. For those who need help in that department, get my marketing book, *How to Sell Yourself as an Actor*.

I know what you are thinking: "Swell. How am I going to amass credits and put together a professional sample without an agent? How am I ever going to get any work? How will I get smarter?"

By growing. Pick up *Back Stage* or *Show Business* for casting notices. Become part of the actor's grapevine by joining a theatre group or getting into an acting class. Invite a group of actors to your place once a week to read a play aloud. Once you start expending energy in a smart way, things begin to happen. Sending out pictures and resumes is not a growth experience.

✦ *Grab a "Back Stage" and start auditioning for everything! Then find a well-known and respected acting teacher who works with accomplished students. These two small actions will be the beginning of your show business networking. Teachers, friends and colleagues provide a conduit to your future agent or to a casting director.*
Jeanne Nicolosi/Nicolosi & Co., Inc.

I asked dance agent Thomas Scott the first thing dancers should do. His advice works for actors too:

✦ *Start to study and become familiar with the choreographers. Begin to form relationships with working choreographers. Both Broadway Dance Center and Steps are dance studios where great working choreographers teach.*
Thomas Scott/DDO Artists Agency

✦ *Decide what you want to do. Narrow your focus. Do you want to sing? Dance? Be in movies? Be specific, get good headshots, and we'll plan it out and do it together.*
Lisa Price/The Price Group

✦ *Gain technique and skill. Nurture your look. You are your own product. Fine tuning your look is the most important thing.*
Thomas Scott/DDO Artists Agency

✦ *Contact everyone you know. Get to class. Get good headshots. If you are "soap" material, send your picture/resume to all the daytime casting directors.*
Diana Doussant/HWA

You're not going to just waltz in and meet agents and casting executives, but as you begin to make friends with others on your level in the business, you will be surprised how one thing leads to another.

The Actor's Job: Looking for Work

Becoming an actor is not an overnight process. A large part of being an actor on any level is looking for work. Don't equate being paid with being an actor.

You are already an actor. Even if you are a student actor, you're still an actor and you already have your first job: get a resume with decent credits. This will begin to season you as an actor, and if it's on camera, you will be able to start building an audition DVD.

What denotes decent credits? Agents are happy to see school and hometown credits on a resume so they know you've actually had some time onstage. However, those credits not only don't mean much in the LA/NYC/San Francisco/Chicago marketplaces as they don't provide an arena for the agent to see you in action, first hand.

On the other hand, if you are able to score a good part in a decent venue that gets reviewed, an agent might see you and/or read your

great reviews and agree to take a meeting with you.

When you can also deliver an example of your work on DVD, you are in business. The DVD is usually no longer than five minutes (shorter is best) and shows either one performance or a selection of scenes of an actor's work.

Agents and casting executives view work endlessly and can tell quickly if you are of interest to them, so even if you have some great stuff, err on the side of brevity. It is better to have just one good scene from an actual job than many short moments of work or a scene produced just for the reel. Some agents will watch self-produced work and some will not. Most casting directors tell me that if they have time, they usually watch whatever is sent.

Technology and editors have gotten so skillful that it's easy to come up with a slick package if you have the money, but caution: slickness is no substitute for quality work. CDs can tell when it's all just tap dancing.

If you can't produce footage that shows you clearly in contemporary material playing a part that you could logically be cast for, then you aren't far enough along to make a DVD. Better to wait than to show yourself at less than your best. Patience.

What CDs and Agents Want in a Picture

The number one dictate from casting directors about pictures is: What You See Is What You Get. Casting directors don't like surprises. If your picture looks like Jennifer Lopez and you look like Joan Cusack, the casting director is not going to be happy when he calls you in to read. And vice versa.

Your picture and your DVD are your main selling tools, so choose carefully. Pictures can be printed with or without a border. Some agents prefer a picture without, but borderless frequently costs more. Your name should be printed on the front, either superimposed over the photo or in the white space below. Name and contact information should be featured prominently on the resume. If your picture is horizontal, print your name on the bottom right edge.

Although the majority of actors hand out a closeup, more and more are using a 3/4 color shot. That's the industry standard for dancers.

The picture of you on your Mother's piano is not necessarily the

best picture for your agent to send out. Be conscious of the jobs you are sent for when you choose your 8 X 10.

There are many good photographers in town whose business is taking actor headshots. They vary in price and product. I've gathered a list of favorites from agents, actors, and casting directors. Don't just choose one off the list. You need to do your own research on something as personal as a photograph.

Make an appointment with at least three photographers to evaluate their book and how comfortable you feel with them. No matter how good the pictures, if you don't feel at ease with that person, your pictures are going to reflect that. Take the time to evaluate your compatibility.

The Internet has made shopping for a photographer easier. Many have their own web pages, so try typing in the name preceded by *www.* and ending with either .com or .org and you might get lucky.

This is an easy way to look at a number of pictures and evaluate why one picture appeals to you more than another. An expensive price tag doesn't guarantee a better picture. It's possible to get the perfect picture for under $200 and a picture you will never use at $900.

The consensus from agents seems to be that you should expect to pay $500-$600 for pictures. Some photographers include hair and make-up artists as part of their package or as an add on. It's nice to be professionally made up, but make sure you can duplicate the look when you audition.

Make sure the photographer "gets you." My friend Mary's pictures were taken by a respected Los Angeles photographer and though technically perfect, they had a moodiness to them that had nothing to do with Mary's natural affability. The pictures were interesting but did not represent who Mary is and how she is cast.

But if you choose the right photographer, you can get appropriate pictures and it can be fun:

✦ *When you schedule your headshot session, you are choosing to make a positive change in your career. It's something you should enjoy doing, and look forward to. Prepare for your shoot by treating yourself well, getting plenty of sleep, caring for your body, and allowing plenty of time to prepare. If you're nervous, bring a friend, and bring music that you like.*

Nick Coleman/photographer

There is no a substitute for a gifted photographer who can stimulate and light you, but if you don't have the money for pictures right now, see what you can do on your own.

With Photoshop at your fingertips, even amateurs can take out unwanted shadows and produce a pretty good picture, so some actors' pictures have been taken by friends or family with digital cameras.

If you do this, be sure to have someone in the business evaluate your efforts, you might not be the best judge.

And how do you evaluate the effectiveness of your picture?

✦ *If you are getting a lot of auditions, but aren't booking work, the problem is not your headshot. If you are having trouble getting an agent to open your mail, or getting called into audition for casting directors, the problem could very well be your headshot. Is it high quality? Does it represent you well? Is it recent enough?*

Nick Coleman/photographer

Photographers & What They Charge

Richard Blinkoff shoots, edits, proofs, retouches and prints his digital photos in his daylight studio in Chelsea. Children and teens up to age 16 pay $450 for 250 shots in 2-3 different clothes, background, lighting. Clients over 17 pay $595 for 450 shots in 4-5 different situations. Make-up and hair for adult women is $150 and men's grooming for adult men is $100.

You get his edited choices on his website plus a hard copy contact sheet and a low res CD file to choose from. There is no extra charge for retouching, type or graphic work. He also does any typesetting and graphic work you need to make other headshots, postcards or composite cards for no extra charge.

212-620-7883 or *www.richardblinkoff.com* for further details

Tess Steinkolk sounds just great. She graduated from the American University in Washington D.C., a city in which she had an illustrious career not only at the White House during the Carter Administration, but also at the Smithsonian where she studied and was on staff. During that time she was house photographer for the Arena Stage. She moved to New York in 1981 and continues her amazing work.

Tess charges $545 for a three-roll session, gives you two 8x10s, and will sell her original negs for $125 each. Her prices escalate to $675 for

five rolls and four 8x10s. She has a special teen/kids price of $425 for two rolls with two 8x10s. There is a $75 discount for cash payment.

To see her pictures and other important information, check out *www.tsteinkolk.com* or call 212-627-1366.

Dave Cross has been a professional photographer in New York for over eighteen years. After pursuing a career as an actor he decided to photograph actors instead of being one. In addition to shooting Broadway, soaps, movie performers and theatre companies, Cross' work has been seen in the *New York Times, Time-Out New York, Dance Magazine* and *Soap Opera Digest.*

He shoots digitally for $725 a session for several hundred images. You see the shots during the session, and leave that day with a proof CD. Your images are also posted online for sharing with friends, family, agents, etc. Each session includes two final images on a CD, ready to be duplicated. There's a $25 charge for each additional final image, and retouching is an additional cost (most images require at least minimal retouching). View his work at *www.davecrossphotography.com* or call him at 212-279-6691.

Barbara Bordnick began her career in Paris and Copenhagen. During a career of more than thirty years, she has garnered awards for outstanding work in film, print, advertising, and art. Her images are in the permanent collections of the International Center of Photography, the Gilman Collection in New York, and the Polaroid Collection in Massachusetts.

She's really a fashion and portrait celebrity photographer so she is pricey at $950. Headshots include three wardrobe changes and three prints, minimal retouching, and a CD with both high res and .jpg files. 212-505-7879. *www.barbarabordnick.com*

Even though actor/photographer/writer/director Nick Coleman is still working successfully as an actor in film, television, theatre and independent film, he's found time to carve out a successful career as a photographer. His graphic designs and artwork can be seen on book covers, theatrical posters, television ads, and as web graphics on internet sites and email blasts.

A $350 two-hour session gives you 200-300 full resolution images on CD. Extra full res images are available for purchase at $25 each. A web-sized image suitable for online casting is included with every full res image. 50% deposit due at shooting, $25 retouching for each photo, and hair/makeup is $150. 917-447-8506. *www.colemanphotographix.com*

Another highly touted photographer is Bill Morris. He charges $425 for a two look shoot. Additional looks are $150 each. Each look includes a retouched master print. His makeup artist gets $160.

Bill shoots high quality digital photography, so you see before he actually starts and you get proofs online. Call him at 212-274-1177 and check out his work at *www.billmorris.com/headshots/index.html*

Jinsey Dauk started shooting pictures in the 8th grade. She studied and then taught photography at Wake Forest University in Winston-Salem, North Carolina, and also studied film production and psychiatry. Dauk is also a working actress and model.

Her webpage is worth a look at *www.jinsey.com*. There's a $300 discount for checking out her work there instead of in her apartment/studio, so instead of paying $795 for at least three rolls and one 8x10, it's $495. Her phone number is 212-243-0652.

Van Williams says he's too old to have a web page or a cell phone but he can still shoot great headshots. He shoots only in natural light, so expect a location shoot. He says his price is still below $200 because newcomers in particular don't have that much money. 212-997-1800.

Although I'm sure it's still illegal from SAG's point of view for an agent to suggest teachers, photographers, etc. (the union wants to avoid agent/photographer kickback at the expense of the actor), some larger agencies have negotiated group discounts for their clients for webspace, pictures and classes.

Because of SAG's concerns, when asked for recommendations for classes and photographers, agents frequently hand you a list.

Resume

A resume is sent along with your 8x10 glossy or matte print. Your resume should be stapled to the back so that as you turn the picture over side to side, the resume is right side up. The buyers see hundreds of resumes every day, so make yours simple and easy to read.

If you have the luxury of a long resume, pick and choose what to list. When prospective employers see too much writing, their eyes glaze over and they won't read anything, so be brief.

There is an example on the next page to use as a guide. Lead with your strong suit. If you have done more commercials than anything else, list that as your first category; if you are a singer, list music. You

may live in a market where theatre credits are taken very seriously. If this is so, even though you may have done more commercials, lead with theatre if you have anything credible to report.

Adapt this example to meet your needs. If all you have done is college theatre, list that. This is more than someone else has done and it will give the buyer an idea of parts you can play. Note that you were master of ceremonies for your town's Pioneer Day Celebration. If you sang at The Lion's Club program, list that.

Accomplishments that might seem trivial to you could be important to someone else, particularly if you phrase it right. If you are truly beginning and have nothing on your resume, at least list your training and a physical description along with the names of your teachers. Younger actors aren't expected to have credits.

The most important thing on your resume is your name and your agent's phone number. If you don't have an agent, get voice mail for work calls as it's more professional and it's safer. Don't use your personal phone number.

What to List on Your Resume

I know you are proud of it, but it's not necessary to list union affiliation on your resume. The names of directors you have worked with are important to note. If you are new to the business or the marketplace, it would be wise to identify parts that you have played so that agents/CDs will have clues on how to cast you.

If you were in a production of *A Streetcar Named Desire* and you played Blanche, by all means say so. If you were a neighbor, say that. The CD or agent wants to know how much work you have actually done; if you have "carried" a show, that's important.

Misrepresenting your work is self-destructive. You not only risk running into the casting director for that show who will tell you that she doesn't recall casting you, but if you list large roles that you have never played, you may not be able to measure up to your "reputation." Carrying a show is a much bigger deal than just having a nice part.

John Smith/212-555-4489

6'2" 200 lbs, blonde hair, blue eyes

Theatre

Spring Awakening. directed by Michael Mayer
Coast of Utopia. directed by Jack O'Brien

Film

The Nanny Diaries. . . directed by Shari Springer Berman & Robert Pulcini
The Tourist. directed by Marcel Langenegger
Goyband. directed by Christopher Grimm

Television

30 Rock. directed by Don Scardino
Law and Order. directed by Gwen Arner
Third Watch. directed by Christopher Chulack

Training

Acting. Karen Ludwig, William Esper, Sam Schacht
Singing. Andrea Green, Maryann Chalis
Dance. Andy Blankenbuehler, Christopher Gattelli

Special Skills

guitar, horseback riding, martial arts, street performer, Irish, Spanish, British, Cockney, & French dialect, broadsword, fencing, certified Yoga instructor, circus skills, etc.

Open Calls

Although Equity Open Calls are limited to members of Equity, in 1988 the National Labor Relations Board required that producers hold open calls for non-union actors. These auditions can be harrowing, with hundreds of actors signing up to audition for a small number of jobs.

✦ *I represent a woman who was interested in being in "Les Miz." She felt strongly that she wanted to play Cossette and although I have a twenty year relationship with the casting directors, they were disinclined to bring her in. I encouraged her to go to the open call, she did, and she got the job.*
Jim Wilhelm/DGRW

✦ *Actors' Equity surveyed 500 members and found that 47% had found jobs through open casting calls. In calls for chorus work, which has its own system, casting directors size up the hopefuls who show up and point to those who resemble the type they are seeking before holding auditions.*
Jennifer Kingson Bloom/*New York Times*[4]

Although some do get jobs in musicals through open calls, all concerned say it's an endurance contest.

✦ *It's not just wearing for the actors; the producers, directors, and casting executives also find it daunting. And only a hundred were given a chance to sing half a song and hoof a few steps. Vincent G. Liff, the casting director for "Big" and "Phantom of the Opera," who turned away no less than 250 women for "Big" alone, called the turnout frightening but said the system, while patience-trying, was valuable.*
"We have cast dozens and dozens of people through these calls," Mr. Liff said.
Jennifer Kingson Bloom/*New York Times*[5]

The most successful people in any business are smart, organized, and entrepreneurial, but almost no one starts out that way. It's like learning to walk: it takes a while before you can get your balance.

As you continue reading agents' remarks about what successful actors do, you will begin to develop an overview of the business that will help you in the process of representing yourself. It's essential to

stay focused and specific, and to give up the natural urge to panic.

Bring the same creative problem-solving you use in preparing a scene to the business side of your career. You will not only be successful, you will begin to feel more in control of your own destiny.

You're Only New Once

First impressions are indelible. That first day of school thing follows you for the rest of your life. How you behave on the first day of school is how your teachers will always think of you. No matter how great you are the second day, if you trip the first day, you're stuck with that. Conversely if you are a good guy that first day, you can sin many days thereafter and still get by on that good boy image.

If you have a meeting with a casting director and/or agent and aren't prepared, it's going to be hard to get another audition/meeting.

My young friend "John" recently tripped. After being in town three years studying at a local conservatory, he had the good fortune to meet an industry professional who began acting as a mentor of sorts, answering questions, inviting him to events. About that same time, John was invited to sign with a manager.

The IP validated the manager and encouraged John to sign. The actor was sent out on all the usual things for a non-SAG actor in his position: independent films, non-SAG commercials, plays, etc. Finally, after a couple of years with the manager, John got the lead in an independent film that would pay for his membership into Screen Actors Guild. He was overjoyed and his IP friend was pleased and impressed at his progress.

Though the movie kept getting pushed for weather reasons, the fact that John had booked it convinced the IP (who had still never seen John work) that John was "sufficiently far along" to be introduced to an agent. He asked John if he would like to be introduced to a successful mid-level agent.

Overjoyed, John counted the days until the meeting. Shortly after he returned home from the meeting, the IP called to ask how the meeting had gone. John said he thought he had done okay and that the agency seemed to like him, "but I stumbled a bit in the monologue and I think the head of the agency might have noticed."

John was surprised when the IP told him that the agent had called

the minute John left the office demanding to know why he had been recommended.

"I told you I had never seen his work, did he not do well?" the IP had inquired.

"He's a nice enough kid, but he was awful. He started the monologue and then just stood there at one point because he had forgotten it."

"Did he know he was going to have to do a monologue?"

"If he didn't have a monologue ready, he should have said so and asked to come back when he was more prepared."

Dumbfounded and embarrassed, John apologized to the IP. His mentor then proceeded to point out to John all the positive things to be learned from this unfortunate event.

- John needs to develop a more informed approach to evaluating his work and his effect on people.
- In a meeting, if someone asks him to do something for which he is unprepared, he has the right and is much better off saying, "I'm sorry, I didn't know I would be asked to do a monologue today, I don't want to waste your time unless I can do my best, may I come back?"
- He should never go to any kind of meeting unless he is totally prepared for any eventuality.
- He needs to get into a high quality acting class, not the string of casting director showcases he's been involved in, and commit to those classes 100%.
- He needs to enlist the help of that teacher in evaluating any monologues the actor intends to show as examples of his work.
- And although he blew this one opportunity, he now has a valuable piece of information: he is not as far along as he thought.

Even More to Learn

If you can step back from the actor's point of view to the other side of the desk, there is something else valuable to learn. What if the IP in our story were an agent had a Breakdown on his desk for which the actor was perfect. If he expended his credibility to get the actor an audition and *then* the actor was unprepared? Then that agent put his

own taste and credibility into question and the casting director might be wary of taking future suggestions.

This is exactly why most agents are only interested in meeting an actor who has either been referred by an industry professional or whose work he has seen.

If you really digest that information, it will be easier for you to persevere in being your own agent. Getting yourself work in plays or independent films not only builds your body of work, but also builds your experience in the audition room.

Acting is about so many things that are not acting. In this situation, John allowed himself to look bad because he didn't perceive that he had a choice. The agent asked for a monologue and John never stopped to think that he hadn't worked on that material for a long time. It never occurred to him to ask to come back. These are the things we learn over time. It's part of the "becoming" process of becoming an actor.

An actor who wants to be successful should always have a monologue in his head, and a picture, resume, and reel in his car. You may only be new once, but you don't have to make the same mistake twice.

✦ *When I teach workshops, I notice that many young actors only want to get the agent and get the job and have an instant career. They want instant success before developing themselves and their craft. I tell all young actors: get in therapy, get into NYU, Yale, Juilliard, one of the league schools.*
Jim Flynn/Jim Flynn, Inc.

✦ *Get decent headshots and a well-presented resume. Get "Back Stage" and look for showcase work and whatever auditions you feel you are right for. Go to shows, movies, watch TV so that you know what's out there and what is current. Get a phone machine that works and get into the habit of checking your messages.*
Dianne Busch/Leading Artists, Inc.

✦ *I think the philosophical basis is to work as much as possible, because the more you work, the more people have an opportunity to respond to it. Everyone in this business who is not an actor makes his living by recognizing talented actors.*

The smartest thing a young playwright can do is to get to know a good, young, talented actor so that when there is a showcase of the playwright's play, he can recommend the actor. That's going to make his play look better.

There are a number of stage directors in New York that, all they can really do

(to be candid), is read a script and cast well and then stay out of the way. That can often be all you need.

Casting directors, agents, playwrights, directors, even stage managers are going to remember good actors. If they want to get ahead in their business, the more they remember good actors, the better off they're gonna be. Having your work out there is the crucial thing.

Studying is important because it keeps you ready. Nobody is going to give you six weeks to get your instrument ready. It's "here's the audition; do it now," so I believe in showcases. Actors tend to be too linear in their thinking. They think, "okay. I did this showcase and no agent came and nobody asked me to come to their office so it was a complete waste of time."

Well, I don't believe that. First of all, even a bad production is going to teach a young actor a lot of important things. Second of all, generally, if you do a good job in a play, it produces another job. Often it's in another showcase. Often, it's a year later, so if you're looking for direct links, you never see them.

What tends to happen is somebody calls you up and says, "I saw you in that show and you were terrific and would you like to come do this show?" It's like out of the blue, and it can take a long time. You may have to do eight great showcases or readings, but if your work is out there, there is an opportunity for people to get excited and if it isn't out there, then that opportunity doesn't exist. It doesn't matter how terrific you are in the office and how charming you are. None of that matters.

Tim Angle/Don Buchwald & Associates/Los Angeles

Show business takes even balanced people and chews them up and spits them out for breakfast. Unless you are able to remain extremely focused and provide a personal life for yourself, you will have a difficult time dealing with the downs and ups of life as an actor. Either get into therapy or start meditating; do whatever it takes to put your life in a healthy state.

✦ *There are some people I know who are brilliant actors, but I'm not willing to take responsibility for their careers because I know the rest of their life is not in order.*
Flo Rothacker

If you are in an impossible relationship or if you have any kind of addiction problem, the business is only going to intensify it. Deal with these things first. If your life is in order, find a support group to help you keep it that way before you enter the fray.

People Who Need People

Life is easier with friends. Begin to build relationships with your peers. There are those who say you should build friendships with people who already have what you want. I understand that thinking, but it's not my idea of a good time.

It's a lot easier to live on a shoestring and/or deal with constant rejection if your friends are going through the same thing. If your friend is starring on a television show or is king of commercials and has plenty of money while you are scrambling to pay the rent, it is going to be harder to keep perspective about where you are in the process. It takes different people differing amounts of time to make the journey. Having friends who understand that will make it easier for all of you.

Ruth Gordon's seventy year career included an Oscar for acting (*Rosemary's Baby*), five Writers Guild Awards, plus several Motion Picture Academy nominations for scriptwriting *(Pat and Mike, Inside Daisy Clover*, etc.). In her interview with Paul Rosenfield she had words of wisdom for us all.

✦ *Life is getting through the moment. The philosopher William James, says to "cultivate the cheerful attitude." Now nobody had more trouble than he did except me. I had more trouble in my life than anybody. But your first big trouble can be a bonanza if you live through it. Get through the first trouble, you'll probably make it through the next one.*
Paul Rosenfield/*Los Angeles Times*[6]

If you don't know anyone, get into a class or explore one of the 12-Step Support Groups. There's comfort for every problem from Alcoholics Anonymous to the other AA: Artists Anonymous. Even though this group is for all different kinds of artists, you'll find a majority are actors and writers.

There are other As: NA (Narcotics Anonymous), ACA (Adult Children of Alcoholics), OA (Overeaters Anonymous), etc. No matter who you are, there is probably a group with which you can identify that will provide you with confidential support for free.

You'll be better served if you don't look to these groups for your social life. They supply a forum where you can talk about what is bothering you, but these support groups are not your family and,

though helpful, they are not your best friends either.

Put energy into your personal relationships to fill those needs. You create your life. Will Rogers said, "people are about as happy as they want to be." I agree. I believe we all get what we really want.

If you are a member of SAG, Equity, or AFTRA, check out their support groups or join one of their committees. Being involved in a productive activity with your peers on a regular basis will give you a family and a focus – and might even lead to information about a job.

If you are fortunate and tenacious enough to find a job in the business, you'll find you are not only finally in the system, but you're also being paid to continue your education. There is no way in the world you can learn what it's really like to be in the business until you experience it firsthand. You'll get to spend every day with people who are interested in the same things you are. Who knows? You might not even like show business when you get a closer look. Better to find out now.

Casting Society of America Job File

Sitting in an agent's office waiting for an appointment, I met a young actor who was manning the phones. He told me he has worked as a casting assistant in both Los Angeles and New York and had come to his present job by faxing his resume to the Casting Society of America job file.

The pay is small, but as he pointed out, the access to the business was well worth it. He said he wouldn't trade a higher salary for the business maturity he had acquired.

I visited the CSA's website recently and found links pertaining to Diversity Showcases, an ABC Talent Showcase, and many other items of interest to actors. Although you can also search for a particular casting director's name, if you don't know any names, you can't search; there is no master list. I also found a link called "Invite a CD," with an option to send a virtual postcard to casting directors inviting them to showcases, screenings, comedy appearances, etc.

Casting Society of America
2565 Broadway, #185
New York, NY 10025
212-868-1260 Ext. 22
castsoc@earthlink.net
www.castingsociety.com

✦ *If you can combine a showbiz job with flexible hours permitting auditions, that's the best of all possibilities. Always be available. Don't say you are an actor if you have a 9-to-5 job. If you must waitress, do it at night.*
Sharon Carry/Carry Company

As soon as you are working in the business in any category, you are in the system and on your way. I don't want to imply that coming up with one of these jobs is the easiest task in the world, but it is definitely worth the effort.

Before your resume is ready for you to be interviewing agents as possible business partners, you may find yourself encountering them either in your work or on a social level. Just as doctors don't like to listen to your symptoms at a party, an agent wants to party in peace. Be a professional and talk about something other than your career. Agents prefer to do business in their offices.

If you detect signs of interest from anyone, directors, producers, etc., follow up on it. Ask if there is anything you can do to help with a current project.

Get Into an Acting Class

In order to find a good teacher, you'll have to do some research. Who did he study with? What is the caliber of his students? Has this person worked professionally? You want someone whose advice is not theoretical. Work in class is totally different from actual professional work.

No one can teach you to act; a teacher can only stimulate your imagination and focus your work. Not everyone will be able to do that for you. Look for the teacher that will.

✦ *Like anything else that you're going to invest money and time in, an actor*

should shop around and see what's best for him. See someone whose work you admire and find out who they study with and audit that class.
Jerry Kahn/Jerry Kahn, Inc.

Teachers

✦ *Actors should study with many different teachers and take what they need from all the different approaches.*
Meg Pantera

If you are coaching for a particular part or audition, coaching one on one with a teacher can be a good idea if you can afford it. At a beginning stage of your career, however, it is important for you to interact with other actors so you can begin to practice one of the most important skills you'll ever need: the ability to get along with people both on and off stage. You'll also learn to evaluate the work of others and learn from their mistakes, as well as your own. Experiencing your peers tackle and solve the same problems you are facing will comfort you on many levels.

Here is a list of well-regarded teachers in New York. I know some personally and others were recommended by people whose judgment I trust.

William Esper is a widely respected acting teacher and director who has headed his own studio in NYC for over thirty-five years, and continues as director of the Professional Actor Training Programs at Mason Gross School of the Arts at Rutgers University.

A graduate of the Neighborhood Playhouse School of Theatre, Esper trained as an actor and teacher with mentor Sanford Meisner, with whom he worked closely as a teacher and director for fifteen years.

Esper charges $300 a month for three-hour classes that meet twice a week. Classes run September through June with a six-week Summer Intensive. There are many teaching associates at his studio and prices vary with the teacher. All teachers have had extensive teacher training with Mr. Esper.

The studio also offers classes in Voice & Speech, Mask, Movement, Shakespeare, and Script Analysis; as well as workshops in Cold Reading, Auditioning and On-Camera Technique.

Esper's list of amazing credits is lengthy and includes a juicy list of students from William Hurt to John Malkovich. Find out more on his web page, *www.esperstudio.com* or call 212-904-1350 for information.

I studied with Herbert Berghof at *HB Studios* when I first came to New York. HB continues to be not only a rich resource for excellent teachers who are all working, but offers also classes that are extremely reasonable.

You are allowed to audit any class once for $10. You are encouraged to audit many classes in order to find the one that is right for you. There is a $45 registration fee and the classes average out to be about $17 each (depending on whether there is a co-teacher, accompanist or videographer, and whether the individual class is an hour and half, two hours, or longer). They offer classes seven days a week, during days and evenings. They define full-time study as seven classes per term.

Students may choose whatever subjects they wish, though if you want to talk to someone about the best choices, guidance is available. Until I checked the web page, I was unaware that HB offers a full array of classes and that full-time students can pursue classes six days a week and end up with a conservatory education. Whether you are looking for that or just a weekly acting, dance or musical class, HB is a respected place to study. 212-675-2370; *www.hbstudio.org.*

Karen Ludwig is not only an actress with an impressive resume, she writes, directs, produces, and teaches at HB Studios, The New School and at Westbeth.

Her class at HB particularly caught my eye: Acting with the Camera (note, not *for* the camera). As part of the three year MFA program at The New School, she teaches an audition class which evolved from her stint assisting a well known casting director. At Westbeth she heads *The Women's Company*, leading women who want to create their own one person shows.

Karen is one of the producers of *Uta Hagen's Acting Class* Video which aired this year on PBS. Though no substitute for a class with Miss Hagen, the video is still an amazing teaching tool. It's available at *www.utahagenvideo.com* for $49.95. Contact Karen at 212-243-7570 or *kpludwig@earthlink.net.*

Jacqueline Segal is a good person to call for private coaching. She charges $100 an hour. 212-683-9428

Terry Shreiber Studios charge $270 monthly for a weekly class that

runs from five-to-six hours. TSS has an amazing staff including veteran *One Life to Live* director Peter Miner and Tony Award winning actress Betty Buckley. Prices vary so check the website for information: *www.tschreiber.org* or call 212-741-0209.

Acting classes at The Independent School of Acting are taught by *Greg Zittel*. The twice weekly two-to-three hour classes runs $250. New classes are constantly forming. Zittel says the classes provide an atmosphere where a student can grow both as a person and as an actor. Camera work is done in the film studio when appropriate. The website gives detailed info *www.theindependent.org* or you can call or e-mail Greg for an appointment: 212-929-6192 or *Greg49@aol.com*.

Improv guru *Gary Austin* (one of the founders of The Groundlings) teaches all over the country. His classes range from Improv Technique to Characters to Acting Technique/Making Choices. He works with students on an ongoing basis to create their own material. Classes have different prices relative to content and time but average about $25 hourly. Details at *www.garyaustin.net* or 800-DOG-TOES.

My friend Allan Miller lives in Los Angeles, but makes frequent trips to New York to teach. A member of The Actor's Studio, Allan is a wonderful actor, director, and teacher. I've always been impressed by his ability to put the actor at ease so he can do his best work. Both his book, *A Passion for Acting*, and his videotape, *Audition*, are excellent.

Find out more at *www.allanmiller.org* or 818-907-6262.

All price quotes are current, but confirm rates when you call.

If I have mentioned a studio with many teachers, know that all teachers are not equal. Hang out a little to see who the students are and audit to find the teacher that seems right for you. See at least three for comparison. In a good class you'll learn as much about yourself and the marketplace as you will about acting.

If you're broke, see if you can work in exchange for tuition.

Dance Classes

Teachers with good reputations include Bam Bam, Drew, Soraya, Angel Feliciano, and George Jones at Ripley Grier Studios, Rhapsody at Broadway Dance Center, and Kelly Peters at both Broadway Dance Center and at Steps. For more information check the webpages *www.ripleygrier.com*, *www.bwydance.com*, and *www.stepsnyc.com*. Many of the

teachers teach at several studios.

Showcases

Showcases offer visibility, experience and the ability to hone the most important skill of all: getting along with people. But choose your material carefully. Playing *King Lear* may give you great satisfaction and stretch you as an actor, but it doesn't present you in a castable light for anything other than a Shakespearean company.

✦ *I think they should try to find a showcase which presents them in a castable light, in a role that's appropriate, and that is convenient for agents to get to.*

Before inviting agents, they should consider (and perhaps have professional advice) whether or not the project is worth inviting an agent to. You can engender hostility wasting an agent's evening if it's abominable.
Phil Adelman/The Gage Group

Be realistic in your expectations. You are probably not going to get an agent as a result of a showcase, but that director will direct another play or someone in the cast may recommend you for something else. You are growing, building your resume, maturing as an actor, and working your way into the system.

Analyzing the marketplace and using that information wisely can save you years of unfocused activity. If you were starting any other kind of business, you would expect to do extensive research to see if there was a need for the product you had decided to sell. In addition to checking out actors, note who is working and where, and keep a file on CDs, producers, directors, and writers.

Note which writers are writing parts for people like you. Learn and practice remembering the names of everybody. Know who the critics are. Note those whose taste agrees with yours. Think of this educational process as your Ph.D.

If you want to be a force in the business, begin to think of yourself as such and assume your rightful place. Synonyms of the word "force" inspire me: "Energy, power, strength, vigor, vitality, impact, value, weight."

Take your opportunities to grow. Your weight grows with every play you see, read, rehearse, and perform. You absorb energy from every

interaction, so put yourself with artists you respect.

The Unions

Beginning actors unduly focus on membership in the unions. Although routinely one-third of the 125,000 SAG members make no money at all in a given year (and the numbers in Equity and AFTRA are similar), actors feel that membership in the unions will change their lives.

It will. It will make you ineligible to work in both the non-union films that could give you footage for your reel, as well as the many non-union theatres across the land that would give you a chance to sharpen your acting tools.

Becoming a member of the union is a worthy goal. I can remember the thrill when I got my Equity card (somehow that was the card that meant you were an actor), but I was far along in my resume before I joined. It makes sense to wait.

Financial Core

While we are at it, let's discuss Financial Core, a situation whereby an actor resigns his SAG membership – essentially to play both ends against the middle – working both union and non-union jobs in order to cash in on reality television and non-union commercials.

I heard recently that a manager was recommending financial core to clients. That information caused me to review my history with the Screen Actors Guild and my own naivete when I first began my career years ago in Dallas, Texas – a non-union town at the time. I didn't know about any actor unions other than Actors Equity, and in my mind, I would become a *real* actor when I became a member of that union. But I was pretty sure I would have to go to New York to do that.

When I moved to New York years later, it was easier to establish a career in television commercials than onstage, so my parent union, and the one that made me a *real* actor, was Screen Actors Guild.

I was surprised to learn that as a SAG member, after earning a certain amount of money, I was entitled to medical coverage for my children and myself. That was just a nice plus, along with residuals,

which were unheard of in non-union Dallas.

In addition, though totally unimportant to me at the time since the idea of my ever being older than thirty was not in my consciousness, I now had a pension fund. And if I were ever to actually age and become old enough to collect it (sixty-five for heaven's sake!), I would actually receive a monthly check.

Though union membership was pretty much a necessity in order to get good paying and respected work, the union was still an abstract thought to me. I appreciated the protection it offered when signing with an agent and the all important SAG minimum contracts with employers, but I never stopped to think what it cost to forge those contracts.

I'm amazed and respectful of those actors who put their careers on the line to form a union. Back in the thirties it was a different time and place; the prevailing thought was for the larger good instead of the individual. The union was originally formed to stand up to the powerful studios who controlled actors by signing them to long term contracts for very little money, and crushed the career of any actor who crossed them.

Can you imagine how hard the studios must have fought to keep the unions from forming? And how difficult it was to organize starving actors? You know how actors are: we'll work for free. I can't even imagine how difficult that journey must have been.

The union was formed to enhance actors' working conditions, compensation, and benefits, and to create a powerful unified voice on behalf of artists rights. That's still the job of the union. But never was the union more in need of a unified membership than today. New technologies enable buyers to use our images without appropriate compensation, and management wants to keep it that way.

It's odd to me that someone (an agent or a manager) who says he works for the actor, who supposedly has the actor's best interests in mind, would ever advise an actor to choose financial core.

Agents and managers who urge actors to go financial core are short-sighted. If the actor needs to pay his rent, it's better in the long run to get a day job rather than scab the union. Every time a union actor crosses over into fi-core territory, he undermines all the actors in the union. The union is only as strong as its weakest link. The union is only able to forge decent wages/working conditions contracts if all the professionals stand firm.

It used to be that when an actor worked in the business for a while, even if not a star, he was be able to establish a *quote* of more than scale. These days having a *quote* means less and less, as producers routinely call and say, "we're paying SAG scale + 10%, take it or leave it?" What if there were no SAG scale? What would the actor be paid then? I wonder if those who advocate fi-core want to end up negotiating every single job that comes in for the working actor whose credits might not merit even SAG scale?

If you want a career, intend to live in a house and drive a car, and have a family, you'll find that pretty difficult to do without residuals, health coverage, and at least a minimum contract. You're not going to get that without union help.

For clarity, going financial core means you resign from the union so that you can work non-union work. The union will no longer let a member who has gone fi-core rejoin, but legally no one can keep you from working if someone wants to hire you. So the fi-core actor has his cake and eats it too. Moreover, he actually eats my cake too.

Anyone contemplating going fi-core should take a long hard look at why he chose to be an actor in the first place. I didn't know it at the time, but I became an actor to get a family. As time went by, I realized that the family created by my school plays was taking the place of the family I never had at home. Like many actors, I grew up feeling invisible and I appreciated finally being seen. I loved being in a play, being part of something, having people count on me.

If you are a member of Screen Actors Guild, remember – you do count, you are part of something, and people count on you.

Working as an Extra

While work as an extra gives you the opportunity to be on the set, unless you are looking for more extra work, I would not list it on the resume. You want any agent, producer, or casting director thinking of you for principal parts, so don't cloud his vision.

✦ *Working as an extra could be valuable for someone who has never been on a set, to help you become familiar with cameras and absorb information. It's not something that should be on your resume or even brought up to the agent.*
Flo Rothacker

There are specific directors or producers that you might want to make an exception for:

+ *An extra job on a Woody Allen film could turn out to be a good job because Woody sometimes notices extras, gives them lines and you can end up working for weeks. You could end up getting upgraded or if you got a chance to work on a Sydney Lumet film as an extra, think of what you could learn.*
Marvin Josephson/Gilla Roos, Ltd.

If you plan to be a career extra, working as an extra makes sense. If your goal is to play principal parts, why amass a resume that advertises you in a different capacity? It's tempting to accept extra work to qualify for guild membership, pay rent, keep insurance active or get on a set. I understand that.

I asked an agent if he had "John Smith" work as an extra, wouldn't casting directors and producers now only consider John to be an extra?

+ *We all do. I spoke to a casting director the other day about an actor and that's exactly what she said. The actor has to learn where to draw the line and say, "okay, I can't do this anymore."*
Anonymous Agent

A lot of people can't. They get used to the money and the insurance and their resumes reflect that they are full-time extras. A credible agent might encourage actors to work as extras (after all, he is making a commission), but he expects them to know when to draw the line and stop doing extra work.

To me it's like saying, "here, these drugs will make you feel better. Just take them for a while, I know you will be able to stop in time." If you are not ready to get work as a principal on a regular basis, it may not be time for you to be in the union.

It would be more advantageous for you to work in some other capacity in order to pay your rent or to observe the business from the inside. Become an assistant or work in production. You will see what goes on, make some money, and you won't be fooling yourself into thinking you are really acting. You will be more driven to pursue work that will further your career.

SAG, Equity, and AFTRA all have financial assistance available to members in an emergency situation. If you are not a member of a

union, ask your acting teacher for advice.

There are also many city agencies equipped to deal with people in need. There is low-cost counseling available through both the city of New York and through the schools of psychology of some universities. Call the schools or look in the front of the white pages of the phone book for information.

Invaluable Actor Resources

Although *Backstage East, Backstage West* and *Ross Reports Television & Film (Ross Report)* still print hard copy editions of their newspapers, their online presence has grown as they became part of the family of showbusiness publications anchored by *The Hollywood Reporter*.

Backstage and *RR* are both rich sources of information for any actor who wants to take control of his career. The depth of casting notices available without a subscription is pretty amazing.

There is so much to digest about their resources that you'll need to visit their websites to begin to appreciate the opportunities. Although there is lots of free information, some info is available to subscribers only. Subscribing looks to me like a good business investment although some information (list of agents, casting directors, etc.) is available free online if you just spend the time.

Many agents and managers advise clients to use these papers as information sources, but to skip placing ads for your performances. They say the prices are exorbitant and that it's unlikely that a casting director is going to view work from an ad in anything but *Variety* or *Hollywood Reporter*.

Also, as these publications point out, just because they print the information doesn't mean they vouch for the integrity of the people who invite you to audition. Visit *www.backstage.com* or *rossreports.com* or find hard copies at newsands.

Use good sense and don't go to weird addresses in the dead of night. We've all read stories about actors, usually beautiful women, lured to their deaths by vague promises of jobs and/or connections. Lana Clarkson went to Phil Spector's house when she must have known his reputation. Be alert for anything iffy and particularly those things that sound too good to be true. Don't go.

The actor database of choice for New York casting directors,

agents, producers, and anyone else looking for actors was *The Players Guide* prior to 2003, but at that point *PG* was folded into a community of online actor services: *Players Guide Online/Actors Access/Showfax* and the *Breakdown.*

AA is a free service for actors allowing them to post two pictures, resumes, contact information and (for a price) video links. In addition to this service, the actor has access to casting information and electronic self-submission via The Breakdown Service. These jobs are typically non-union, or very small parts, or a "when all else fails" plea that a casting director might release for general viewing. These Breakdowns cover the entire country and could be that much more valuable for actors outside the large entertainment centers.

There is a $2 charge for each submission on Actors Access and each download of sides from Showfax. A $68 annual membership fee gives you unlimited submissions and sides.

These two resources cover the entire United States as well as Vancouver and Toronto. Check them out online at *www.actorsaccess.com* and *showfax.com.* I'd try the service for a while, paying each time until you establish this is something that works for you. You should find at least one job if you use these tools intelligently.

Showbusiness Weekly, the "original casting weekly for stage and screen" was created in 1941. SW also has an online presence, offering many of the same services as Actors Access. An annual subscription is $84, or month to month for $7.95. *www.showbusinessweekly.com*

Casting Websites

There are many websites where actors can upload their reels and publish their resume. The trick is to find the sites that buyers visit:

✦ *Three of my clients booked a Bollywood a feature film recently from choreographers seeing their work at* www.sceneinteractive.com. *Actors and dancers can put up their reels online on this website and casting directors from all over the world see their work and directly book them them.*
Thomas Scott/DDO Artists Agency

Your Reference Library

At the beginning of my career I was fortunate to get a part in what turned out to be an important film called *A Touch of Class*. The night I arrived in Marbella, Spain, where the film was shot, I found myself standing next to the wife of the writer-producer-director at a party honoring the cast.

Making conversation, and truly delighted to be involved with such a lovely script (Mel Frank eventually won an Oscar for it), I said to Ann Frank, "what a wonderful script. Is this Mel's first script?"

What did I know? I thought he was primarily a director and, as a New York actress, I was ignorant of things Hollywood. Ann was so cool. She neither walked away, nor behaved in any way condescending. She just began patiently enumerating the edited version of her husband's incomparable credits.

It turned out that Mel was a famous Hollywood writer who, along with partner Norman Panama, had written the Bing Crosby-Bob Hope *Road* pictures, plus many other classic films. I almost died of embarrassment, but Ann was all class. She patted my arm and smiled, "this will be our little secret." All the time I was apologizing for my ignorance, I was promising myself that I would never be in that position again.

If you have Internet access, it's a snap to power up *www.imdb.com* (Internet Movie DataBase) to check credits. I also recommend your library be stocked with books that tell you what the business is really like (*Adventures in the Screen Trade, The Season* and *Final Cut,* etc.), as well as biographies of successful people (in our business and others) that will provide role models in your quest for achievement.

Some of these books give you real guidance about what a career costs, and illustrate that success doesn't fix you. It may feel better for a while, but you're always you, just with a different set of problems. The more you read about people's journeys, the more perspective you gain.

Here is a list of books that will give your library a good start:

Aaron Spelling: A Primetime Life/Aaron Spelling
Act Right/Erin Gray & Mara Purl
Adventures in the Screen Trade/William Goldman

AFTRA Agency Regulations
A Passion for Acting/Allan Miller
Audition/Michael Shurtleff
Book on Acting/Stephen Book
Comic Insights: The Art of Stand-up Comedy/Franklyn Ajaye
The Devil's Candy/Julie Salamon
Equity Agency Regulations
Final Cut/Steven Bach
Hollywood Representatives Directory/Hollywood Creative Directory
Hollywood Creative Directory/Hollywood Creative Directory
How I Made 100 Films in Hollywood and Never Lost a Dime/Roger Corman
How to Sell Yourself as an Actor/K Callan
Hype & Glory/William Goldman
Indecent Exposure/David McClintock
The Last Great Ride/Brandon Tartikoff
The Los Angeles Agent Book/K Callan
Making Movies/Sydney Lumet
Monster/John Gregory Dunne & Joan Didion
My Lives/Roseanne
The New York Agent Book/K Callan
Next: An Actor's Guide to Auditioning/Ellie Kanter & Paul Bens
Rebel Without a Crew/Robert Rodriquez
Reel Power/Mark Litwak
Ross Reports Television & Film/Back Stage/Back Stage West Publication
Saturday Night Live/Doug Hall & Jeff Weingrad
Screen Actors Guild Agency Regulations
The Season/William Goldman
Theatre World/John Willis
TV Movies/Leonard Maltin
Ultimate Film Festival Survival Guide/Chris Gore
You'll Never Eat Lunch in This Town Again/Julia Phillips
Wake Me When It's Funny/Garry Marshall
Wired/Bob Woodward

For fun, read Tony Randall's book, *Which Reminds Me.* For inspiration, Carol Burnett's *One More Time.* To gain insight on how to get into and what goes on at film festivals, read Chris Gore's *The Ultimate Film Festival Guide.* Roseanne's book, *My Lives,* speaks candidly of the behind-the-scenes intrigue involved with her show. It's

instructive.

If you know of any books that should be on this list, let me know and I'll include them in subsequent editions. I consider books like *Wired, Indecent Exposure* and *Saturday Night Live* to be instructive and realistic about the business. They keep my values in perspective. I need reminders of how easy it is to get caught up in the glamour, publicity, money, and power of this fairytale business. I need to remember that those things leave as quickly as they come.

Standardizing Non-Union Work for Dancers

Young dancers not yet far enough along to get into SAG and working non-union work have a friend in the Dancers Alliance website.

✦ *Welcome to Dancers' Alliance, an organization created by dancers to standardize non-union work. D.A. rates are minimums imposed by dancers and agents to protect dancers' wages and working conditions that are not covered by union jurisdiction. D.A. is not a union! These rates are most effective and attainable if dancers know them and make an effort to attain them on every job. You don't need to have representation to apply these rates to your work.*
www.dancersalliance.com/frame.html

Breakdown Services

Back in the day, agents in Hollywood journeyed to each studio every day to read the latest script, make notes, and submit actors. Gary Marsh was one of those readers, doing the job for his agent mother. He changed the system forever when he called the studios and said something like, "if you give me all your scripts, I will summarize them and make a list of the types of actors needed for the parts, the size of each role, etc., and provide that information to all the agents. This will be better for everyone. You won't have those people in your offices and they won't have to drive." Thus Breakdown Services was born.

The much-maligned service costs agents and managers a hefty amount. Though they must agree not to show it to actors, some actors get their hands on it anyway. A woman in Beverly Hills charges actors $20 per month for access. She hides it under a rock behind a gate. Actors drive up, lift the rock, sit in their cars, read the Breakdown and

make notes. They return it to its hiding place and drive away. I'm sure there's a New York version of this somewhere.

Whether or not it's a good idea to have access to the Breakdown is debatable. Casting directors already don't have enough time to look at all the agents' submissions. How will they ever open all the actors' envelopes, much less consider what's inside?

◆ *It's just plain counterproductive for the most part [when actors get their hands on the Breakdown]. The casting directors are likely ignoring submissions from non-represented actors. And as far as represented actors go, you better hope you're wasting your agents' office time pointing out what you're right for. Our work is about everything after (and hopefully before) the Breakdown. We continue to talk to casting and find out so much. Often they want a name for a part, or are just looking for back-up ideas if their offer falls through, or change their mind about the "specs" after the first round of auditions, or cut the part, or a myriad of other factors.*

Casting is an activity and that means change, give-and-take, and yes mistakes happen. For an actor to pin his expectations to the snapshot in time of a Breakdown is wrong. Our office's response to an actor quoting Breakdowns is "that's not a mail-order catalogue there."

J Kane/HWA Talent Representatives

Whereas some actors are able to use the purloined information intelligently, others merely manage to alienate their agents. Though invaluable, the Breakdown doesn't include everything. Many roles aren't listed unless the casting director needs an unusual actor for a role.

Frequently the script is truly not available. More times than not, the audition sheet will be filled with producer requests, not from submissions.

Since not everything comes out in the Breakdown, it is important to assess your agent's other contacts. If your agent is not in a position to have more information than is in The Breakdown, that's still a lot of information if he uses it wisely.

Stumbling and Physics

You're not going to be perfect when you begin. It's part of the physics of life that you have to stumble a bit to find your way. My

research of people and careers (including my own) leads me to conclude that there is a "three year stumble rule," so don't give yourself a bad time for not having things together immediately. One just has to be "green" for a while before you can season and grow.

Law of nature.

So move in, get settled and begin your stumble.

Wrap Up

Tools for First Agent

✓ support group
✓ decent credits
✓ open calls
✓ audition DVD
✓ focus
✓ entrepreneurial skills
✓ integrity
✓ fellow actors
✓ growth

Personal Resources

✓ family
✓ teachers
✓ friends

Professional Resources

✓ job in business
✓ acting class/teachers
✓ theatrical publications

Reference Library

✓ educational
✓ inspirational
✓ indispensable

Breakdown Services

✓ important tool for agents
✓ can be self-destructive in the hands of the wrong actor

Physics

✓ three-year stumble rule

⊷ 5 ⊶
Self-Knowledge

Before you can sell yourself to the marketplace, you must decide what you have to offer. A reader e-mailed that she sent her picture and resume to many agents and though many asked to meet her, no one would sign her. I asked her to send me her picture. She was an adorable sunny Drew Barrymore type. I could understand why everyone had wanted to meet her.

I studied the pictures trying to figure out why all these agents passed after asking to meet her. I wondered what didn't match. Finally I asked if by chance she had an "edge." When she answered affirmatively, I knew we had identified the problem. All the agents who asked to see her obviously had room on their lists for Drew Barrymore but not for Angelina Jolie. Once the actress adjusted the picture to match her personality, she was quickly signed.

✦ *[Actors need to] be aware of their strongest gift and concentrate on it.*
Diana Doussant/HWA Talent Representatives

✦ *Before you start meeting people, you need to find an image to present. Check to see what the demand is and where you fit in.*
Ann Steele/Ann Steele Agency

✦ *Know yourself. Know what you want to do.*
Archer King/Archer King, Ltd.

✦ *Be the best person you can be. Learn about yourself. You need a solid center to deal with life when things get tough. You have to know what your bottom line is and what you are willing to sacrifice in order to get what you want.*
Jack Menasche/Independent Artists Agency, Inc.

✦ *Know yourself. You are the president of your company and you are the product. If you know what you've got, you can market the product better.*
Bill Timms/Peter Strain & Associates, Inc.

✦ *Be aware of where you fit into the marketplace and if you don't know now, you might one day. Most importantly, if there is anything else you can see yourself doing with your life, do it. This business is very tough and you have to want it more than anything else in your life in order to stick with it.*
Diana Doussant/HWA Talent Representatives

Acting class is a good place to start the investigation into your persona. Ask your teacher to suggest some material for you. That choice will give you an idea how the teacher sees you. If you tackle a variety of characters, you'll soon get a feeling for the material that resonates within you. You'll see what begins to feel "right." My first teacher Herbert Berghof encouraged us to explore playwrights from our own part of the country.

Do you have the right talents?

When people use the word talent in relation to actors, they usually refer to acting talent, but other talents govern how effective the acting talent can be. Once you reach a certain level, all your competition is terrific. Any one actor sitting in the waiting room would be a good choice. The talent to self-motivate, focus, maintain balance and one's own voice under pressure will be the deciding factor in who prevails.

✦ *Talent has never been enough. Talent never will be enough. You have to have commitment and a singular purpose. Every decision has to be a career decision.*
Archer King/Archer King, Ltd.

When you hear about the thousands of starving actors vying for five agents and one part, you can screen out many of those thousands. They won't be your competition because they have no appetite for taking care of business. It doesn't matter if there are only five agents and one part, as long as you get the part and one of the agents.

I asked agents to name the most important single piece of advice they would like to give to actors. Almost everyone gave some version of the same answer, "know which one you are."

Don't expect to play Catherine Zeta-Jones' parts if you look like Bonnie Hunt. When I first arrived in New York, I did everything I could lest I be mistaken for the middle-class lady from Texas I was. I wanted to be a sophisticated New Yorker.

What I didn't realize, Texas accent not withstanding, was that my very middle-classness is what I had to sell. I have played women who went to Vassar, but more often buyers can and will get someone for those parts who actually went to Vassar .

I'm an authentic lady from Texas who has raised three children and had various life experiences that continue informing my persona. I'm a mother, a carpenter, a quilter, a theme partygiver, an ex-Catholic, a grandmother and on and on.

There is nobody else who has my particular components. If I don't prize what is uniquely me and find a way to tie that to a universality of the life experience, not only will I not work consistently and honestly, but my life will be a mess as well.

Also, as a person who has just begun to travel, I cannot say strongly enough how I wish I had started sooner. Traveling piques the curiosity and gives you a much broader life perspective.

✦ *I personally believe that anyone who comes into this business has one point where they can enter the business: literally a skill, a qualification, that will get them a job tomorrow.*

If they are willing to take the time to find out what it is and go for that area, they can get hired, they can start working. And then they can begin to explore the other areas that they might not yet be prepared for.

There are certain qualifications that are required in every area. People who want to do musical theatre have to be able to sing and dance. They need to take the classes. They must do regional theatre and work their way up, just like in corporate America. Those who want to do film and TV, other than those soap beauties who land a job just on their looks, you have to have certain qualifications.

Whatever area you are strongest in, you should go for that first. Then when you are making money in the business, you interview better and you audition better. You meet people better when you are working in the business than when you are a waiter or a waitress trying to get just any job. You're going for film, you're going for commercials, you're going for television, and just grabbing for everything rather than learning to focus and say, "where can I get hired today?"

Once you are working in the business, then you can move your way through the path you want to be on. That's the client I like to work with. One that is already at this point and we can move you from here to here to here and take you to where you want to be. Then you are a goal-oriented career-driven client.

H. Shep Pamplin/Agents for the Arts

✦ *Actors need to be in touch with who they are, their type, their strengths and*

weaknesses. They have an inability to grasp the fact that they can't be seen for everything in town and that just because a friend gets an appointment doesn't mean he will get one too. Actors have to figure out what they are right for and what they are best at; they need to know their own limitations.
Gary Krasny/The Krasny Office

✦ *Know your place in the business. It's good to have goals and expectations but they must be realistic expectations.*
Bill Timms/Peter Strain & Associates, Inc.

✦ *Many young actors are celebrity wannabes. They're not process oriented. They're not working on their craft. They're not working on who they are and what they do and making that the best, bringing the life to it.*

They're more goal oriented and looking just to get the job. Unless you have the training, that one job you get is going to be a flash in the pan. After that, that actor's career is over unless they have a good solid foundation of training.
Jim Flynn/Jim Flynn, Inc.

Lionel Larner is out of the business now but he had a lot to say:

✦ *A lot of people are just totally unrealistic. They're either young and unattractive and/or overweight, and inexperienced. And they do have a chance of being an actor, but when you look like that, it's not going to happen for twenty or twenty-five years. They'll have to be a character person. They have a fantasy of acting and they haven't done anything about it. They must do the work, they must learn the craft.*
Lionel Larner

✦ *An actor can develop objectivity. It's very difficult. I don't know how one does it, but one has to have a certain objectivity about oneself and not freak out in certain situations that are difficult; in a crisis, not to allow your emotional life to carry you over into decisions that are not correct decisions. Decisions have to be weighed over a period of time and not in hysteria.*
Jeff Hunter/William Morris Agency

A friend of mine struggled when she first came to Los Angeles. I tried to help her by suggesting a part in a show I was doing. Mary was a young pretty actress with great comic gifts. The part was the town bad girl. She said, "you obviously don't know who I am. I have no breasts. No one will ever cast me in a part like that."

She wasn't whining, just stating a fact. When she got her break, it

was playing an upper crust young lady born with a silver spoon in her mouth. The clarity with which she was able to see herself gave her a focus on and offstage that won her huge rewards. She became a hugely successful actress.

It's Your Machine

In an interview, Sigourney Weaver quoted George Wolfe's speech to graduates of NYU's Tisch School for the Arts.

✦ *He said early on he'd written this musical called "Paradise" and he'd had great hopes for it. And the day it opened was the day it closed. He looked out at all the students and said, "I'm going to tell you what your greatest teacher is, and the greatest creative tool you have in your career. It's failure. Failure will teach you all these things that you need to know."*

He said, "it's like standing in a huge casino and everyone has a slot-machine. And you're feeding your slot machine and nothing is happening and all around you people are hitting the jackpot and getting all this stuff. And you're going, 'well, I want to go over there to that machine. It's obviously a better machine than mine.' "But," he said, "stick with your own machine. It may take you longer. But when you hit, you're still yourself."

Scott Poudfit, *Back Stage West*[7]

✦ *Actors make a big mistake when they turn over their power to everybody else, making it about everybody else. Actors have to be very clear about who they are and what choices they are going to make when they go into auditions, and, if it's not working, to change their direction. You can't blame it on everybody else.*

Actors don't understand how the business works. I can't really blame them. All they want to do is act and everything seems to get in the way of doing their piece. I feel bad about that. They don't understand the reality of what it takes to mount a project, the amount of money involved, the fact that everybody involved is scared to death for their lives, their reputations, and that when somebody comes walking through the door, they better be less scared than these people are or they're not going to get the job. Nobody's going to trust them with the money and the responsibilities that go with some of the roles.

Marvin Starkman/Producer

Sometimes we do get the idea that insecurity is charming and that admitting it is even endearing. We announce to buyers at an audition

that we are petrified of being there and that we are sure we won't do our best.

Really?

When had you planned to do your best? In front of 5,000 people? Will that be easier? Insecurity is not charming. It is not appealing. It is not endearing. And it is certainly not going to inspire the people with money to trust you with the responsibility of carrying their project.

If you find yourself in a continuing state of anxiety, there is either something physiologically wrong with you or you are getting off on it.

If you enjoy being a basket case, take responsibility for that. This can be a marketable attribute if you prepare yourself to play those kinds of roles. Otherwise, get yourself together and start behaving as though you have complete confidence in your abilities. Pretty soon, you won't be pretending anymore.

All we have is now. If you are not fulfilled by the now, get out of the business. If the payoff for you is the big bucks, the Tony, the Oscar or the Emmy, change jobs now. You will miss your whole life waiting for the prize. If you are unlucky enough to get the prize with this mindset, you will find you are just the same unhappy person that you were the day before, but now you have an Oscar.

Mental health, balance and self-esteem are essential.

✦ *An actor is in a very tough position because he has to believe in himself in order to produce. On the other hand, there's a point where an actor believes so much in himself that he's unrealistic. There's a dichotomy between self-confidence and self-infatuation.*

Jeff Hunter/William Morris Agency

The late Barry Douglas from DGRW was articulate in his analysis of the actor's self-confidence.

✦ *The most important person to like you is the audience. Before the audience can like you, the producer has to agree to pay your salary. Before the producer agrees to pay your salary, the director has to agree to work with you.*

Before the director can agree to work with you, odds are, the casting director has to bring you in and say you're right for the role. Before the casting director can say you're right for the role, an agent has to submit you. Before any of these people get to see you, the first person who has to say, "I'm good," is the actor.

You've got to be confident enough to take a risk with a piece of material, to look at a piece and say, "ah, I can expose the humanity of this character; I can

develop the creativity of this moment of the theatre or film or television better than anyone in the universe. I am the first person on this." If the actor doesn't believe that, no one else will. It's got to come from the actor first. The actor who is too insecure to ask for an agent just might not make it.
Barry Douglas

Reality

In a fantasy business, it's a constant struggle to maintain perspective and remain excruciatingly realistic.

✦ *Realize that everybody's career is different. Someone may be twenty-five years old and be a star and then another actor may not make a dime until they are fifty. Actors have to relax and not be so concerned with success. You have to be a constant actor. You can't say, "well, my friend is doing a Long Wharf show and I'm just doing off-Broadway." Everybody's career is different.*
Harry Packwood

✦ *It's a business of survival. Your turn will come if you're good. It may not come as often as it should, but it'll come. They will eventually find you. You can make it if you can survive and you can only survive if you have no choice.*
Some go into the business saying, "well, I'll do this for five years and I'll see what it's like or I'll do something else." If you have something else you can happily do, do it. It's only the people who are so committed, so desperate in some way that they'll put up with the humiliation, that they will allow themselves on ten minutes notice to be there, they'll allow themselves to be open and vulnerable; to still expose who they are and still be strong and protected enough to survive that kind of open wound life. They're the only ones who are going to make it, the people who have no choice.
Barry Douglas

Further in the *BSW* interview Sigourney Weaver says:

✦ *You know, Meryl Streep was at school with me. And she was obviously ready for success more than nerdy me, at least. And it was hard, because she went right from Yale into Lincoln Center with no showcases at all. But I've learned that everyone has their own timetable and that's just the way it is. Everyone has their own path. It may not be the path you want, but in the end it's better for you.*
Scott Poudfit, *Back Stage West*[8]

✦ *This is a business that rightfully or wrongfully, prefers prettier people. The prettier person gets the second look. It's a reflection of what the audience wants.*
Tim Angle/Don Buchwald & Associates/Los Angeles

The late Fifi Oscard had these words of wisdom:

✦ *I believe you will arrive at the success point you are intended to arrive at simply by working hard, not faltering, and having confidence that it does happen. It does happen. You get where you're supposed to get in our business.*
Fifi Oscard

✦ *Don't look at other actors' careers from the wrong end of the telescope. Don't look at what they did and think, "oh, they just went from one thing to the next. It was just this inevitable golden path and they just had to walk along it."*
Tim Angle/Don Buchwald & Associates/Los Angeles

Just because you don't get the job doesn't mean you're not good. There are variables you can't control. You can't expect any kind of time table as to when you can work. That is not the actor's life.

While you are paying your dues, you might get a job that gives you visibility and money for a month or even a year or two that makes you think you are further along in the process than you are.

Once your series (only one job, after all, no matter how long it lasts) or movie or play is over, you are not visible in that show business way and may think your career is over since your employment opportunities are no longer high profile.

Visibility is a double-edged sword. In television especially, the buyer may prefer a talented new face over an actor who has just finished a series. Frequently a semi-famous face finds itself unemployed because the buyer thinks it's too identifiable with a previous show.

Consistent Work

The task that takes more time than anything else is looking for and winning the work. Even two-time Academy Award winner Sally Field had her ups and downs. She says it isn't like she thought it would be. She's constantly reading scripts, creating opportunities for herself. When things weren't happening in films, she went to Broadway starring in *The Goat*. Now her star is shining again with her brilliant Emmy

winning performances on ABC's *Brothers and Sisters*. But when it's over, it will be over and Sally will be reading all those scripts again.

That's depressing, isn't it? It never lets up. I think sometimes that maybe it's the chase, that if they just gave me all the jobs, that I might lose interest and leave the business. I certainly wouldn't mind putting that one to the test!

Assess Yourself & the Marketplace

Are you a young character person? A juvenile? Someone who is right for a soap? In order to see yourself clearly within the framework of the business, study the marketplace. View theatre, television, and film with distance. Notice what kinds of actors consistently work. What is common to the people that work? Notice who is like you and who is not. Keep a list of roles you have seen that you realistically think you would have been right for. Ask your agent if he agrees.

As you become informed about the business, you will begin to perceive the essence of people and notice its role in the casting process. More important than the look is essence. The thing that is the same in the many diverse roles of Robert De Niro is the strength of spirit.

Practice thinking like a casting director. Identify the essence of Kevin Kline, Billy Crystal, and Whoopi Goldberg. Cast them in other people's roles. What would have been the effect if Tom Cruise had played Russell Crowe's part in *Gladiator*? What if Gwyneth Paltrow had played Julia Roberts' role in *Erin Brockovich*? Impossible? Yes, but this exercise will help you understand why you will never be cast in certain roles and why no one else should be cast in your parts — once you figure out what those parts are.

Does your appearance match your essence? Another responsibility you have is to be the best looking you that you can be, given what you came with. As Tim Angle said, the business gravitates toward prettier people. Just as in life. Getting upset about that fact is like throwing a fit because the sun shines in your window every morning and wakes you up. Get a shade. If you are not pretty, be clever.

In dark moments I like to read Ruth Gordon's words from a *Los Angeles Times* interview:

✦ *Two things first. Beauty and courage. These are the two most admired things in life. Beauty is Vivien Leigh, Garbo; you fall down in front of them. You don't*

have it? Get courage. It's what we're all in awe of. It's the New York Mets saying, "we'll make our own luck." I got courage because I was five-foot-nothing and not showgirl-beautiful. Very few beauties are great actresses.

Paul Rosenfield, *Los Angeles Times*[9]

The Process

✦ *Nobody changes the rules. What you can do is play the game for what you want or at least toward your ends. Nobody will force you to do work that you find insulting or demeaning. You have to figure out the rules in order to figure out how to play the game. You have to figure out what is a variable and what's not.*

If actors would take the time to put themselves in the shoes of the people they're dealing with, they would very quickly figure out what's reasonable and what's not. Actors don't understand why Equity Principal Auditions are a bad idea.

The reason is that no one can look at 250 people auditioning in a single day and give an accurate response. That's one of the reasons they only see forty people for a role. Knowing that isn't going to make your life easier, but it means it's not some arbitrary system where God touches this person and says, "you get to audition," and you, as the untouched person, sit there wondering. If you think about a director casting a play and you understand what he has to do to cast it as well as possible, at least you know what you're up against. It's not some vague, amorphous obstacle. It's not fair but at least it makes sense.

What you know is never as bad as your imagination. If you know what you're up against, it can be difficult, but at least it's concrete. What you don't know, your imagination turns into, "everyone in the business knows I shouldn't be doing this. I'm just not talented." It's like conspiracy theories.

Tim Angle/Don Buchwald & Associates/Los Angeles

When Sigourney Weaver was a young girl, her father ran NBC. When he left there and tried to start a fourth network, he received death threats and subsequently lost everything. Weaver says:

✦ *...From my father, I learned that business was not fair. I knew that things did not happen in any kind of logical, nice way. I didn't believe that people necessarily got what they deserved. Knowing that the business was unfair helped me.*

Scott Poudfit, *Back Stage West*[10]

✦ *We'd all be a lot better off if actors knew what went on behind the agent's door. There's not much mystery about what happens between the agent and the casting*

director, and the director and the producer, as a lot of actors want to weave myths about. Most of the time, the actor is just not right for the part.
Kenneth Kaplan/The Gersh Agency

✦ *Careers are like pyramids. You have to build a very solid base. It takes a long time to do it and then you work your way up. No single decision makes or breaks a career. I don't think actors are ever in a position where it's the fork in the road or the road not taken, where it's, "okay, your career is now irrevocably on this course. Too bad, you could have had that."*

If an actor looks at another person's career and says, "I don't want that," he doesn't have to have it. People do what they want to do. It's like people who are on soaps for twenty years. Well, it's a darn good job, pays you a lot of money and if you're really happy, great. But if you're an actor who doesn't want to do that, you won't. Nobody makes you sign a contract. Again. And again. And again.

Every decision you make is a risk because it's all collaborative and it can all stink. Every play at the Public is not a good play. Not every television series is a piece of junk. People make decisions based on what price they want to pay, because there is a price.

If you don't want to work in television, there's a price. If you want to work in television, there's a price. If you want to work in New York in theatre, there's a price. You have to decide if that's worth it; it's an individual decision, not a moral choice. It shouldn't be something you have to justify to anybody but yourself.

It's not about proving to your friends that you're an artist. It's about what's important to you at that moment. People can do two years on a soap and that can give them enough money to do five years of theatre. And that's pretty important. It depends on why you're doing it and what you're looking to get out of it. What is the big picture? Nobody knows it but you.
Tim Angle/Don Buchwald & Associates/Los Angeles

Almost every agent echos Jerry Kahn's words:

✦ *One of the things I wish actors knew about was the business part of the business. A little bit more about their union rules and regulations so that every time you get an actor a job you don't have to explain to them what the contract entails. That information is as readily available to them as it is to the agent. It's irritating to have to go through all that when you book somebody.*
Jerry Kahn/Jerry Kahn, Inc.

Get familiar with the wealth of information on the various union webpages: *www.sag.org, www.actorsequity.org, aftra.org*

✦ *For the actor who wants to work all his life, the most important thing is continuity of management. Once you have established a reputation within the business that you are a good performer, the telephone generally rings. Your name is on a submission list. "Yes, she's right for this." "No, she's not right for that."*
Jerry Hogan/Henderson/Hogan

Being Smart

The world is small. The world of show business is even smaller. Be circumspect with your comments about other people's work, about auditions, about casting directors, and about agents. Never talk in rooms where you don't know people. Never. It's hard to believe while sitting in a coffee shop that anyone hears your words.

I met a writer who told me we had been in the same restaurant one day years before. He repeated the conversation I had had with my friend. Fortunately we hadn't been speaking about the business, but he did make a believer out of me.

One of the most candid and entertaining people I ever met was the late agent Beverly Anderson who said her best advice is:

✦ *Be smart. Don't be naive. If you're not smart, it doesn't make any difference how much talent you have or how beautiful you are. You're dead. In all my experience of thirty-nine years, of all the people that I can sit here and say, "They made it," they did not make it because they were the most talented or the most beautiful or even the best organized or the most driven. They made it because they were basically extremely smart human beings.*

It has nothing to do with the best looks and the best talents, the best voice or the best tap-dancing ability. It's being smart. Donna Mills is smart. Alan Alda is smart. Johnny Carson is smart. Barbara Walters is smart. They made it because they're smart, not because of talent. Talent is just automatic in this business.

Who's to say that Barbra Streisand has the best voice in the world? I mean, let's face it, she sings well and has gorgeous styling and she makes a great sound, but who's to say if she has the best voice? I think the one ingredient that counts the most in this business is "smarts." You could be talented and be sucked in by some agent who signs you up and never sends you out and you sit there for five years and say, "well, I thought they were going to get me a job." Is that smart? To be smart is the best thing. Talent is a dime a dozen.
Beverly Anderson

Part of being smart is factoring in what your dream may cost. In an interview while working on *The X-Files*, *Californication* star David Duchovny underscored a reality I have witnessed firsthand.

✦ *"I'm OK, I can take care of myself, but I feel isolated and lonely. I'm not happy. If I knew what it was going to be like, would I have taken the series? Can I also know what it would have been like if I didn't take the series?*

I hate those kinds of things, where people say, "stop bitching, you could be working at Burger King now." As if those are the only two options for me, either act, or "would you like a soda with your fries?" But doing a television show is like riding an elephant: it goes where it wants, with or without your say. Does that make me an ungrateful bastard?"

Martha Frankel, *Movieline*[11]

Visionary Buckminster Fuller says it's a law of physics that if you take all the wealth in the world and redistribute it equally, in a hundred years (or fifty or whenever), the distribution will return to what it is today. Some people work hard, some don't. Some save. Some squander. Them that has, gets; them that don't, won't.

It's up to you and how smart you are: whether you make positive choices; whether you choose to walk away at the first sign of negative thinking; how well you know which one you are. You will have just what you want.

Isn't that nice? It's all in your hands.

Wrap Up

Analyze

✓ how the business works
✓ who gets hired
✓ who hires and why
✓ which actor is getting your parts?
✓ what do they have that you don't have?
✓ your strengths
✓ your weaknesses

Important

✓ focus on the process not the goal
✓ study
✓ nourish your talent
✓ be organized
✓ acquire business skills
✓ be smart

⚞ 6 ⚟
Avenues of Opportunity

Now that you are settled, educated, and know which one you are, it's finally time to talk about agents. Many actors regularly curse and malign them, either feeling rejected that they can't get an agent to talk to them, or frustrated once they have an agent simply because of their unrealistic expectations.

You can save yourself a lot of heartache and ultimately move your career along faster, if you take the time and effort to learn how the business really works, how agents do their jobs, and how the agent is not the person who can make things happen for you. What?

Let's start by defining what an agent is and is not and what he does. Do you even need one at this point? Where would you find one? How can you get one to even meet with you and once there, what would you say? Are there rules of behavior? How can you tell if someone is a good agent? When is the right time to look for one? If they all want to sign you, how would you choose the right one? If no one wants to sign you, what will you tell your mother?

Let's dispense with the mother issue right off. Unless your mother is an actress, she is never going to understand. Those who have never pursued a job in show business (civilians and would-be actors who are still in school) can never understand what an actor goes through in pursuit of employment and/or an agent. So don't waste time on that conversation.

Just say: "Mom, I'm doing great. I'm unemployed right now and I don't have an agent, but that's part of the process. There are things I need to accomplish before it's time for me to look for an agent."

She's still not going to understand that, but it will mean something to her that you have a plan and it's something to say to her friends.

What Is An Agent?

Whether your agent fantasy includes the old-fashioned stereotype of cigar-chomping hustlers or the newer version of the cool customer in the expensive suit, many actors fantasize that the right agent holds

the secret of success. Ex-William Morris agent Joanna Ross left the business and moved to Italy, but I'm still quoting her because her perspective on the actor/agent relationship is so insightful.

✦ *Actors feel that if they make the right choice, the agent is somehow going to make them a star and help them be successful, or they're going to make the wrong choice and that's it. And that's just not it.*

No agent can make anybody a star or make him a better actor than he is. Agents are only avenues of opportunity.
Joanna Ross

That being the case, what do these "Avenues of Opportunity" do? The dictionary (which knows very little about show business) has several definitions for the word "agent." By combining a couple, I've come up with one that works for show business: a force acting in place of another, effecting a certain result by driving, inciting, or setting in motion.

Huh?

In its simplest incarnation, the agent, acting on your behalf, sets in motion a series of events that result in your having a shot at a job. He gets you meetings, interviews, and auditions. And he prays that you will get the job or at the very least make him look good by being brilliant at your audition.

When an actor grouses that the agent is not getting him out, he seems to think the agent doesn't want him to work, completely forgetting that if the actor doesn't work, the agent cannot pay his rent The actor also often overlooks the fact that his part of the partnership is to get the job.

It should be simple. After all, you've spent years perfecting your instrument: learning your craft, training your voice, strengthening your body, defining your personality, and building a resume that denotes credibility.

Haven't you?

An Agent Prepares

While you have been working on every aspect of your craft, the agent has spent his time getting to know the business. He's seen every

play, television show, and film. He's watched actors, writers, directors, and producers birth their careers and grow. He's tracked people at every level of the business. He has networked, stayed visible, and communicated. He's made it his business to meet and develop relationships with casting directors, or CDs, as they are sometimes referred to throughout this book.

The agent you want only represents those actors whose work he personally knows. When he tells a casting director that an actor is perfect for the role and has the background for it, the casting director trusts his word. That's the way the agent builds credibility and it doesn't happen any faster than the building of the actor's resume.

In addition to getting the actor the appropriate audition, the agent has to be prepared to negotiate a brilliant contract when the actor wins the job. That entails knowing all the rules and regulations of the Screen Actors Guild, Actors' Equity, and American Federation of Television and Radio Artists, as well as having an understanding of the marketplace and knowing what others at similar career levels are getting for similar jobs.

He must have the courage, style, and judgment to stand up to the buyers, and must ask for appropriate money and billing for the actor without becoming grandiose and turning everyone off. The agent must also fight the temptation to sell the actor down the river financially in order to seal his own future relationships with the producer or casting director.

What Do Agents Think Their Job Is?

The Association of Talent Agents (ATA) is the official trade organization of talent agents. From their webpage is a description of their role in an artist's life:

✦ *Creating opportunities for their clients is at the heart of what ATA agents do. Licensed and regulated by state and local government agencies, ATA agents are at the focal point of change in the industry and at the forefront of the development of new relationships for their clients. In an era of media consolidation and vertical integration in the industry, ATA agents are the artists' strongest allies.*

In contrast to many other industry professionals, ATA agents are licensed and strictly regulated by state and local government agencies in California, New York

*and the other parts of the country where agents do business. In California, for
example, ATA agents are not only licensed by the State Labor Commissioner and
subject to annual review, but the artists' contracts are approved by the State Labor
Commissioner. ATA agencies also work under negotiated agreements with DGA,
WGA, AFTRA, Actors' Equity and AFM. While the SAG agreement expired
in 2002, ATA agencies continue to work with actors under ATA state-approved
agency contracts.*

 www.agentassociation.com/frontdoor/faq.cfm

✦ *I feel that I'm responsible for my clients' attitudes and for their self-confidence.*
Kenneth Kaplan/The Gersh Agency, Inc.

✦ *If someone puts their trust in me, then I need to help them earn a living. I want
to get them work. I want actors who are talented, but I have to like them.*
Marvin Josephson/Gilla Roos, Ltd.

✦ *If you sign someone, if you agree to be their agent, no matter how big the agency
gets, you've agreed to be there for them and that's your responsibility.*
Kenneth Kaplan/The Gersh Agency, Inc.

✦ *Sometimes actors don't really consider all the work an agent may do for them
that doesn't result in an appointment. The agent may have said your name many
times to the casting director until the CD has heard it often enough that he begins
to think you are actually working.*

 *At that point, the actor happens to call the casting director himself and ends up
with an appointment and subsequently a job. Now he calls his agent and says,
"well, hey. I got the job myself. Why should I pay you commission?"*

 *In my head, I'm going, "who sat down with you and told you how to dress?
Who helped you select the photos you are using right now that got you that audition?
Who helped you texture your resume? Who introduced you to the casting director?
What makes you think you did that on your own?"*

 *They don't see it. They don't see that, like a manager, I have taken them from
here to there. I set up the auditions. Most actors don't realize the initial investment
we make, the time, the energy, the phone calls, the mail, the hours of preparing the
actor and getting them to the right places. There is no compensation for that until
maybe two years down the road.*

 *At that point, you've made them so good that someone else signs them anyway.
There's not a lot of loyalty among actors. They'll always want the person who gets
them the next job. They don't comprehend what we go through to get them ready for*

that point where they can get a job.
H. Shep Pamplin

Try to digest the truth of Shep's statement. It is an unusual person who arrives on the scene poised enough to handle himself in the audition room. That kind of poise usually cannot be acquired without going through the struggle time. An agent who invests his time and energy in the struggle time should be rewarded, not discarded.

✦ *I offer hard work and honesty and demand the same in return. If I'm breaking my ass to get you an audition, you better show up.*
Martin Gage/The Gage Group

Although it might be nice to be pals with your agent, it is not necessary. One of the best agents I ever had was never available to help me feel good when all was dark. He did, however, initiate new business for me, was respected in the community, negotiated well, showed impeccable taste, and had access to everyone in the business.

He also believed in me and retained that faith when I did not win every audition. He gave me good notes on my performances, clued me in to mistakes I was making, and made a point of viewing my work at every opportunity.

Oh yes, and he returned my phone calls!

A friend of mine toiled for many years on a well-regarded series. She was happy to be working, but felt her agent had not negotiated well. She changed agents and doubled her salary. A year later she changed agents again: "They were good negotiators, but I couldn't stand talking to them."

You can't have everything.

Being a tough negotiator sometimes displaces graciousness. So maybe your agent won't be your best friend. He's not supposed to be, he's your business partner. You have to decide what you want and what you need.

Ex-Los Angeles agent Lynn Moore Oliver offers a comprehensive picture of what agents are doing on our behalf, even when we can't tell they are even thinking about us.

✦ *I'm working on the belief that symbiotically we're going to build a career. While the actor isn't working, I'm paying for the phone, the stationery, the*

envelopes, the Breakdown Service (which is expensive), the rent, the overhead, stamps, all the things that one takes for granted in the normal turn of business.

All this is coming out of my pocket working as an employment agent, because that is really what I am. The actor is making no investment in my promoting his career. If the career is promoted, we both benefit and I take my 10% commission. Meanwhile, the overhead goes on for months, sometimes years with no income. The first thing the actor is going to say is, "nothing's happening. My agent is not doing a good job." What they forget is that I have actually invested money in their career and I've probably invested more money in the actor's career than he has, on an annual basis.

Lynn Moore Oliver

If you think about what Lynn says, you will understand why credible agents choose clients carefully. Looking at your actor friends, are there any that you would be willing to put on your list and pay to promote? Puts things more in perspective, doesn't it?

Franchised Agents or Not?

The terms of the franchise agreement between the Association of Talent Agents and SAG have been in flux since 2002 when SAG members voted down a proposed new agreement from ATA. The agreement would have allowed agents to partner with corporations, to produce, and to expand the scope and size of commissions on all jobs worked, including foreign use.

The original agreement (in place for forty years) is no hardship for conglomerates representing actors with million-dollar paychecks and rich packaging deals. However mid-level agencies are having a hard time keeping their doors open when casting directors routinely request that agents "please submit only actors who will work for scale + ten."

(Scale + 10 is the going SAG scale rate plus 10% of that rate for the agent, as SAG rules forbid an actor working for less than scale.)

✦ *Independent talent agencies (i.e., those agencies that are not affiliated with either the Association of Talent Agents [ATA] and/or the National Association of Talent Representatives [NATR]) continue to be franchised and regulated by the SAG Franchise Agreement [or, Rule 16(g)], the Agreement that has regulated your relationship with your SAG agent for the last 63 years. Accordingly, so long*

as your agency abides by the terms and conditions of Rule 16(g), it may continue to represent you. Any standard SAG agency contract you sign with an independent agency may be filed with, and processed by, the Guild. If your independent agency chooses to surrender its franchise with the Guild, SAG will immediately notify you of that fact.

SAG's franchises with agents that are members of the ATA and/or NATR have ended. However, pending further review, SAG's National Board of Directors has temporarily suspended application of Rule 16(a) of the Rules and Regulations section of the SAG Constitution, which requires SAG members to be represented only by a franchised agent. Because of this temporary suspension, a SAG member may continue to be represented by one of these formerly franchised agents.

For those members who are contemplating signing new contracts with their ATA/NATR agents, you should insist, whenever possible, upon the standard SAG representation contract or a contract whose terms and conditions mirror those in (or are better than) Rule 16(g).

www.sag.org

If your agent hands you a General Services Agreement to sign, do take SAG up on their offer to go over it with you and offer advice. Most agents will not require that you agree with every single line in the contract.

The only thing the agent must do is have a license to operate from the state. The license addresses only about 10% of the areas covered by the agreement hammered out by SAG. Just because an agent says, "hey, we're fine, we're licensed by the state," that license doesn't constitute much protection for the actor. Neither this nor the old franchise agreement guaranteed the agent to be ethical, knowledgeable, or effective. You'll have to check that yourself.

Even if the franchise agreement is not in place at your agency, you'll find nothing much has changed between you and your agent.

Wrap Up

Agent

✓ a force acting in place of another, effecting a certain result by driving, inciting, or setting in motion

✓ many no longer formally regulated by SAG
✓ licensed by the state

Agent's Job

✓ to get the actor meetings, interviews, auditions, and to negotiate salary and billing

✍ 7 ✍

Kinds of Representation

Now it's time to consider whether or not you are far enough to be signed exclusively to one agency, and/or whether it's even wise at this point to make that choice.

In New York at least, it's more than possible to have a career working free lance with several agents. Is that a good idea? Or maybe just a beginning idea – for both you and the agent?

Freelance

If you have several agents submitting you for projects, that might be a better choice at the beginning of your career, since not everyone sees you in the same way. One person might not think of you for a project, while another would, so you might get in on more things. Might.

The drawback is that all this takes more time. You'll need to continue courting your agents, making sure to see all of them regularly and remind them of your activities, much as if you were represented by a conglomerate.

The other downside (the one agents hate most) is that according to Screen Actors Guild rules, in order to submit a freelance actor's name for a project, the agent must clear the submission with the actor before his name can go on a submissions list. You've got to be phone-available at all times if an agent calls to ask if he can submit you. So if you're not, you could definitely miss out.

And there are other reasons as well.

✦ *Some people are better off not signing, possibly because they're the kind of actor that agents will only submit from time to time. The agent may not feel that the actor is very marketable and won't want to really work hard for him.*
Jerry Kahn/Jerry Kahn, Inc.

It's perfectly fine to freelance until you and the agent get a chance to know one another, but once you are an established actor, it's time to

sign. I took too long signing myself, so I know.

If you are just beginning your career, target several agents and freelance with them until you get a feel for who you like. If you have the chance to sign, my advice is to go for it.

Exclusive Representation

A signed relationship with the right theatrical agent is a worthy goal. Don't be so afraid of making the right choice that you make no choice. Being signed can make your life a lot easier.

✦ *New York is much more of a signed town than it used to be. If you are going to have a career, you really should settle on someone because freelance is not the way to go. You don't get pushed. You don't get submitted for that many things and there is no development done, let alone any marketing.*
Gary Krasny/The Krasny Office

The agent makes his choice based on his belief that you will work and help him pay his rent if he submits you for the right projects. Once you and an agent choose each other, it is easier to stay in touch and become a family. It behooves you to put a lot of energy into the relationship so that the agent does think of you. If you are signed and your agent doesn't think of you, there are no other agents down the line to fall back on.

If you are smart, you won't give up your own agenting efforts just because you are signed. Instead, you'll focus them differently. Too many actors sign and sit back waiting for the agent to take over all the professional details of their lives. The more you can do to help your agent, the better off both of you will be. Laurie Walton was an actress who decided to agent at her agent's office before she retired to become a Mom. Her perspective is worth mentioning because she has been on both sides of the desk.

✦ *I'm finding the actors that I'm attracted to and respect the most are those that, though they rely on me for some things, are out there doing things on their own as well.*
Laurie Walton

Theatrical vs. Commercial Representation

Resume expectations of commercial agents are quite different than those of theatrical agents. Although this book is focused on agents who submit actors for theatre, film, and television, I would like to discuss one particular aspect of the commercial agent/actor relationship that relates to theatrical representation.

Some agencies have franchises with SAG and AFTRA that do not cover commercials. Some agencies have no franchises with SAG and AFTRA that cover actors for film and/or television. Some agents have everything. And some don't have SAG agreements because of the union/agent franchise conflict. Usually they are still conforming to the regulations of the old agreement, other than for commissions and producing.

Because commercials are so lucrative (and theatre is not), some agents require your name on the dotted line on a commercial contract before they will submit you theatrically. If that is the deal someone offers you, be wary. If they have confidence in their ability to get you work in the theatrical venue, they will not require commercial participation.

Frequently the commercial resume builds more swiftly. The actor finds he hasn't had the work opportunities that lead to the same credibility on the theatrical level. He doesn't realize the agent does not feel comfortable sending him on theatrical calls because of the disparity between his theatrical and commercial resume. Until the actor addresses this, signing across the board is not a good business decision. There are many reasons, not the least of which is the contractual commitment.

Since theatrical success takes longer, sometimes hot commercial talents are urged to sign joint agreements, only to find out later that they were never submitted with the agency's theatrical clients. Don't put yourself in that disappointing position.

Paragraph 6/Gone?

Paragraph 6 of the Screen Actors Guild Agency Regulations allows either the actor or the agent to end the contract by a letter of termination if the actor has not worked for more than ninety-one days. The actor can void his contract with an agent simply by sending a letter

to the agent plus copies to all unions advising them of Paragraph 6.

The defeat of the SAG/ATA referendum changed many things. The new General Services Agreement changes the terms of Paragraph 6 from ninety-one days to four months. As discussed on page 69, your General Service Agreement is negotiable.

Whatever agreement you sign, the principle is this: if you have been working commercially, but are not sent out theatrically, you might want to find a new theatrical agent. However, since you have been making money in commercials, you cannot utilize Paragraph 6 to end your relationship.

On the other hand, if you have a successful theatrical career and no commercial representation and your theatrical agent has commercial credibility and wants to sign you, why not allow him to make some realistic money by taking your commercial calls?

People win commercials because they are blessed with the commercial look of the moment. It's easy to get cocky when you are making big commercial money and conclude that you are further along in your career than you are.

What you really are is momentarily rich. Keep things in perspective. Thank God for the money and use it to take classes from the best teachers in town so that you can keep building your theatrical credibility.

It's possible to cultivate some theatrical casting directors on your own. A few are accessible. When you have done a prestigious showcase or managed to accumulate film through your own efforts with casting directors, theatrical agents will be more interested. It's all a process.

Signing Contracts

Consider carefully the commitment you make when you sign a contract. If you aren't making any money at all, it's tempting to sign with anyone who shows an interest. A commission of 10-15% or more of "nothing" doesn't seem like a big risk, but pretty soon your "stumbling around" time will be over and you will be making money.

That employment may be the result of an agent or manager working for you, but it may all come from your efforts. When you're making money, anyone with access is going to want a piece of it.

You may have heard about actors who got out of their contracts easily, but I also know actors who had to buy their way out with a large

financial settlement.

Wrap Up

Freelance

✓ expands submission possibilities
✓ requires more upkeep
✓ requires vigilant phone monitoring
✓ gives you a chance to get to know the agent
✓ no overall game plan

Exclusive

✓ gives you more focused representation
✓ puts all your eggs in one basket
✓ allows a closer relationship
✓ it's easy to get lazy
✓ can backfire

Theatrical vs. Commercial Representation

✓ more financial rewards for commercial success
✓ all representation at same agency can block Paragraph 6 protection
✓ takes different credits for theatrical credibility

✎ 8 ✐

Research & Follow-through

Unfortunately, agents do not send out resumes in search of clients. Even if they are looking for clients (and they are all looking for the client who will make them wealthy and powerful beyond their dreams), agents don't send out a list of their training, accomplishments, and/or a personality profile.

Beyond their list of clients (which is not, by the way, posted on their door), there is no obvious key to their worth. Therefore, it is up to you to conduct an investigation of your possible business partners.

You have taken your first step: you bought this book. I've already done a lot of research for you by interviewing agents, asking about their background, looking at their client lists, interviewing some of their clients, and in general engaging in conversations with anyone and everyone in the business who might have something informed to say about theatrical agents. I've also read everything that I could get my hands on regarding agents and the way the business is conducted.

Agent Conversations

You should begin to have agent conversations with everyone in the business with whom you come in contact. If you are just beginning in the business and your contacts are limited to your peers, they will probably be just as uninformed as you. Never mind ask anyway. You never know where information lurks.

Ask what they have done thus far to attract an agent. Ask if they have a list of agents they would like to have. Ask if they were able to get an agent to talk to them and why they picked that agent.

If you are in a group of actors and someone is further along than you and has an agent, ask that actor for advice.

Tell him you don't want to be a pest, but because you are just starting you want to educate yourself about agents and could he fill you in. Ask if he met with several agents first and what that was like, and if so, how he made his decision.

Find out how they approached the agent for the meeting, and how they knew to call that agent. It's okay to ask every dumb question you can think of, but first announce that you want advice, not help, that you are there to learn. Try not to salivate. Don't totally monopolize the person. Ask your questions and move on, thanking the person for his or her time.

How to Score

You can't make an informed decision about your readiness to attract an agent or what kind of agent you seek until you educate yourself. Learn how the business really works, what you have a right to expect from an agent, what you can realistically expect of an agent, and what your contribution is to the mix.

Prepare yourself as an artist and as a business person so that you can operate on the level to which you aspire. If your work and presentation are careless, what kind of agent is going to want you?

Before he agrees to meet with you, an agent has done his homework. He's researched you. If you had prior representation, he's asked about it. If you've done any work, he's called casting directors who cast you to find out what you're like.

He's going to expect that you've done the same. It's more difficult for you, but it's not impossible. Try the internet. I was surprised when I plugged a name or two into google and found actor websites where they named their agent.

Get On With It/Agent Research

After you've digested this book completely, go back and read the agency listings again and take notes. You'll learn the agent's lineage, education, credits (clients), the size of their list, and have some idea of their style. If there is someone who interests you, check the index to see if the agent is quoted elsewhere in the book. Those quotations can give you additional clues about how the agent conducts business and views the world, and how comfortable you might feel with him.

If you read his dossier and don't recognize any of the clients' names, that may just mean his clients are respected working actors whose names you don't happen to know, or they could be up-and-coming actors who have not yet worked. You can only evaluate the agent

accurately if you know exactly what his list means. If he only works freelance, that tells you something too.

If the only clients the agent has on his list are stars and you are just beginning, that agent is too far along for you. If the agent has bright-looking actors with no important credits, he is building his list. If you fit that client category, perhaps you and the agent can build credibility together. It's worth a shot.

If you are an actor of stature, you will be looking for an agent that lists some of your peers. There are always new young agencies that have opened in the last two or three years whose names may not be as well-known as older agencies, but who have real credibility. Usually the agents interned at larger offices, learned the business, groomed some clients, and left the nest (frequently with some of the agency's choicest clients) to open their own agencies.

A subscription to *imdbpro.com* costs only $12.95 per month and gives you lists of agencies and their clients. You can get a free two week trial to see if it works for you. Type in the agency name and you'll see a client list. It's not hugely accurate, but accurate enough for your purposes. They don't list theatre credits, of course, but you'll see film and television clients who probably already have theatre credits. If an agency is filled with your peers, they might be appropriate for your wish list.

SAG's agency listings (available only to members) are not complete since most agencies no longer have SAG franchises.

As your research continues, you'll have fantasies about the large conglomerate agencies. Check out chapter nine before you form your final opinion. There are many pros and cons to representation by star agencies at every level of one's career.

While you are salivating about life at William Morris, consider that most stars come to celebrity agencies after an actor achieve a level of stature and access that financially justified the interest of the conglomerate agency.

William Morris, CAA, United, ICM and Endeavor do not offer career-building services. Although star representation enhances some careers, it is not true in all cases. In making your agent selections, make sure you are seeking an agent you have the credits to attract: George Clooney's agent is probably not going to be interested.

Make sure clients on the agent's list are your peers. It's all very well and good to think big, but you must walk before you run. Don't expect an agent who has spent years building his credibility to be interested in

someone who just got off the bus. You must effectively agent yourself until you are at a point that a credible agent will give you a hearing.

I met a young actor with no credentials who arrived in California and managed to hustle a meeting with an agent far above him in stature. The agent wanted to see a tape. Although he had none, the actor said his tape was in New York and that he would send for it. He volunteered to do a scene in the agent's office and ended up getting signed – then he confessed there was no tape.

A year and no jobs later the actor angrily left the agent in search of another, saying the agent didn't work for him. It didn't occur to the actor that the reason he had no jobs was because he was not ready for representation on that level. Not only that, once having landed the agent, the actor totally lost all the hustle that undoubtedly appealed to the agent. Instead of learning from the experience and rethinking his approach, he did what many actors do: he blamed the agent.

When you're in pain, it's tempting to lash out at whoever is closest, but the common element in all our problems is ourselves. The day I figured that out, I was depressed until I figured out the plus side: if my problems were caused by others, I was powerless, but if the problem was me? Hey, I can change me.

+ *I feel sorry for the people who spend all their time trying to use various forms of manipulation to get an agent while their contemporaries are working and learning. And the ones working at working will rise right up. The people who were assuming it's some kind of game will disappear.*
Fifi Oscard

Who Do You Love?

At this point, you should have some idea of which agents appeal to you. Some names will keep coming up. Make a list. Even if you know you are only interested in Jim Wilheim or Jeanne Nicolosi, target at least five names. You can't intelligently make a choice unless you have something to compare. You don't know that you like Agent A best unless you have seen Agent B and Agent C.

It's time to ask advice from casting directors with whom you have formed relationships. A CD who has hired you will probably be pleased that you asked his opinion. Tell him you are agent shopping and that you would like to run a few names by him. Also ask for any names he

might like to add to your list. Listen to the casting director's opinion, but remember that he has a far different relationship with an agent than you will have. Make your own decision.

At this point your research is based on style, stature, access, size of list, word of mouth, and fantasy. Let's forge ahead to face-to-face encounters.

Getting a Meeting

The best way to contact anyone is through a referral. If you know someone on the agent's list who will act as a go-between, this is good. If a casting director whose advice you have sought offers to call, this is better, but don't put the CD on the spot by asking her to recommend you. If you ask for advice about agents and she feels comfortable recommending you, she will. If she doesn't, be thankful for the advice.

If someone you contact just says, "use my name," that is a polite brush-off. Unless a call is made, the referral is useless. Anyone can call and say, "Juliette Taylor told me to call." Unless Juliette picks up the phone for you, it doesn't count.

What Can Get You in the Door?

Winning an Oscar, a Tony, or an Emmy gets people on the phone. In the past I told the Young and Beautiful to drop a picture off in person (mid-week, late afternoon), looking as Y&B as possible. These days for security reasons most doors are locked and won't even crack an inch to receive a picture.

If you want to give it a shot and a door is opened to you, it can be a short-cut. It is sad for the rest of us, but true, that if you are really Y&B and can speak at all, few will require you to do much more. Cash in on it!

If you are smart, you will study while cashing in, since Y&B doesn't linger long. You may want to work in those gray years of your thirties and beyond.

You're not Y&B? Me neither. If you are just starting in the business or don't have any strong credits, concentrate on classes. Join theatre groups. Get involved with showcases. View as much theatre, film and television as possible. Go backstage and congratulate the actors afterwards even if you don't know them. If the writer and/or director

is there and you liked the work, say so and give them your card and tell them you want to see the next thing they do. This is not about getting a job, it's about building a place for yourself in the theatre fraternity.

Begin making a list of actors/writers/directors with whom you would like to work. Align yourself with peers whose work you respect. Form a group that includes all of the above and focus on furthering each other's careers by working together.

If all you do is get together in someone's living room once a week and read the writer's new work or a current or classic play, you have accomplished a lot. Band together and buy a camera and write your own independent movie. You can buy a high resolution video camera for $2500 that can actually shoot a whole film. Target has one for under $100 that shoots for 30 minutes, surely good enough quality to put something up on *youtube.com*.

So what if your efforts are not works of art? Neither were Woody Allen's or George Lucas'. Neither was your first acting scene. This is how you learn.

Take a writing and/or directing seminar. You need to expand your horizons into those fields anyway. Make yourself available to read scripts or work in independent films. New York is the capital of the independent film movement.

Check out the film school at NYU and see if you can leave a picture and resume. Read the bulletin board. Volunteer to do anything that needs doing and you will gain access to the Spielbergs of tomorrow. Independent Feature Project (IFP) is also a good connection

Don't approach agents and/or casting directors asking for meetings until you build up your resume and have something to show them. I spoke to an agent who told me that several young agent-shopping actors banded together and sent her a basket of goodies along with their 8x10s and resumes.

This definitely got the agent's attention. The downside was that the actors were still just too green to be looking for an agent. Don't blow your chances by getting people to look at you before you are ready.

I've always spoken ill of casting director workshops since I think casting directors should see actors in their offices, or in small theatres for free, but the world isn't like that anymore. Some casting directors still lead that life, but most don't.

I've always thought CD workshops were ripoffs. Even though the big signs say, "you will not get cast from this, the session is informational," the actor pays his money and hopes the CD sees him

and actually casts him.

My response has always been, "yes, you might be case in a two-line part." However, an agent I interviewed said he had a call from a CD who had seen three of his clients in a workshop and she asked to meet them all.

So, hey, I'm wrong. If you are packaged and you are ready and you get a real casting director (not some assistant there to pick up $100, with without any real power to cast) you could be cast.

It's a crap shoot, but it's worth trying. Somebody wins in craps.

Once You Are Ready

If you have graduated from one of the league schools, and/or have some decent credits, and/or an Audition DVD (see Glossary), and have a clear idea how you should be marketed, it's time to begin. Send a letter to a specific agent, not the name of the agency in general, preceding the picture and resume by a couple of days. This is not a cover letter. A cover letter accompanies material. Single letters get read; pictures and resumes tend to sit on the "whenever I get to it" stack.

Make sure your letter is written on good stationery. The feel of expensive paper makes an unconscious impression that the writer is to be taken seriously. Say who you are and why you are writing. State that you are interested in representation, that you are impressed with the agent's client list (mention somebody's name), and that your credits compare favorably. If you have a particularly impressive credit, mention it.

I've provided an example below to stimulate your thinking.

Dear Mary Smith:

I've just moved to New York from Timbuktu and am interested in representation. I met George Brown and Sheila Jones in Karen Ludwig's acting class. They told me they have worked through you.

Since I am in their peer group, I thought I might fit in with your client list. Although I am new to town, I do have a few credits. I met John Casting Director and have worked two jobs through him: *Hello Everyone* and *It Pays to Study*.

The parts were small, but it was repeat business and everyone has to start somewhere. I'm compiling an audition tape. My picture and resume will be in your office by Thursday. I'll call on Friday to see if

you have a few minutes and might be interested in seeing my audition DVD. I'm looking forward to meeting you.

Sincerely,

Hopeful Actor

A fabulous cover letter sample is on Andy Lawler's web page: *www.geocities.com/Broadway/Mezzanine/4089/letter.html*

I was told by an agent recently that the best way to get an agent to notice your picture is to walk it in. Don't attempt to chat up the receptionist or ask to meet the agent, just deliver the picture in a manila envelope addressed to a specific agent with a note inside. He told me that hand-delivered pictures usually pique interest. As before, many doors are locked these days. This might work better in LA than in NY.

He also said that Mondays bring a barrage of mail, so your picture might garner more interest arriving mid-week.

If you've just graduated from one of the league schools, mention this and some roles you have played. Make sure your picture and resume tell the truth and arrive when you promised them. If your letter has stirred interest, your picture will be opened immediately. Call the day after your picture arrives.

When you call (late afternoon is best), be dynamic and be brief. Be a person the agent wants to talk to. If he doesn't want a meeting, get over the disappointment and get on to the next agent on your list. Try to set up meetings with at least three agents and plan all the details of the meeting.

Be on time and look terrific. This is a job interview, after all. Choose clothing that makes you feel good and look successful, and that suggests you take pride in yourself. Bright colors not only make people remember you, but they usually make you feel good too. Remember, in today's world packaging is at least as important as product.

Go in and be yourself. Be natural and forthright. Don't bad-mouth other agents. If you are leaving another agent, don't get into details. If the agent asks, just say it wasn't working out. Agents are all members of the same fraternity. Unless this agent is stealing you from someone else, he will be at least a little anxious about why you are leaving. If you bad-mouth another agent, the agent will wonder, subconsciously at least, what you will say about him. Not only that, it's not good for you to be indulging in negative energy.

In general, don't talk too much. Give yourself a chance to get comfortable. Adjust to the environment. Notice the surroundings.

Comment on them. Talk about the weather. Talk about the stock market, the basketball game or the last play you saw. That's a great topic. It gives you each a chance to check out the other's taste. Don't just agree with him. Say what you think. If you hated it, say it just didn't work for you.

This is a first date. You are both trying to figure out if you want another. If you've seen one of his clients in something and liked it, say so. Don't be afraid to ask questions, but use common sense. It's not what you say, it's how you say it.

Phrase questions in a positive vein. Discuss casting directors that you know and have worked for. Ask which CDs the office has ties with. Tell the agent your plans. Mention the kind of roles that you feel you are ready for and that you feel you have the credits to support. Ask his opinion. Are you on the same wavelength? Don't just send out; make sure you are also receiving.

Find out how the office works. If you are being interviewed by the owner and there are other agents, ask the owner if he will be representing you personally. Many owners are not involved in agenting on a day-to-day basis.

Check office policy about phone calls. Are you welcome to call? Does the agent want feedback after each audition? What's the protocol for dropping by? Will he consistently view your work? Will he consult with you before turning down work? Explore your feelings about these issues before the meeting.

If you need to speak to your agent on a regular basis, now's the time to say so. Does the office have a policy of regularly requesting audition material for their actors at least a day in advance of the audition? Let him know what you require to be at your best. If these conversations turn the agent off, better to find out now. This is the time to assess the chemistry between the two of you.

✦ *What makes a good agent? Partially the chemistry between an actor and the agent and partially the chemistry that goes on between the agent and the casting director; that they can communicate on an intelligent, non-whining wavelength. A good agent has to be able to not be so restricted by casting information and the Breakdown, so boxed in by what they read that they don't expand the possibilities. And finally, that they can get people appointments for good work.*
Marvin Starkman/Producer

During the meetings, be alert. There are intangible signs that reveal

a person. Note how he treats his employees, if he really listens, his body language, how he is on the phone. How do you feel when he's speaking to you? What's the subtext?

The agent will want to know the CDs with whom you have relationships. Have this material available so that you can converse easily and intelligently. Even if your specialty is playing dumb blondes, your agent will feel more comfortable about making a commitment to a person who is going to be an informed business partner.

✦ *Morgan Fairchild came in, and out of the hundreds and hundreds of actresses and actors that I have seen and had appointments with, I've never been literally interviewed by an actress: "Okay, what have you done? Where are you going?" Incredible. She interviewed me. Yes, I was turned off to a degree, but I was so impressed by her brilliant mind and her smarts that I thought to myself, "Gal, even without me, you're going to go very far." She came in here and she knew where she was going and she interviewed me and I thought, "That's fantastic."*
Beverly Anderson

Beverly points out an important truth. Although she was turned off by Fairchild's approach, she saw the potential. If you want an agent to want you, it's like any other relationship, you can't be desperate. It's important to be respectful, but don't genuflect.

Andy Lawler's Meeting Tips

1. If you haven't been hitting the gym, you've got a few months to shape up. Do it! In the short period of time you've got to perform, a physical impression will be as strong as any other you can make. We want our new clients to be appropriate for the roles that are out there, which are almost uniformly leading roles.

2. Unless you are another Kenneth Branagh, Shakespearian scenes are usually not as appropriate or as effective for an audience as contemporary material. And we assume that you can handle the classics, doing a scene raises the possibility that you may prove us wrong. On that note, avoid Moliere, Chekov and other classics like the PLAGUE. Outside the context of the plays these scenes come off as dull dull dull.

3. Shorter is better in regard to scenes. Most people make up their minds about you in the first twenty or thirty seconds. Don't drag it out. No scene should be longer than two or three minutes.

4. Funny is better than anything, if you can handle comedy. We sit through a lot of scenes, laughter makes us oh so grateful.

5. Try to avoid scenes that are done every year. The "Are You a Homosexual" scene from *Angels in America* is so overdone. Aren't there other scenes in that play?

6. If you're going to do a scene from a film (which is fine) try to avoid scenes with are linked inextricably to certain performances. Doing John Travolta or Samuel L. Jackson from *Pulp Fiction,* or Brando from *On the Waterfront* is bad. Why? Most of you aren't going to be able to compete with our memories of the original. Look at John Sayles' films, tons of great stuff in there.

7. Dress simply but to flatter. Guys should wear jeans or slacks and t-shirts or oxfords to show off their physique. Women should wear skirts or dresses and heels to do the same.

8. A showcase is NOT the time to explore your ethnic, racial, sexual or gender identity.

9. Don't do material just to shock or to tell us about the inner you. More often than not it comes off as amateurish and polemic.

10. Finally, remember why you're there. It's not about art. It's about getting people to like you, to hire you, to sign you.

Andy has even more information about preparing for your meeting on his web page at: *www.geocities.com/Broadway/Mezzanine/4089*

And a special tip from Andy's old boss at DGRW:

✦ *Make us feel something. Good acting has the power to make us laugh or make us cry. In two or three minutes, those are the buttons to push.*
Jim Wilhelm/DGRW

Closing the Meeting

Now that you have met the agent, focused on him and his accomplishments, office and personnel, impressed him with your straightforwardness, drive, punctuality, resume, appearance, and grasp of the business and your place within it, it is time for you to close the meeting.

Make it clear that you are having such a good time you could stay all day, but you realize that he is busy and that you just have time to make your voice lesson. It doesn't matter where you are going. Just have a real appointment to go to and leave.

Suggest that you both think about the meeting for a day or two and set a definite time for when you will get back to him or vice-versa. If he asks if you are meeting other agents, be truthful.

If he's last on your list, mention that you need to go home and digest all the information. He will probably have to have a meeting with his staff before making a decision. Let him know you were pleased with the meeting. Even if it was not your finest moment or his, be gracious. After all, you both did your best.

My advice is to hurry home and write down all your feelings about the meeting and put them away for twenty-four hours. Then write your feelings down again and compare them. When I was interviewing agents for this book, I found I would have signed with almost any of them on the spot. They are all salesmen and they were all charming.

The next day I had more perspective. The hyperbole seemed to have drifted out of my head and I was able to discern more clearly what had gone on.

If the agent said he would get in touch with you and he doesn't, leave it. There are others on your list. If he forgot you, do you want him as your agent? If he is rejecting you, don't insist he do it to your face. Remember, you are choosing an agent. The traits you look for in a pal are not necessarily the qualities you desire in an agent.

If you want an agent on a higher level who's not interested, don't be deterred. There are other agents on that level. If they all turn you down, then perhaps you are not as far along as you think.

Don't be depressed. This just means you need to do more work on yourself until you are ready for those agents. If you feel you really must have representation at this time, you may need to pursue an agent on a lower level. But let's think positive.

Just like any other relationship, you're going to click with some and not with others. The agent is looking to see if there is a connection, if there isn't, there is a better agent for you and client for him.

✦ *Some clients I would like to work with, but not sign. Someone who is sixty-five years old with that look is limited. Someone like that, I might want to represent on a freelance basis.*
Marvin Josephson/Gilla Roos, Ltd.

✦ *When you have a meeting with an agent, make sure you touch base with everyone afterward. Send a thank you note or a card and, if you do decide to go with that agent other than the one you were interviewing, just let them know how much you enjoyed meeting him and that you are appreciative of his time.*
Even if they say, "if you don't go with us, you don't need to call back," make the effort. If you treat people politely, you'll find that's the way people treat you.
Gary Krasny/The Krasny Office, Inc.

Making the Decision

Mike Nichols gave a speech to his actors one opening night:

✦ *Just go out there and have a good time. Don't let it worry you that the "New York Times" is out there, that every important media person in the world is watching you, that we've worked for days and weeks and months on this production, that the investors are going to lose their houses if it doesn't go well, that the writer will commit suicide and that it will be the end of your careers if you make one misstep. Just go out there and have a good time.*
Mike Nichols

I think that's the way many of us feel about choosing an agent. At the beginning of my career, I freelanced much longer than was career-appropriate because I was afraid of making a wrong decision that could have irrevocable consequences on my career.

✦ *I find that actors are sometimes overly cautious. They are sometimes guided by anxiety or fear and that leads one to say, "no, I'm going to wait," when there is nothing to lose by signing with a particular agent who is interested.*
If it doesn't work, the actor can always get out of it. It's only for a year. There is so much more that can be done when there is an effective responsible agent at

work that sometimes it's an actor's insecurity that holds him back, and I think wrongly so.
Gene Parseghian/Parseghian Planco, LLC

There are some agents who do not share Gene's feelings. Many would rather not sign you if they feel you are not ready for a long-term commitment.

If you don't get in a position where you trust yourself and your instincts, how can you expect someone to hire you? How can you expect someone to put all his money and hard work on your judgments as an actor when you don't believe in yourself as a person?

Innovative's Alan Willig put it very well:

✦ *Know thyself and trust your agent.*

Wrap Up

Research

✓ peruse this book
✓ consult casting directors
✓ don't underestimate word of mouth
✓ have face-to-face meetings

Tools to Set Up Meetings

✓ referrals
✓ good credits
✓ awards
✓ beauty
✓ audition tapes
✓ a well-written note stating your credits
✓ picture and credible resume

The Meeting

✓ be punctual
✓ act intelligently
✓ be well-dressed
✓ be focused
✓ know what you want
✓ ask for what you want

After the Meeting

✓ end the meeting
✓ set definite time for follow-up
✓ send a nice note

⚜ 9 ⚜
Star/Conglomerate Agencies

I guess we've all heard the joke about the actor who killed four people, ran over a baby, bombed a building, ran across the street into William Morris and was never seen again. It's the quintessential actor story about the wisdom of being signed by a conglomerate agency.

It does seem like it would be nice to have the same agent as Brad Pitt and Angelina Jolie, but is that really a good choice for you?

The question is perplexing and research doesn't support a definitive answer. As in all other important decisions — who to marry, where to go to college, whether or not to have elective surgery, etc. — your decision must be based upon a combination of investigation and instinct.

Research leads to the conclusion that star agencies (CAA, William Morris, ICM, etc.) have more information and, if they want to, the best likelihood of getting you in for meetings, auditions, and ultimately jobs.

A successful writer friend of mine was repped by one of the large conglomerates. She was making about $300,000 a year and an employer owed her money. She kept calling her agent asking him to pursue it.

The agent was becoming increasingly irritated with her calls. She finally left when the agent said, "I really wish you were more successful and made more money so I wouldn't have to keep having these conversations with you."

If $300,000 a year is not enough to get the attention of the big guys, then there are a lot of agents who will take your calls and treat you respectfully for a lot less.

What Do Casting Directors
Think About Star Agencies?

I asked one casting director, "Who do you call first and why?" He answered, "CAA, William Morris, ICM," and mentioned the name of a one-man office. The casting director said that although he can cast all the interesting parts from the conglomerates, he dare not skip this

particular office because everyone on the list was special and capable of brilliance.

He explained that although many prestigious independent agents have hot new actors, the process is like shopping for a suit. If you want the best suit, you go to Bergdorf Goodman first. At Bloomingdale's you can get a beautiful suit and expect to spend a comparable amount of money, but Bergdorf has cachet, the perception that it is the source for the new and the unusual.

Casting directors also tell me they prefer dealing with distinguished independent agents like DGRW, The Gage Group, The Krasny Office, Nicolosi & Company, and others, and that an actor would be crazy to leave such caring families for a conglomerate.

The conglomerates have made it their business to represent most of the star actors, writers, and directors in the business, so if casting executives and producers want to do business with those stars, they will have to succumb to a certain amount of star-agent blackmail. "Take this one or you don't get that one," for example. So if they care, perhaps they could increase your employment possibilities.

It makes sense to choose an agency with a powerful client list, information, and stature. However, when I met a well-known actress at a party, she had other thoughts. The Los Angeles-based actress works mostly in film, but had recently been doing more theater, an activity not prized by star agencies since relatively little money is involved.

She ended up leaving the agency. "It's too much trouble to keep up with all those agents. They won't all come and see your work. Who needs it?"

I asked if she would return to the conglomerate if she got hot. Her answer was illuminating: "I was hot when I was at the smaller agency. My name was on everybody's list. I didn't need to have a big office behind me. The only way I'd ever go back to a big agency is with a very strong manager. That way the manager could call and keep up with all those agents. So, no, I don't think it's necessarily a better business decision to be at a conglomerate."

It's true that the conglomerates have more power and information, but do those attributes compensate for lack of personal attention? The strength of the large agencies comes from having A-list stars. The bankable stars get the attention of the buyers and the agents.

Power Structure

When you have Matt Damon and Emily Blunt on your list, you have the attention of the buyers. The kicker is that if you are Matt or Emily, you don't need star agencies because you are the power. If you are not Matt or Emily, you are filler.

A big star was in the final stages of closing a deal on a big new movie, when a higher-priced star at the same agency decided he was interested in the project. The original plans were shelved and the bigger paycheck did the movie.

An independent agent might do the same thing, but the chances are less likely that he will be representing you and your closest competitor.

Packaging

A large agency, one representing writers, directors, producers, and actors has a script written by one of its writers with a great part for one of its stars or first-billed actors. It then selects one of its directors and/or producers and calls ABC (or whomever) and says, "our star writer has just written a terrific script for our star actress and our star director is interested. Are you?" ABC says, "yes," and a package is sold.

Television pilots, TV movies and theatrical films are merchandised in this way. This phenomenon is called packaging. Non-star actors frequently choose agencies with package potential because they feel they too will get jobs out of the arrangement.

When John Kimble was still at William Morris, he told me:

✦ *You maybe can package the first-billed actor, maybe the second actor, but at that point people at the studios and the networks want their creative input.*
John Kimble

If you are cast in a project your agency packages, your agent is not allowed to charge commission because he is already getting a fat packaging fee. This can be a good deal since you won't have to pay commission, but it offers no incentive for your agent to place you in the package.

He cares much more about the packaging fee and doesn't care much who is cast in it. And if you are tied up in a job for which the agent is not collecting commission, he is unable to sell you for something on

which he can make money.

There are many horror stories recounting star clients who were never told of an offer because the agent was withholding the star's services in order to get a packaging fee for the project. If the producers didn't go for it, the actor or writer or director never knew there had been an offer.

The value of packaging lays more importantly in the amount of access your agent is able to have with the buyers. Because the agent or someone at his company is talking to the buyers daily, there's naturally more of a feeling of comradeship.

Money Money Money Money

To the big agencies, it's all about money. They have a big overhead. But actors sometimes have different needs. James Woods, interviewed by Stephen Rebello, spoke of a harrowing two years at CAA:

✦ *If there was anybody meant to star in a Tarantino movie, it's me. Ten days after I went with Toni Howard and Ed Limato at ICM, they sent me up to meet Tarantino. The first words out of his mouth were, "Finally, I get to meet James Woods."*

I'm sitting there thinking, "I haven't worked on a decent movie in two years and he's saying this?" I said, "What do you mean?" and he said, "I wrote Mr. So-and-So in 'Reservoir Dogs' for you."

I don't want to say the exact role because the actor who played the role is really wonderful. I said, "Look, I've had a real bad year, so could you explain why you didn't offer it to me if you wrote it for me?" He said, "We made a cash offer five times."

Of course, it was for less money than my [former] agents wanted me to work for, but that's not the point. I wanted to cry. I'd rather work for a third of my salary and make "Reservoir Dogs." But I didn't get to do "Reservoir Dogs," didn't get to know Quentin, so I didn't get to do "True Romance" or "Pulp Fiction."

All because somebody else decided money was more important. They were treating me like I was an idiot ... I made less money this year doing six movies than I made when I was at CAA doing two movies. And I couldn't be happier.
Stephen Rebello, *Movieline*[12]

✦ *The problem is that they're too big and they can't possibly function as effectively for an individual client as any number of not huge agencies. I don't see it, even for*

a star. I don't see the personal attention. To me, negotiation is easy. You keep
saying no until you get what you want.
Kenneth Kaplan/The Gersh Agency

Kenneth told me that when he was still an independent agent in New York. Since then, he has moved to The Gersh Agency, a bi-coastal agency with an important list of actors, writers, directors and below-the-line personnel. What does he say now?

✦ *Yeah. I know I said some things about conglomerate agencies in your last book. But, I have to admit that being able to work from the script instead of the Breakdown, which is really somebody else's interpretation of what the script is, plus access to directors and producers, really does take a lot of frustration out of being an agent.*
Kenneth Kaplan/The Gersh Agency

There are many prestigious independent agencies that have had a shot at the big time and chose to go back to a more intimate way of doing business. One of my favorite agents has groomed several stars. When those actors became more successful and demanding, the agent grew tired of being awakened at midnight to endlessly discuss the next career move. It was disappointing when the actors went to William Morris or ICM, but the agent just didn't see himself as a babysitter.

When Gene Parseghian was still at William Morris, he confessed that there were days when he wished he still had a small office with three or four people and twenty clients, tops. Since that time, Gene has opened his own management office, Parseghian Planco LLD, and now has a much smaller client list headed by his ex-William Morris client, Bruce Willis.

Sandy Bresler, a successful, distinguished Los Angeles agent (whose list includes Jack Nicholson, Judd Hirsch and Randy Quaid) left William Morris and started his own office. When that got too big for him, he left and started his own smaller office again. Of course, he did take Nicholson, Hirsch, et al. with him. That helped.

Conglomerates are not equipped to handle actors who are not making a lot of money. They don't develop talent. They take you while you're hot and they drop you when you're not.

My friend was on a soap opera for ten years while her conglomerate agent collected 10%. When her character was written out, she went for an entire year without an audition until the agency finally dropped her.

You're Aging Even As You Read This

Star agencies are more interested in youth, not only because of the longevity factor, but because the most lucrative jobs in television and film (the leads) are for young, good-looking actors. So if you have the look and manage to snag a nice part in a film that makes some money, you may well have the option of being signed by one of the Big Five.

If they are able to move your career forward quickly, you'll be well served. The conglomerates have access to not only the biggest star actors, but they also have the star writers and directors.

But, if/when your career hits a snag and you have some downtime, as we've discussed before, the conglomerates have a very high overhead and they don't have time to nurture careers. They can move you forward if you have the momentum. Once that's lost, you'll have to stoke it up again on your own.

A director friend of mine declares that CAA was marvelous for him when he was hot with a new film, but when he let himself cool down by taking too long to make up his mind for his next project, the agents lost interest. Once he came up with a project to sell, CAA was terrific at promoting it and helping him realize his goal. He took responsibility for his part in cooling down and hasn't let it happen again.

Part of being a grown up and getting how the business works is taking responsibility for dropping the ball, and taking steps to get back in the game on your own.

For insights into the business in all areas, particularly into life at the star agencies, I heartily recommend Mark Litwak's book, *Reel Power*. All of us may dream of the validation we might feel as a CAA client but as James Woods said in the Rebello interview, sometimes that validation costs more than we might like to pay.

✦ *All CAA thinks about is the biggest salary you can get, period. My [former] agents were saying stuff like, "If you star in a movie with so-and-so, and it makes $100 million, then you can work with anybody." I said, "You know what? I beg to differ. I don't think that if you do a movie with Pauly Shore, with all due respect, Sydney Pollack is then going to hire you."*
Stephen Rebello, *Movieline*[13]

doesn't every actor dream of growing up and going to William Morris? Yes, he feels bad to leave his agent, but his career might really be better served by the conglomerate."

The agent countered, "I understand too, but the actor could compensate his earlier agent by negotiating with the star agent to give 1% of his commission on future earnings to the original agent."

So if you're ever in that position, you might consider that.

When all is said and done, the swell offices, script libraries, limos, flowers, and packaging considered, you'll make your decision based on what is important to you.

I'm pretty loyal and I love my agent, so my vote would be for the prestigious, tasteful mid-level agency. But then, no one has plied me yet with limos and flowers, so who knows what I would do?

Wrap Up

Conglomerates

✓ have more information
✓ command more power
✓ have access to more perks
✓ can package effectively
✓ give less personal attention
✓ advice is corporate
✓ lose interest when you are not in demand
✓ have big rent; need big revenue

Distinguished, Smaller Agencies

✓ offer more respect
✓ offer more personal attention
✓ have more empathy
✓ might encourage riskier choices
✓ allow freedom for career fluctuations
✓ don't plie you with limos, candy or flowers
✓ less information
✓ less access

Manhattan Stars

CAA, William Morris, ICM, United Talent, Endeavor, Paradigm, and Gersh continue to be the names on everyone's list of powerful conglomerates. Star wars continue between the powers as clients and agents defect and are seduced to change teams.

When Mike Ovitz headed CAA there was no question as to which agency was the most powerful. Today you have to ask what kind of power you are looking for? Film? Television? Theatre?

The most recent power struggle is covered pretty well in this feature from *The Los Angeles Times.* Reading this reminds me that it's not only actors who get caught in the cross-hairs of change and age.

Sometimes, progress comes painfully.

✦ *When Jim Wiatt left International Creative Management as co-chairman eight years ago to become head of the William Morris Agency, many Hollywood insiders marked the departure as the beginning of a slow bleed for ICM's movie department. Wiatt took along with him a roster of A-list clients that included Julia Roberts and Eddie Murphy.*

This week, the defections continued when Ed Limato, who was considered by many industry watchers as the last pillar of the talent agency's movie star business, departed for William Morris, taking with him clients such as Mel Gibson, Denzel Washington and Steve Martin.

Once the runner up to powerhouse Creative Artists Agency, ICM is no longer part of the big leagues in the movie business.

The question now is whether Chris Silbermann, the 39-year-old television agent being groomed to lead ICM into the future, can recover some of the agency's former glitter.

Lorenza Muñoz, *Los Angeles Times*[14]

So although Silbermann is getting a lot of bad press and second guessing right now, perhaps he will have the last laugh when all his seeds sprout. The landscape continues to change, but these mammoth corporations have their fingers in every pie. If you are big enough to go to any one of them, you'll surely be better served in the long run.

Years ago my prestigious mid-level New York agent and I were talking about the disappointment of another mid-level agent who had really become a "farm team" for the major players. I said, "well, what's to be done? Yes, the smaller agent did the developmental work, but

⩓ 10 ⩔

What Everybody Wants

If you could sign with any agent in town, who would you choose? Would WMA be right for you? Could Bauman Redanty & Shaul be the answer? Maybe you would be better off with The Gersh Agency? All of these agencies are prestigious, but that doesn't necessarily mean selecting A instead of B would be a wise career move. Before we look for the ultimate agent or agents, consider what agents are looking for.

The Definitive Client

✦ *I want to know either that they work and make a lot of money so I can support my office, or that the potential to make money is there. I am one of the people who goes for talent, so I do take people who are not big money-makers, because I am impressed by talent.*
Martin Gage/The Gage Group

I love Beverly Anderson's story about meeting Sigourney Weaver:

✦ *She floated in and she did something no one had ever done. She had this big book with all her pictures from Bryn Mawr or Radcliffe of things she had done. She opened this book and she comes around and drapes herself over my shoulders from behind my chair and points to herself in these pictures. She was hovering over me and I thought, "No matter what happens with me, this woman is going to make it." There was determination and strength and self-confidence and positiveness.*
Beverly Anderson

Part of Weaver's strength comes from having a strong, successful role model in father Pat Weaver, producer of *The Today Show*. She also had another valuable asset: a top-drawer education.

✦ *Come from a background of good solid training. I'm always attracted to the kids from the league schools, from good theatre training.*
Bill Timms/Peter Strain & Associates, Inc.

One of New York's most insightful and successful agents, the late Michael Kingman, was articulate about what drew him to an actor:

✦ *His talent. To be moved. To laugh. Feelings. Somebody who has contagious emotions. I'm looking for actors with talent and health, mental health and the ability to say, "it's my career and I devote my life to this." It's an attitude, not a spoken thing. It's an attitude that says, "today is not the last day of my life."*
Michael Kingman

Geez, if we had mental health, would we need to be actors?

✦ *I'm looking for an actor with the ability to get a job and pay me a commission. I'm looking for people who are gorgeous and don't stutter. I'm looking for people who already have credits so I can sell them.*
Beverly Anderson

✦ *We are always looking for young people age fifteen to twenty-five who are savvy about the biz and have poise and talent. Good looks are extremely important to our TV and film contacts, so we are forced to make that important too.*
Dianne Busch/Leading Artists, Inc.

✦ *The people we work with best are actors who are committed to their craft and are willing to do regional theatre as well as off-Broadway and Broadway as well as film and television. The focus should be on training and growing yourself.*
Experiencing life so you can bring that to a character and to a performance. The interview part of the audition is just as important as the audition. Who you are as a person, as well as who you are as an actor.
Jim Flynn/Jim Flynn, Inc.

✦ *I'm drawn to actors who I feel are talented and have a commitment to win. I'll go through anything with an actor as long as his commitment is to win.*
Bruce Levy/Bruce Levy Agency

✦ *It always boils down to the talent. If somebody has a talent even though it's someone who's a drunk, you know that there's still the wonderful performance to be gotten. On the other hand, you must ask, "Is it worth going through all that to wait for that wonderful performance?"*
Jeff Hunter/William Morris Agency

✦ *It's really difficult to turn down actors. Old friends need an agent. I want to help them all out, but when my boss holds that picture up in front of my face and says, "are you ready to make a phone call to Jay Binder and ask him to see this client?" That puts things more in perspective. And actors don't understand that I don't make the sole decision.*
Laurie Walton

✦ *I look for preparedness, humor – about the process of looking for work – thick-skin (unfortunately).*
J Kane/Peter Strain & Associates, Inc.

✦ *The things that attract me are the sense of self as an actor, sense of humor, being prepared, taking responsibility for themselves and their work.*
Diana Doussant/HWA Talent Representatives

✦ *I want clients to come to me prepared, to have a sense of who they are, the kind of career they're likely to have, good self-knowledge, good reality about themselves.*
Phil Adelman/The Gage Group

✦ *If they're older and have been in the business and don't have some career going, it's harder because they're now going to be up against people who have many more important credits.*
Robert Malcolm/The Artists Group East

✦ *Since I am my own boss, I can choose who I want to work with. When a client approaches and I get even an inkling that this is going to be a high-maintenance client, I don't choose him.*
Jim Flynn/Jim Flynn, Inc.

✦ *I like performers who see themselves clearly, who have clear ideas of who they are, what they can do and I like them to be responsive to comments, criticism and advice born of having done this since 1949. Period.*
Fifi Oscard

✦ *A spark. Something that's unusual. Usually from a performance. But they can cool my interest by their behavior at our interview. You not only have to have the talent, you have to apply it. You can tell sometimes by their responses that they don't yet have that capacity.*
Jeff Hunter/William Morris Agency

Notice what Jeff said. They don't *yet* have the ability, that doesn't mean you're not going to. It doesn't even mean the agent thinks you're not going to. You just don't have it *yet*. Remember process.

What to Look for in an Agent

✦ *Schools sometimes give students a laundry list of questions to ask agents that the actors ask without even knowing why they ask them. When I meet an actor, I want to have a conversation with him out of which questions come.*

I think actors should have an idea of what they want to hire because they are hiring the agent. If I were an actor, I'd want to know that the agent and I were on the same page about the kinds of projects he would be interested in submitting me for. I'd want to know the agent's perception of my ability.
Jim Wilhelm/DGRW

✦ *One of the chief factors that determines the value of an agent is the amount of information that he has available to him. It is impossible for a small agent to possess the amount of information that a large agency can. We track hundreds of projects weekly at all of the studios and networks.*

If a client walks in and asks about a project, I can haul out 400 pages of notes and say, "Oh yeah, it's at this studio and this is the producer and they're doing a rewrite right now and they're hoping to go with it on this date and talking to so and so about it. I have that information."
Gene Parseghian/Parseghian Planco, LLC

✦ *The art of communication is extremely important. You have to imagine that apart from your lover, family, boyfriend, this is the person you are going to speak to more often than your mother and you have to not be intimidated to pick up the phone and have a conversation. Is that agent someone I want to talk to?*
Jim Wilhelm/DGRW

Busy Work?

Be practical in your assessment of auditions. Actors sometime grade their agents by the number of auditions they generate, not the quality or appropriateness. If you're not being sent on projects that you are right for, all those auditions are just for show. Producer and former agent Marvin Starkman has a realistic perspective:

> ✦ *If the actor/agent relationship were based on getting auditions for everything, then the agent would have a right to say that you must get everything he sends you out on. If you don't get everything he sends you on, then you have a one-sided relationship.*
> Marvin Starkman

Ouch! Of course, that's predicated on his getting you out on everything in town. But still, his point is well taken. Neither actor not agent is going to score every time.

Vision/Goals

The actor and agent need to be on the same wavelength:

> ✦ *I had a funny looking lady come in, mid thirties, chubby, not very pretty. For all I know, this woman could be brilliant. I asked her what roles she could play, what she thought she should get. She saw herself playing Gwyneth Paltrow's roles.*
> *I could have been potentially interested in this woman in the areas in which she could work. But it was a turnoff, because not only do I know that she's not going after the right things so she's not preparing correctly, but she's not going to be happy with the kinds of things I'm going to be able to do for her. So I wouldn't want to commit to that person.*
> Phil Adelman/The Gage Group

> ✦ *What's essential is that the goals the actor sets for himself and what the agent wants for the actor be the same. Or at the very least, compatible, but probably the same. If an actor walks in and I think that actor can be a star next month and the actor doesn't, it ain't gonna happen.*
> *If the actor thinks he's gonna be a star next month and I don't, it ain't gonna happen. By that, I mean it's not gonna work between us. Even though a great deal of it may be unspoken, there has to be a shared perspective.*
> Gene Parseghian/Parseghian Planco LLC

Size

A key aspect to consider in overall agent effectiveness is size. When we speak of size in relation to agents, we are speaking of his client list: the number of actors the agent has committed to represent exclusively.

One person cannot effectively represent a hundred people. It's like going to the store and buying everything you see. You can't possibly

use everything, you're just taking it out of circulation. There are some agents who may sign you just to protect their client who is in your category.

It might feed your ego to be signed ("I have an agent!"), but if you are not signed with a credible agent that you can trust, you may just be taking yourself out of the marketplace.

Better to wait until you have the credits to support getting a better agent than to sign with someone who can't represent you effectively. Many agents believe a good ratio is one agent to twenty to twenty-five clients. An agency with four agents can do well by a hundred or even a hundred and forty clients, but that really is the limit.

Or it used to be the limit. More and more agencies are loading up their list with far more clients than they can handle. For one thing, even though the list might be full, it's hard to resist a promising talent.

Though I note the size of their lists, many agents say they have less clients than they do to make the client/agent ratio look better.

An agency with a lot of series regulars has clients who are out of circulation for a large part of the year and don't require much upkeep, which gives the agent time to attend to other clients. It's dicey. Bottom line is how much attention you find you are/are not getting.

It's easy to get lost on a large list.

It's all very well to have stamina, discern talent, have a short list, and be a great salesman. I take that as a given. But there are two other attributes that separate the contenders from the also-rans.

Access and Stature

The dictionary defines the word "access" as "ability to approach" or "admittance." Since the conglomerate agencies have many stars on their lists, they have plenty of ability to approach. If the studios, networks, and producers do not return their phone calls, they might find the agency retaliating by withholding their important stars.

Stature on the other hand is different entirely. Webster defines the word as "level of achievement." Thus, Phil Adelman and Bob Barry certainly have more stature than some beginning agent at William Morris. But because Adelman and Barry don't have an equal number of bankable stars, they might not have as much access. Get both stature and access if you can, but if you have to choose, go with access.

The central issue is, how do you choose the agent who will provide

the opportunity for you to be gainfully employed in the business?

Wrap Up

The Ideal Client

✓ has talent
✓ possesses contagious emotions
✓ displays a singular personality
✓ exhibits professionalism
✓ manifests self-knowledge
✓ shows drive
✓ is innately likeable
✓ maintains mental health
✓ is well-trained
✓ boasts a good resume

The Ideal Agent/Manager

✓ is aggressive
✓ has stature
✓ has access
✓ is enthusiastic
✓ shares the actor's career vision
✓ has optimum actor/rep ratio
✓ has integrity

⚞ 11 ⚟
Everybody's Responsibilities

Once you have made a decision, there are many things to do. If you are switching agents, it's only right to have a face-to-face meeting to say goodbye. Say you're sorry it didn't work out and follow-up afterwards with a nice handwritten note saying the same thing. Make it a point to thank all your agents individually, as well as everyone else in the office. Then pick up your pictures, DVDs, etc. and leave. If the parting is amicable, buy your agent a drink if that's appropriate. You might want to send flowers. Send the necessary letters to the unions.

Setting Up Shop

The next stop is your new partner's office to sign contracts and meet and fix in your mind all the auxiliary people who will be working for you. Make notes as soon as you leave the office as to who is who and where they sit. Until you become more familiar with them, you can consult the map before subsequent visits.

Leave a supply of pictures, resumes and DVDs. Be sparing. Bringing supplies is always a good excuse for dropping by. Make a list for each agent's file of the CDs, producers and directors with whom you have relationships.

Alphabetize them if you ever want them used. Also leave lists of your quotes (how much you were paid for your last jobs in theatre, film, and television), plus information about billing. The more background you give your agent, the better he can represent you.

Now the real work begins. Remember the agent only gets 10% of the money. You can't really expect him to do 100% of the work. That may be why you are leaving your old agent. You felt he didn't work hard enough. Maybe your expectations were out of line. Maybe you were lazy. Maybe you didn't keep his enthusiasm high enough. Maybe he was a goof-off. Even if that was the case before, it really doesn't matter now. What matters now is how well you and your new agent are going to function together.

90%-10%

The concept of 90%-10% is fascinating. How many of us have resented our agents when we have been requested for a job and all the agent had to do was negotiate? In fact, if all our jobs were requests, would we just have a lawyer negotiate and do away with the agent altogether? Or is the support and feedback worth something?

Maybe our whole thought process about agents is incorrect. In our hearts we really think the agent is going to get us a job. Based upon my years in the business and my research, I finally know that the agent does not get me work. He gets my appointments, but my work gets me work. This happens not only by my ability to function well as an actress, but also by my adjustment to life.

The times I have not worked steadily have been directly connected to either physical or emotional growth spurts. I went into a terrible depression when my children left home. I willed myself to be up, but it was a loss that I had to mourn.

During that time I was not particularly attractive to casting directors or anybody else. Life's processes must be endured. We can change agents and mates and clothes sizes, but we can't alter reality. We must experience it. Those realities are reflected in our work and ultimately enrich us as performers.

✦ *If you're not working because you are in your mid-life crisis, divorce, whatever, you may not be able to readily fix it, but it's up to you to assume you have a problem and set out to fix it.*
Martin Gage/The Gage Group

We can hope that agents are going to initiate work for us and introduce us to the casting directors, producers, directors, etc. What they are really going to do over the span of a career is negotiate, initiate meetings, arrange appointments when we are requested, and hopefully, support us in dark moments and help us retain perspective in our bright ones. Notice I say moments. Neither state lasts as long as it seems.

Because we are getting 90% of the money, we have to give up being cranky when we have to do 90% of the work. I assume you are willing to do that, if you only knew what that meant.

What the Actor Can Do

✦ *The actor's job is to give me something I can go sell: a showcase, a new picture, a wonderful credit with a tour de force role. He has to be president of his own company, to treat the agent as his employee, to motivate him, to help guide him and to find a way to communicate with him so they can work as a team.*
Nancy Curtis/Harden-Curtis Associates

✦ *Trust me to have your interests at heart. Check you messages frequently. Live your life but let me know before you buy a ticket out of town. Keep up with what's happening. Always be as prepared as possible for your auditions.*
Dianne Busch/Leading Artists, Inc.

✦ *See everything you can, film, television, theatre. What's filming in New York? What's the style of it? See who they are hiring. If there is something in town that has a part for you, go see it. Sooner or later, they're going to need replacements.*
Bill Timms/Peter Strain & Associates, Inc.

Nancy Curtis envisions her advice to all clients written on her tombstone: Run your own company. Partner Mary Harden feels communication and a strong career plan are key to a successful actor-agent relationship.

✦ *Stay positive and make sure you look good, be part of the artistic community where information is passed around, and don't alienate your fellow artists.*
Diana Doussant/HWA Talent Representatives

✦ *I like our clients to be pro-active and to stay in contact with the office. Let me know if you have a special relationship with a director who's casting his new production. Information is a powerful tool. Keep your resumes updated. Return calls promptly. Remember, this is a partnership: both actor and agent working in tandem to build a career.*
Jeanne Nicolosi/Nicolosi & Co., Inc.

✦ *Develop some "radar" about the room, what they're open to across the table; it changes room-to-room and even hour-to-hour in the same room. Also, figure out how to act for "tape."*
J Kane/HWA Talent Representatives

Being an actor is an extraordinarily difficult job. You must be working on your craft and on your person all the time, staying abreast of what's going on and keeping your instrument tuned.

+ *The actor has to be clear about what he wants and what he says. If he says he doesn't want to go out of town, but then misses out on an important project because it was out of town and gets mad at his agent, the agent is going to say, "Well, you said you didn't want to go out of town." Once you put qualifiers on your career, you are not going to have as many auditions.*
Ellie Goldberg/Kerin-Goldberg Associates

+ *Keep active. Even a lousy Scene class will help you put less pressure on auditions.*
J Kane/HWA Talent Representatives

+ *It's very important for actors to network. If they have occasion to meet someone, follow up, stay in touch. It's important to keep your name afloat. I encourage proactivity, classes, showcases, open calls, trying to rustle up your own work.*
Jim Wilhelm/DGRW

+ *An actor needs to be doing anything he can to establish a line of communication with people in the business who might provide him with information.*
Jerry Kahn/Jerry Kahn, Inc.

+ *Count for lost a day without acting. Whether it be in a paid acting job or in an acting class or in a small theatre group or getting together with friends and doing a few scenes or sitting in front of a mirror and practicing a monologue, if you don't act every day, you're not an actor.*
Bernard Leibhaber/Bernard Leibhaber Agency

+ *You have to do a lot of work on your own. You sit around in circles with actors and everyone is saying, "well my agent didn't get me in on..." Now that I'm sitting in this chair, I can see that even the agent's best efforts sometimes go unnoticed.*
You need the combination of the actors doing their work and trying to get themselves in. I tell actors, "If you know the musical director or the company manager, go to them. You may get in that way easier than I can get you in." Getting an agent is not the be all, end all of the way to get work.
Laurie Walton

✦ *Keep your acting wheel greased by doing readings. This is very valuable. Everyone does them. You get to know a group of people.*
Charles Kerin/Kerin-Goldberg Associates

✦ *Actors need to figure out what they want, why they are here. They need to have realistic expectations, get in to class and into some kind of focus group, or form a networking group from their class. They need to surround themselves with people they respect, people who might be better than they, who are where they want to be. You can learn from others' achievements. You need to figure out a way to stay in touch with your family to help you stay grounded.*
Jack Menasche/Independent Artists Agency, Inc.

✦ *Make sure that we have enough pictures and up-to-date resumes without our having to call. If you are a musical comedy performer, be willing to go to an open call if we have discussed this is what you should do. It's important to keep working whether it's in a class or a workshop or a group; always keep your instrument finely tuned. Networking is important, but don't expect that every time your friend gets an appointment that you will too, and just because you call or drop in all the time, that we are necessarily going to think of you more. You don't want to become a pest. It is a business, in spite of how casual it is.*
Gary Krasny/The Krasny Office

Clients and would be clients all want your agent's attention. What would be the best way to get your attention under the circumstances?

✦ *If I have to take time from my day to talk to you to see how your day is going, then I'm not on the phone doing what I am supposed to be doing. If you hear of a project, make a two-minute call, "I heard about this, is there anything in it for me?" That's the way to be a good partner.*
Ellie Goldberg/Kerin-Goldberg Associates

✦ *You need to know who you can call on for help whether it's a producer, director, casting director or other actors. No matter what work you take, make sure it's work you are proud of. There is no use doing bad work for free.*
Jack Menasche/Independent Artists Agency, Inc.

✦ *Actors need to understand that until 11:00 or 11:15 in the mornings, agents need to organize for the day, set up what Breakdowns they have to do, solve all the problems and handle the calls that came in at the end of the day before. This is organizational time for agents.*

If the actor can just wait until 11:00 or 11:15 to call to find out about their next important piece of news, they would receive a more favorable response from the agent. Anytime after 11:15 and before 4:30 or 5:00.
Gary Krasny/The Krasny Office

✦ *Get seen. Do something to be seen because visibility is the name of the game. You're all competing for the attention of the casting director. You've got to do something to make them aware of your existence.*
Jerry Kahn/Jerry Kahn, Inc.

Important Details

- ✍ Have a pen and paper in your hand when you return your agent's call.
- ✍ Check in often.
- ✍ Return calls promptly.
- ✍ Make sure your agent never gets a busy signal; get call-waiting.
- ✍ Take a picture and resume to every audition.
- ✍ Pay attention to the common sense details of keeping lines of communication open.
- ✍ Trust your agent and follow his advice from picture and resume to what kinds of shows to audition for.
- ✍ Provide your agent with ample supplies of pictures and resumes without being reminded.
- ✍ Go by and pick up the script before the audition.
- ✍ Arrive well-prepared and on time at the audition (build in time for emergencies).
- ✍ Don't try to date the receptionist.

Networking

I know that networking is a dirty word to many of you. You say, "oh, I'm not good at all that," or, "I don't want to get a job just because I know someone," or "I'm here for art, not for commercialism," or,

some other elevated actor-jargon we all use from time to time to keep ourselves from testing our limits.

The most effective networking is done with your peers. You're not going to be able to pal around with Jerry Zaks or Christopher Durang. But you can pal around with the next Jerry Zaks and the next Christopher Durang by becoming involved with playwriting groups.

If you make it your business to attend theatre wherever it's happening, you will begin to notice who the writers and directors are who are starting their careers. Focus on those whose work appeals to you. Let them know you like their work. Give them your card and ask to be on their mailing list.

After you've seen their work a time or two, let them know that you are available if they need anything. Become involved in their projects. You will all develop together. It's hard to break in to what seems like the charmed circle because people would rather work with people they already know and trust, particularly when a great deal of money is at stake. Wouldn't you rather work with friends and proven talent?

It is difficult behaving naturally around those who are higher on the food chain than you. But if you are well-read and cultivate an eye and ear for what's good, you'll soon contribute to the conversation and move up the food chain toward your goals, one rung at a time.

Don't You Really Want to Work?

I'm a pretty quick study and, with concentration, I have the ability to memorize audition material and not hold the script for something as brief as a commercial. When I was a beginning actor, however, I would always hold the pages because my background had taught me to be self-effacing. It seemed to me that putting the sides down was too pushy. It would make them think I really wanted the job.

On the day I decided to stop holding the script and take responsibility for the fact that I really did want the part, I began booking jobs.

I looked up self-effacing in the dictionary: it means self-obliterating. Don't do it. Sir Laurence Olivier used to ask anyone working on a project whether there was anything in it for him. If Sir Laurence could admit he wanted a job, am I going to pretend I don't?

After successfully freelancing for a long time, when I finally signed with an agent I thought my own agenting efforts were over. From the

perspective of time and research I realize that because I was passive, didn't educate myself, and had abandoned all the job getting tasks I practiced before, I missed out on exploiting my success in a more meaningful way. I had this idea that you have a breakthrough and then everything just comes to you. Maybe for Julia Roberts, but even then, I doubt it. I just had no idea how the business works. It's a business, not a fairy tale. And it's a 24/7 business. That's the life you've chosen.

Some actors become angry when they have to tell their agents how to negotiate. They feel the agent is not doing his job if he has to be reminded to go for a particular kind of billing or per diem.

We all need encouragement and respond to reminders. I don't like to admit it, but I can almost always do better with prodding. I might not think so initially, but my extra efforts usually pay off.

If the agent does everything perfectly, great. But it's your career. It's up to you to know the union minimums and how to get your price up. It's up to you to figure out the billing you want and to help the agent get it. You are getting the 90%. Not only is it your responsibility, it's a way for you to be in control of your destiny in a business where it is too easy to feel tossed about by the whims of the gods.

Agents' Expectations

Before I talk about the agents' responsibilities, let's hear what agents expect from actors:

✦ *If I sign an actor for a year, I expect consistent callbacks. I expect, at least, growth. I'm not going to look at somebody's track record and say, "you've been out on fifty things here and you haven't booked a job; I don't think there's anything we can do here." It's difficult. It's very competitive. If I've believed in someone from the beginning, and if I see progress, if I see growth, and if I see the potential is still there, then I'm encouraged.*
Kenneth Kaplan/The Gersh Agency/Los Angeles

✦ *I expect that they'll prepare the audition material ahead of time, they'll show up punctually, that they won't be afraid to go out on a limb and take some risks with the material, that they will return my phone calls promptly.*
Gary Epstein/Phoenix Artists

✦ *I expect my client to be on time, to be prepared, to be pleasant and to do the*

best job he can. Once I get you in the door, you are on your own. I think actors should not be afraid to take control of the situation. If they want to start over, they should say so.

If they want to read different sides, they should ask for it. If they want to read another character, they should go for it. If they feel they were ignored, they should say so and not complain and whine to the agent.

The actor is a grown-up and casting directors are not demi-gods. They are people even though they have total control. I don't mean the actor has to complain, but he should make it known that he wasn't comfortable.

Gary Krasny/The Krasny Office

✦ *A client will say, "are you angry with me because I didn't do so and so?" No. I'm giving you choices and opportunities. You make the decision and I'll go along with it. If I think it's a self-destructive point, I'll tell you. We can talk about it, but it's ultimately your decision.*

Tim Angle/Don Buchwald & Associates/Los Angeles

The agent puts his reputation on the line by sending you in. And in every audition, you put your reputation on the line by the quality of your work.

Agents' Responsibilities:
What the Actor Has a Right to Expect

All we want an agent to do for us is get us meetings for projects we are right for. This seemingly simple request requires of agents all the things that actors need to do: be informed and be professional, network, stay visible, and communicate.

As we maintain our credibility by giving consistently good readings, the agent maintains his credibility by building trust with the buyers. When he calls and says, "see K Callan, you won't be sorry," the casting director knows he won't.

If K Callan gets the job, the agent must be ready to do a wonderful job of negotiation, one that will make the actor (and the agent) happy and, at the same time, make the casting director feel he got a bargain.

The agent has all our responsibilities and more. The agent must maintain relationships with all of his clients and with the buyer. He must keep the buyers happy so that he can have return business.

If your agent can't get you in, the buyer will never get a chance to

see how talented you are. Once in the buyer's presence, it's up to you to make your agent and the casting director look good by your brilliant work.

What the Actor Doesn't Have a Right to Expect

The actor/agent relationship is no different than any other relationship. No one likes to be presumed upon.

Don't

- Call your agent at home other than in an emergency.
- Drop by the office unannounced expecting the agent to be available to talk to you.
- Expect your agent to deal with your personal problems.
- Arrive late (or very early) for meetings.
- Expect to use the agent's phone for personal calls.
- Hang around with the agent's staff when they should be working.
- Bad-mouth the agent to others in the business. If you have a gripe with the agent, take it up with him.
- Interview new agents while your agent thinks your relationship is swell.
- Call and say, "what's happening?"
- Expect the agent to put all the energy into the relationship.

Although many agents will be amenable to your dropping by, using the phone, and visiting with the secretary, etc., it's best not to take these things for granted. After all, you want these people to be available to do business for you. If they are talking *to* you, they're not talking *about* you.

If you are not feeling confident about yourself, go to class, talk to a friend, a shrink, whatever, but don't burden your agent with that information. Will he feel like using up his credibility telling them that you are the best actor since Meryl Streep when he knows you can't even get out of bed?

If you are not up to auditioning well, tell your agent and postpone

or cancel the audition. You are not only not going to be performing well enough to get the job, but people will also lose confidence in you and in your agent's instincts. It will be harder to get the buyer to see you next time.

Although the agent's main job is to get you appointments and negotiate, I believe you also have a right to expect him to consistently view your work and to consult with you before turning down offers. Your agent's advice regarding career moves is one of the things you are paying for. He is a conduit to and from the casting director; he should convey feedback honestly about the impression you are making.

Make it clear you are ready to hear the bad with the good, but you would prefer he express it in a constructive manner. Instead of "you did lousy," how about "you were late," "you were not prepared," or "the casting director said your energy was down." Let him know that you want to remedy any problems, but that you need to know what they are. It's hard to assess auditions accurately without feedback.

Some agents give advice about pictures, resumes, dress, etc., but unless you are just starting in the business or have just come to the New York marketplace, established agents assume you have that all in tow. Your relationship will suffer if they constantly feel you are asking for their time in matters that are basically your responsibility.

That said, you may ask if your agent is interested in having input regarding pictures. This is the agent's sales tool (along with an audition tape) and he may feel strongly that pictures are one area where he wants to take time to advise you.

Sometimes I take my pictures to my agents for advice and sometimes I don't. My agents are busy and they haven't made a point of asking me to consult them when I select new pictures so I frequently choose without their guidance. Sometimes they don't think I made the best choice.

If I were writing a book I thought agents would read, I would suggest that periodically they call the actor in (whether the career is going well or not) and ask the actor to rate the agency. Is the actor feeling comfortable? Cared for? Serviced properly? An annual mutual rating wouldn't be a bad idea. Is the actor doing his part? Is feedback good? Pictures and/or resume need updating?

At contract renewal time perhaps the agent himself (instead of an assistant) would call and say: "K, how are you? It's contract renewal time, I'd love to have you stop by and have a cup of coffee with me (lunch?) and have us talk about our relationship. We're still happy, we

hope you are, but I'd like to get some input from you on what kind of job we're doing. Come in. We'll talk. We'll celebrate your contract renewal."

If I were suddenly a hot commodity, it would sure be a lot harder for me to think about leaving that agent for the attentions of WMA because I had been made to feel valued by the agent before my big break.

I asked several agents what they thought would surprise actors most if they spent a day in their agent's office. I loved J Kane's response.

✦ *That the system works. Sometimes, each and every job seems to call for a Florida re-count.*
J Kane/Peter Strain & Associates, Inc.

Staying In Touch

Keep in touch with your agent by being a good partner. Call with information that will give the agent something to do. "I just got beautiful new pictures," "I just did a mailing," or "I'm doing a show at EST." "Can I come in and have five minutes to talk about a mailing about how to reach people?" Or "hey, I just heard at my commercial audition about this series that's casting. The actress who is going in and I are always up for the same role, I know I'm right for it."

✦ *Give me a tool I can use. Actors need to do 50% and I will do the other 50%.*
Nancy Curtis/Harden-Curtis Associates

Los Angeles manager Ric Beddingfield says actors should make it a point to be seen by their agents once a week. Although most agents agree grudgingly that actors and their agents need to be in constant contact, most also agree that they hate the phone call that says, "what's going on?" They translate that into "where's my appointment?"

It's like when you were little and your mom said, "what are you doing?" when she meant, "is your homework done?" If you think about it from that perspective, perhaps you'll find a way to have a conversation that does not make the agent feel defensive. If you are calling to say you've just gotten a good part in a showcase, or just began studying with a new teacher, or "hey, did you see the new play at The Public? It's great, don't miss it," the agent is going to be a lot happier to

hear your voice or see your face.

When Laurie Walton was still agenting, I asked how she liked agenting.

✦ *The only thing I'm not enjoying is that actors call me daily. It's tough. I would never be unkind because I've been there, but on the other hand, I think a lot of them are taking advantage and that's the part I'm not enjoying because actors can really be annoying.*

It's because everybody wants to work. I understand that hunger and need but it's interesting for me that they're not using their heads more and knowing that it's probably going to have the reverse effect.

Laurie Walton

A Los Angeles agent put it succinctly, "my worst day is when I talk to more clients than buyers."

Remember that while you are taking the negative step of whining to your agent, you are avoiding taking some kind of positive action for your career.

Fax/E-mail

If you really really want to make a bad impression on an agent and guarantee that he will never be interested in you, fax and/or e-mail him little notes, flyers and reminders of your existence. It may save you money and time sending off these little message, but while you are doing that, you may well be disrupting his business.

If he is expecting a contract or a deal memo and his line is busy or he has a million e-mails because he is receiving a flyer from you, it's not going to make him kindly disposed in your direction.

A non-obnoxious way to stay in touch presents itself when you drop off pictures and resumes. Call ahead and say that you are going to drop off new pictures and want to pop in. Once there, ask the receptionist if you can just stick your head in and say "hi." Late afternoon is best.

You can just be in the neighborhood and drop by to show a new wardrobe or haircut. Then be sure to do that; just poke your head in. Don't sit down unless asked and if asked stay no more than five minutes. Be adorable and leave.

If you are depressed and need to really talk, call ahead and see if your agent has time for you. Suggest a cup of coffee after work or, if he

has time for a snack in the middle of the afternoon, you can bring goodies. Everyone is happy to see a treat in the late afternoon. Since all many ever brings in is sweets, bring something healthy.

Make the effort to speak to everyone in the office and call them by their names. Get to know your agents and their support staff on a person-to-person basis. Learn something about each one of them and take notes so you can establish personal relationships. You'll be able to say something that is not about you and/or the business. That will make all of you feel more comfortable.

✦ *We don't need phone-ins. We don't have the manpower. We encourage people to let us know when they are in showcases. Obviously, we can't go to all of them. We usually end up picking reliable ones. By that, I mean reliable by reputation of the theatre, quality of production, the kind of cast they usually attract, and also the material. We stay away from showcases that do a lot of the classics. I don't think they're going to show the actor in anything we could sell them for.*

Peter Strain/Peter Strain & Associates/Los Angeles

It takes two energy-expending components to make any merger work. The agent must work hard for you all of the time and you need to deliver all of the time. If you don't stay abreast of what's in town, what shows are on television that might use your type, what you got paid for your last job, which casting directors you have met, who your fans are, and/or if you are late or ill-prepared for appointments, the agent is going to get cranky.

If he doesn't drop you, he'll stop working for you. Worse, you'll get work anyway and he won't feel able to drop you. He'll just hate you.

If you are diligent, do everything you can do for your own career, and consistently give your agent leads that he doesn't follow up on, then you're going to get cranky and leave. It takes two.

Wrap Up

Details

✓ officially notify the previous agent that you are leaving
✓ take pictures, resumes, tapes, quotes, billing, etc., to new agent's office
✓ meet everyone in the office
✓ make map of where everyone sits

The Actor's 90%

✓ stay professionally informed
✓ network
✓ follow through
✓ communicate
✓ make informed suggestions
✓ get in a good acting class
✓ have call-waiting/dependable answering machine or pager
✓ check in and return calls promptly
✓ stay visible
✓ be loyal
✓ pick up the sides
✓ be punctual
✓ do great auditions
✓ give and get feedback

The Agents 10%

✓ arrange meetings with casting directors, producers and directors
✓ arrange auditions
✓ negotiate
✓ network
✓ maintain credibility
✓ communicate
✓ make informed decisions
✓ stay professionally informed
✓ return phone calls promptly
✓ guide career

❧ 12 ❧
Stand-Ups/Children

Abbott and Costello, Jack Benny, Chevy Chase, Jerry Seinfeld and Ray Romano are all examples of performers and stand-up comics who crossed over into films and television. Today, added to that list are performers who write, stage and act in their own one-person shows. Theatrical agents don't deal with this type of performer usually, so I interviewed a few agencies who specialize in this area of the business. The longer version of this information is in my book, *How to Sell Yourself as an Actor*, but here's the *CliffsNotes* version.

✦ *We've definitely steered toward a very personality oriented comic. A charismatic style comic. "The Tonight Show" might use a comic because they're a very good comic in terms of their writing: a structural comic who writes a perfect setup and a punch line. Some of those comics wouldn't crossover into a sitcom because they might just be joke tellers. We want somebody who is a very full bodied character a la Roseanne, Tim Allen, Seinfeld. The development and casting people are looking for that. They are already walking in with a character. Some comics have stronger skills in that area.*
Bruce Smith/Omnipop Management

In Franklyn Ajaye's terrific book of interviews with other comics, Jay Leno talked about his seven year rule.

✦ *"I've always told comedians that if you can do this for seven years, I mean physically make it to the stage for seven years, you'll always make a living. If you've been in the business longer than seven years and you're not successful, there's probably another reason. Sex, dope, alcohol, drugs - - you just couldn't physically get to the stage. Sam Kinison is sort of an example. He was funny, hilarious, but near the end he couldn't get to the stage anymore. No matter how popular you are, promoters are not going to rehire you if you miss gigs."*
Franklyn Ajaye, *Comic Insights*[15]

✦ *A lot of comedy clubs across the country have closed, but there are still some in the Northeast, so it's easier to keep a comic working there as they start to develop.*

The more stage time, they better they become. We encourage them to get into acting classes, not to become actors, but just to start. We want to know what their long range goals are. In order for a comic to become popular, he needs television exposure. If you can support that with a strong act, you're going to have a good career.

Tom Ingegno/Omnipop Management

✦ *I wouldn't assume that just because you are a comedic actor that you can do stand-up. Soap opera people try to do stand-up. Most of them, because they are so pretty, have not lived that angst ridden life that comics have. It becomes a frivolous version of comedy. The first thing you want to establish with an actor that is going into comedy is: Do they have a natural feel for it? Do they have comedic rhythm for it? There are many actors who are wonderful with comedy, but can't do stand-up. You need the stage time.*

Bruce Smith/Omnipop Management

✦ *A comedic person has to have the backing of theatrical training, otherwise you're looking at a personality-oriented project. Many stand-ups came out of theatre and did stand-up as a means of survival.*

Steve Tellez/CAA

✦ *I would say to really know whether you have any place in the comedy business at all, that you would have to give yourself at least two years. Less than that is not enough. The first year you'll spend just trying to get your name around, trying to get people to know who you are so they will give you some stage time.*

It's a long trip. Just like an actor. Don't seek representation with five minutes of material. You need to keep working. The next thing to do is to try to get work in road clubs. It's very important to get the experience. There is limited experience if you just stay in one city.

Bruce Smith/Omnipop Management

The personal appearance agents that I spoke to supported what I learned from theatrical and literary agents: no one is interested in one-shot representation.

If you get a guest shot on *30 Rock* and call an agent with that as an entree, he will probably take your call. But if you don't have a track record of credits (they don't all have to be as important as *30 Rock*) then the credible agent is not going to be interested. 10% of one episode is not enough of a payoff to put you on his list and share all his introductions and hard work.

If you have written a one-person show and Disney is interested, that

might be interesting to a stand-up agent. However development deals go south with regularity and if you don't already have a stand-up career going for yourself, personal appearance agents are not going to be interested. They want people who have been playing clubs in and out of town and have the stage time and some good material.

Stand-up and performance artist shows are a bonafide way to be entrepreneurial about the business, but there are no short-cuts to theatrical/comedic maturity. You gotta do the time.

Children in the Business

I don't think life as a child actor is a good deal for kids. You only get one shot at being a child and being taken care of. If you blow that, you are up a creek.

The tabloids make a lot of money running stories on the messed-up lives of former child actors. Britney Spears anyone? I know you think you and/or your children could never have those problems. Maybe you won't. But at least think seriously about the possibilities before you take the next steps. If your child is paying your rent, the balance of power tips and there is no more family hierarchy.

That said, if you are still interested, here's the procedure.

Professional experience is not necessary, but it helps. Children's agents don't expect professional pictures. Kids change too quickly, so it's a waste of money. Agents are perfectly happy to see snapshots of your child. Mail them with a note giving vital statistics: age, weight, height, coloring and any activity that had your child in front of people and taking direction.

What your child absolutely must be is comfortable with people. Happy. Confident. Gregarious.

If the picture interests the agent, he will ask to see the child. He will want to speak to the child alone. Parents are invited out while the agent gets a feel for how the child handles the meeting that would be part of an audition.

If you are a child reading this, let me tell you that agents are very impressed when a child makes his or her own arrangements. It means you are motivated, organized and adult about the whole thing. A children's agent told me that her role model for a child actor was a client who at thirteen had done lots of local theatre, called SAG, gotten a list of agents and sent in pictures himself. He got a manager and the

manager got him the agent. He got the first job he went for: the national tour of *The Sound of Music.*

Children are paid the same per day as adults and will be (all things being equal) expected to behave as one. No sulking, tantrums or crankiness. They don't like it when adult actors do that either!

Set-Sitters

Parents should be prepared to ferry children to many auditions and, if the child books a job, to be on the set with him at all times. Not only is it a SAG rule that a parent or designated set-sitter of some type be provided, but it is never wise to leave your child in an adult environment on his own.

Someone needs to be there to be your child's advocate. No matter what the job or how good management is about things, they are in the business to make money. Someone must be there who is not afraid of losing his job if he speaks up that the set is too hot or the kid needs a break. We all want to please and do a good job, but certain rules must be followed.

You or your designated representative should be there. You should have both read the SAG, Equity and AFTRA rules so that you know when the child must be in school or resting or has a right to a break. You should also know about overtime and payment for fittings. SAG holds Young Performers Orientation Meetings on the third Tuesday of every month and is happy to provide guidance and support for its young members.

Many child actors work through managers. Managers can be helpful at this stage by putting a child together with an agent and making recommendations concerning dress, pictures, study and so on. Many parents fulfill the same role. And while some agents provide the same managerial-type services without an additional 15% charge, many tell me they prefer managers as a buffer between themselves and the parent.

So saying, it's imperative that parents recognize their role in the process.

✦ *"What parents have to understand is, they are the excess baggage that comes along with the talent," says Innovative Artists' Claudia Black. "It's the parents' responsibility to make sure the child is prepared, on time and has rehearsed the scene.*

"....If agents can't get along with the parent, they won't take the kid. It's really not just about the kid being amazing," says Cunningham Escott Dipene's Alison

Newman. "It's a joint thing, fifty-fifty."
Alexandra Lange, *New York Magazine*[16]

Parents may be viewed as excess baggage, but they are necessary baggage. If your child begins to work steadily, it's a full time job for one of the parents. It might be exciting at first, but when/if your child is really successful, you might find yourself not only in an inferior position on the set but, also with your child.

Examine your reasons for putting your child under such stress. If your child is motivated and has dreamed of acting forever, that's one thing. If he's just excited about seeing himself on television, or if you always wanted to act, but didn't, you should step back and consider your decision.

Wrap Up

Stand-ups

✓ need fifteen to twenty minutes of material to begin
✓ need a persona
✓ should have theatrical training
✓ gotta do the stage time

Children

✓ can get by with a snapshot to begin with
✓ are paid as an adult, must behave like one
✓ must be able to talk to anyone
✓ require a set-sitter
✓ are only half the package, it's the parents' job too

Parents

✓ a full time job if your child starts working only you're invisible
✓ consider all the ramifications of your decision

✦ 13 ✦

Managers

I fully intended that with this edition of *The New York Agent Book,* to track managers and include their profiles, but finally decided there should be a separate book for managers. The New York/Los Angeles Manager Book will be published in 2008 asking the questions actors are usually too timid to ask, "How did you become a manager? Where did you train? What is your background?" "Who are some of your clients?" Until that book is a reality, here are some thoughts on managers.

Can a Manager Sell What an Agent Couldn't?

Many beginning actors seek a manager because they have been unable to attract an agent. If a credible agent doesn't feel he can sell you yet, why would a credible manager think he could?

If the agent did not see anything marketable, is the manager going to create something? It could happen, but I'd want to see some proof that the manager has access and developmental skills. Some managers will latch onto every new face in town, hoping that somehow one of them will hit.

Beverly Robin Green is an entertainment attorney in San Francisco. Although she works mainly in the music field, her words about managers are valid for managers of actors:

◆ *Artists often say they would like to put together a professional "team" of a manager, agent, and attorney. They ask me where they can find the manager or agent. That is a good goal and a good question. It opens up a lot of other questions about what the artist is really looking for, and what the artist has to offer. The different roles that managers and agents play in the music business are difficult to define. They even vary widely in their own categories and from situation to situation, and this can be confusing. Also, what an artist wants may simply not be available to them at this point in their career, especially with respect to managers and agents, who usually work strictly on a commission basis. Another problem is that many of these people simply do not want to bother working for an artist until the artist has*

already gotten a record contract or is otherwise already taking off in their career. This creates a "Catch 22" situation for the aspiring artist.

On a practical level, in selecting a manager, you need to define what you need the manager for and see if that role fits the person you are considering. A lot of times people say they want a manager to get them gigs (wrong, but often done) or to get them a record deal (in California anyway), but a manager who is unknown and inexperienced is not going to have the knowledge, connections or reputation to be of much help in this regard.

Beverly Robin Green, *onstage magazine*[17]

I spoke to an agent who had been asked by a friend to review a contract between the friend's daughter and a manager. Not only was the manager taking 15% of any acting work, but 15% of *any* work, even the actress' day job. Huh? When the agent asked the rationale, he was told, "well, when I'm working the day job, I won't be available for work." Does that make any sense to anyone?

Many feel that handing off their careers to a manager increases their cachet in the business. It may. It may not.

Hampered by outdated agreements with the performers unions and what they deem unfair/unregulated competition from managers, some excellent agents are choosing to dump their agency franchises and become managers themselves, but that's mostly in Los Angeles.

These people have credibility as far as I am concerned, but I wonder about all those people who just woke up one day and decided to call themselves managers.

A manager that is connected and in love with you could surely enhance your career. If you just graduated from one of the leagues and scored well in their showcases, many agents and managers may be giving you their cards. Don't let anyone rush you into signing anything. Check out all possibilities before you decide.

It's possible that a manager could get to you before you meet any agents and say, "hey, don't bother meeting any agents, I'll take care of that for you when you are my client."

I see where they are coming from on that. If you are going to have a manager, one of the services you might expect would be his input into your agent selection. However, if you never even meet any agents, how will you make an informed decision regarding the need for a manager?

It makes sense for you to meet with anyone who calls you just to see what they have to say. You'll see how others see you and your career, and with every meeting you'll become more confident.

Don't be in a hurry. These people are all salesmen and make brilliant impressions. You'll be tempted to sign in the moment, but you're not just magically going to pick the right person; you'll need to do some research. The right manager, one who is connected and passionate about your career, can definitely make a difference. But so could the right agent.

When Julia Roberts came to New York (already connected because of brother, Eric Roberts), her manager, Bob McGowan, uncovered a part for her in the movie *Satisfaction*. The part called for a musician, so McGowan enrolled Roberts in a crash drum course and enticed William Morris into repping her for the job.

So, if we had McGowan for a manager and happened to have the looks and charisma of Julia Roberts, who knows what could happen?

Ultimately, Roberts dropped McGowan and opted for William Morris, and no manager, choosing to not have any more layers between herself and her employers.

Managers Can't Legally Procure Work

Although the law has rarely been enforced, managers are not legally allowed to procure work. That's the business of those people who have licenses from the state: you know, the agents.

✦ *LOS ANGELES, July 3 — Actress Jennifer Lopez has filed a petition with the California Labor Commissioner accusing her former manager of violating the state's Talent Agency Act by procuring employment on her behalf.*

The primary charge centers on whether Benny Medina was acting as her agent. Because Medina allegedly procured and negotiated work for her, the petition is requesting that all oral and engagement contracts she had with Handprint be voided. Those contracts saw her pay 10% of earnings from movies and television, 15% of her music, recording and publishing earnings, and 10% of her earnings from ancillary activities, including fashion and cosmetic interests.

Chris Gardner and Peter Kiefer, *Hollywood Reporter*[18]

Nia Vardalos won a similar lawsuit against her former manager.

✦ *The state court judge has refused to hear a challenge from Nia Vardalos' ex-manager to California's law barring managers from acting as talent agents. Tuesday's ruling by Los Angeles Superior Court Judith Chirlin sets the stage for the state labor*

commission to go ahead with a proceeding next week against Marathon Entertainment
for performing as an unlicensed talent agent for Vardalos.

The management company sued Vardalos in January for failing to pay 15%
commission from her earnings from the hit comedy feature, "My Big Fat Greek
Wedding," which she wrote and starred in.

Dave McNary, *Daily Variety*[19]

No one believes that Lopez and Vardalos have suddenly found
religion and don't want to be in business with someone who is breaking
the law. The lawsuits look like a way to avoid paying commissions and
get out of a contract. The fact remains that it's illegal for a manager to
procure work for you.

The Association of Talent Agents webpage has this to say:

✦ *The job of the ATA agent is to create opportunities, procure and negotiate*
employment for clients, and counsel them in the development of their careers. Agents
in most states must be licensed by the state, city or appropriate governing body.
Managers are not regulated nor are they required to have a license. Under law,
managers may not procure employment for artists or negotiate without a licensed
agent, and any person who renders Agent services without a license may have their
contract invalidated and be forced to relinquish any commissions paid.
www.agentassociation.com/frontdoor/faq.cfm

And if he's not going to procure work for you, why would you be
wanting a manager? There are other reasons, believe it or not.

When It Makes Sense to have a Manager

• Managers are a definite plus for child actors who need guidance and
whose families have no show business background. A manager
usually places the child with an agent, helps select pictures and
wardrobe, monitors appointments, and some even accompany the
child to meetings and auditions.

• If you are entering the business and need someone to help you with
pictures, resumes, image, etc., managers can be helpful. However,
many agents delight in starting new talent and consider this part of
their service.

- When you are at a conglomerate agency and it's too intimidating and time consuming to keep in touch with twenty agents, it might be advantageous to have a connected manager in your corner.

- Changing agents is easier when you have a manager because the manager does all the research, calling, and rejecting of the former agent.

If agent-changing is the only reason you have engaged the services of a manager, it's an expensive antidote to one uncomfortable meeting. If you have the credits to support getting a good agent, you can do that on your own. If you don't, the manager can't create them.

I have a few friends who feel the presence of a manager enhanced their careers, at least momentarily. One in particular said her agents were considering dropping her, so she and the manager made her more attractive to the agents by getting some jobs themselves. They read the Breakdown and the actress delivered her own submissions to the casting offices.

If the manager got a call for an appointment, the actress went in. If she got the job, they called the agent to make the deal. The agent became more enthusiastic about the actress for a while, but ultimately dropped her. The agent's earlier disinterest signaled what he had already decided: that the actress was no longer appropriate for his list. In that case, the manager, though helpful, only delayed the inevitable.

And his actions were, of course, illegal.

What Do Managers Think Their Job Is

From The National Conference Of Personal Managers website,

✦ *First, let's state what a personal manager is not. A personal manager is not an agent (whose role is to obtain employment). A personal manager is not a publicist (whose role is to generate publicity). Nor is a personal manager an attorney (whose role is to provide legal counsel). And, a personal manager is not a business manager (whose role is to provide accounting, investment, and other financial services).*

A personal manager advises and counsels talent and personalities in the entertainment industry.

www.ncopm.com

The site goes on to say:

Personal managers have the expertise to find and develop new talent and create opportunities for those artists which they represent. Personal managers act as liaison between their clients and both the public and the theatrical agents, publicists, attorneys, business managers, and other entertainment industry professionals which provide services to the personal manager's clients.

Even though the NCOPM says managers "have the expertise...", there is no governing body that certifies this to be true. You could decide right now to be a manager, hang a shingle, announce your new business to the trades, and wait for the 8 x 10s to flood your mailbox. So just as you would in any business situation, ask questions. It's difficult to withstand a full court press from someone who professes to love you and want to help you, but find out if this person has the credentials to do that.

✦ *There are managers out there who wine and dine actors after the showcases and tell them not to meet with agents themselves and not to return their phone calls, particularly mid-level agents. Those actors might really be missing out. They should be meeting with the agents and making their own decisions. It's possible they don't even need a manager.*
Gary Krasny/The Krasny Office, Inc.

A highly visible friend of mine recently lost a job because her manager discouraged her from speaking to her agent. The actress lost the job over money that would make no difference in her lifestyle. The agent might have prevailed in the negotiation.

The job was in a show that is now a huge hit and would have given real momentum to my friend's career. I kept saying, "why don't you call your agent and ask what is happening?" Her reply? "I don't want to make my manager mad."

On those two unsuccessful occasions when I did have a manager, the thing I liked least was that I was not supposed to talk to my agent myself. If I can't talk to my agent, how can he have a clear understanding of who I am and what I can do? The more you hand off your power to someone else, the less control you have over your own destiny.

Researching Managers

Check out managers the same way you do agents. First, Google them to see if there is anything online. Then ask friends if they have heard of anyone who has a manager who has enhanced their careers.

If you know any casting directors well enough to ask, ask them if there are managers they work with that they could recommend.

If you do set up a meeting, be prepared to ask how the manager got into the business, what casting directors he has relationships with, and who are on his client list. I've heard that managers really don't like their other clients to know about each other.

In Los Angeles that can't be true, as the star managers routinely take out congratulatory ads when their clients are nominated or win an award.

Go in with your own idea of how long you are willing to be committed contractually and how much you are willing to pay in commissions. Just because he asks for 15% doesn't mean you have to pay that. These things are negotiable.

Don't be short-sighted. Have faith in yourself. Whether you are choosing an agent or a manager, don't just take the first person who shows some interest. Even though it may not seem that way right now, you have assets to protect: your face and your career.

You may say, "well, so what if someone wants to charge me 25%. Right now, I am making nothing. If I make money, give this person 25%."

That's fine today while you aren't making any money. But when you do work, you'll have a manager taking 25%, an agent taking 10% and Uncle Sam taking up to 50% leaving you with only 15% from all your work.

Wrap Up

Managers

✓ can provide guidance
✓ take a larger percentage than agents
✓ can't legally procure work
✓ are not governed by industry standard contracts

✓ are not licensed by the state
✓ Google them
✓ check with casting directors
✓ check other clients
✓ ask informed questions
✓ negotiate length of contract and commissions

⚔ 14 ⚔

Divorce

It's difficult to decide where to place information about relationships that don't work out. When I first started writing about agents, I began the book talking about this painful subject. Vigilant folk pointed out that you have to have an agent before you can leave them. True, but some people who are reading this book already have an agent and are contemplating leaving. They need guidance.

Don't skip this part just because you don't have an agent yet. You may learn some valuable lessons that will help you avoid a divorce in the future.

If an actor is not working, frequently he thinks it's the agent's fault and the actor fires him. But the agent might not be the problem.

Valid Reasons for Leaving

If your agent won't return your calls, if he's been dishonest, or is not getting you out, those are legitimate reasons for leaving. Maybe you and your agent have different ideas regarding your potential. This is something that should have been ironed out before the contract was signed. When that conversation comes later in the relationship, reality must be faced. Sometimes careers change and actors feel they can be better serviced by agents with a different set of contacts.

Perhaps your level of achievement in the business has risen. Through brilliance, or possibly a lucky break, you have now become an actor of greater stature than your agent. This is very possible if fortune has just smiled on you.

Actor/agent relationships are just like any other relationship: as long as it's mutually rewarding, it thrives. When it's not, things must change.

Actors and agents seek each other for mutual gain. The agent must see money-making potential to be interested in taking on partial responsibility for your career. While thirty-five perfectly credible agents may pass on you, number thirty-six might fall in love, send you to the right place with the right material and the right director, and suddenly

you are a star.

Of course, it can happen the other way too. One minute you're hot and the next moment you're not. You didn't necessarily do anything so differently to get un-hot; frequently getting hot works the same way.

+ *Jumping ship every six months (which a lot of actors do) only serves to hurt the actor because everybody knows about it and it shows that the actor can't necessarily get a job because something's wrong and it's not because of the agent.*
Gary Krasny/The Krasny Office

Before you replace and/or bad-mouth your agent, consider the following possibility:

Maybe It's You

- You might have gained or lost weight and now no one knows what to do with you.

- You may be traveling into a new age category and have not yet finished the journey.

- You might be getting stale and need to study.

- You might be having personal problems that are reflected in your work; after all it's the life energy that fuels our talent and craft.

- The business might have changed, beautiful people may be in (or out).

How many projects can you list that had parts for you for which you were not seen? And were there really parts for you? Your physicality and temperament must not only match the parts, but also you must have the credits to support being seen for significant parts.

What part would you have been sent up for on a Broadway show? Yes, it would have been nice if you had played the part in that film instead of Brad Pitt, but no agent would have sent you up for the part. You're just not that far enough along in your growth or visibility.

Maybe the reason you want to change agents is that your friend seems

to be getting more auditions than you. It is hard to listen to others speak of their good fortune when you are home contemplating suicide, but before you get out the razor blade:

Consider

- Although you may frequently be seen for the same roles as your friend, there are aspects of your persona that are not the same.

- It cuts both ways. There have surely been roles that you were right for and your friend was not. You and your friend may be on different career levels.

- Perhaps your friend has not been totally candid in the descriptions of his auditions.

- It just might not be your turn right now. Be patient, it will be.

Maybe it's time for you to be proactive: get into a class; court casting directors; do a showcase; mount your own project.

Measure your progress against your own development. Judge your relationship with your agent on whether or not it is mutually rewarding and respectful. If your agent has been dishonest with you or if there have been financial improprieties, those are valid reasons to leave.

Is Your Agent Doing His Part?

How can you tell if it's just not your turn, or if the agent isn't tending to your business? You can check with casting director friends, writers, directors, and anyone else you know in the business. If you are being as involved as you should be, you'll be abreast of current projects so that you will have a realistic idea concerning projects for someone like you. You can't be a hermit and expect to work.

Ask your agent what you can do to help get more auditions. Discuss casting directors you would like to meet. Have a list of two or three who

cast material for which you are appropriate in both career and type.

Check with friends you trust to see if they have had any activity. Let them know you are not fishing for information, but just checking on your own paranoia. "Is my agent just not sending me out right now or is nothing going on?"

Drop by your agent's office with new pictures. Is the phone ringing? Are they calling other clients? Or is the place calm with inactivity? If the office isn't busy, this may give you and your agent a chance to chat.

Communication

If you and your agent can't talk, that is a serious problem.

✦ *The biggest problem in the actor/agent relationship is lack of communication.*
Martin Gage/The Gage Group

✦ *Most of the time, when someone leaves, it's mutual. The bottom line is that it is the actor's career. If he is not happy, then it's up to him to say, "can I have a meeting because it's been too long?" And then we will say, "what have you seen that you weren't up for? Or what have you heard of?"*

He might mention a project that he wasn't in on and we'll pull it out and see that on that project they were looking for stars or younger or whatever. As soon as we talk about it, the problem is usually over. It's important, though, to have the conversation.
Ellie Goldberg/Kerin-Goldberg Associates

✦ *If the agent screws up a job, I think you should leave. If you don't get any appointments and you think you should be getting appointments, then you should move on to someone who is excited. If the agent doesn't take your phone calls, that's really a sign that there is something wrong. Sometimes you just have to get a fresh outlook. It works both ways.*
Gary Krasny/The Krasny Office

If you are not getting auditions you might be unhappy enough to leave your agent, but make sure you are being realistic. If there are no parts in your category right now, a new agent can't change that. He might send you out on auditions you're not right for and make you feel busy, but you're still not going to get a job you are not right for.

Not everyone gets to do everything. Agents tell me the number one reason that a working actor leaves one prestigious, credible agent for another is that the actor sees his career in a different venue.

If he's on soaps, he wants to be on primetime. If he's a television star,

he wants to do films. When an actor becomes a star in one area of the business, that means (among other things) many people are constantly telling the actor how terrific he is and how he can do anything. That may not be true.

Research your peers. Have they made that change? Some people have enormous breaks come their way, but not everybody is going to make a movie and not every actor is going to do Broadway.

✦ *I think you know what you've been submitted for, how many appointments you've gotten. You have to take the explanation of the agent and weigh it.*
Jeff Hunter/William Morris Agency

Every agent has different contacts. An agent may have great theater contacts and no film contacts, but tells the actor he does. If you were that actor and the agent didn't get you a film audition for a year, you'd be getting the sense that he wasn't being truthful.

✦ *We have to tell actors what we think they can realistically expect. That pierces their dreams sometimes and they move on.*
Jeff Hunter/William Morris Agency

The larger agencies are not in the business to handle less profitable jobs. They either drop you, or their lack of interest will finally tell you that you're no longer on their level. This is the moment when you might be sorry you left that swell agent who worked so hard to engineer the big break for you.

Will he want to see you now? He might. He might not. It depends on how you handled it when you left.

Maybe your career is doing okay but you feel you haven't progressed in several years. Some actors leave their agents on a manager's advice. Sometimes that's a good idea. It's also possible the manager is just jealous of the relationship the actor has with his agent and the manager is seeking to put himself in a more powerful position.

Maybe you want to leave your agent because the magic has gone out of your marriage, just as the magic can go out of a traditional marriage if both partners don't put energy into it. Check the discussion of the actor's responsibilities in chapter eleven for ideas on how to add energy to your relationship.

Agents Divorce Actors Too

It's worth noting that agents divorce actors too. Sometimes it's for bad behavior (*life's too short*) or lack of communication, sometimes it's because the agent's list has gotten too big/costly and he needs to trim, but most times it's because an actor is not working, although some agents don't let even that shake them,

✦ *When a client of mine doesn't get work, I just figure the people who are doing the hiring are morons. I know when I take on a client that it's for life. I have so much faith in my own taste that I would never lose faith in a client.*
Phil Adelman, The Gage Group

If you are both willing to save the alliance, that will take a lot less energy and resourcefulness than going through the "just learning to get to know each other" period involved in any new relationship.

✦ *The bottom line is you're not getting work. It doesn't make any difference what the reason is. If you're not getting work, you have the right to leave and if you're smart, you will leave.*
Beverly Anderson

Don't Wait Until It's Too Late

Just like anything else, if something is bothering you, speak up. Candor comes easily to very few people. Most actors have a need to be liked and it's not pleasant to confront people.

If you are not going out, call your agent and try to have a face to face meeting. He knows as well as you that you are not going out. Tell him you are concerned; I'm sure he is too. Don't make him defensive. Let him know you understand that this is a mutual problem.

Ask him if there is anything you can do. Ask if he has heard any negative feedback. Whatever you do, don't just start interviewing for a new agent and bad-mouthing your present agent to your friends.

It's easier to whine to bystanders about your dissatisfaction than to confront your agent, but that's a childish thing to do. It's also ineffective, dishonest and makes you look bad. If you intend to succeed in this business, you'll have to do better than that.

✦　*Early on, at some moment, discuss problems with the agent. There are actors who hide in their kitchens, angry because they have not had auditions. By the time they can't stand it any longer, they call and tell you they're leaving. We're not omniscient; we don't know sometimes what is happening or not happening.*

We have meetings every week at the office and discuss all the clients and we might know someone is dissatisfied. But even if we miss it, you are obliged to come in and speak to your agent, not an assistant, because you are signed by the agent. Then we'll discuss it. We'll have a discussion and try to solve it.

Fifi Oscard.

Leaving Your Agent

If you waited too long and it's too late for a talk, or if the talk didn't help, at least leave with a little class. Though it might be uncomfortable, get on with it.

✦　*I would be very upset if someone with whom I've had a long relationship fired me by letter. I think it would be the ultimate rudeness, ingratitude, lack of appreciation for the work I've done. Get past the guilt, the embarrassment. I'm owed a certain consideration. Deal with it. I understand the difficulty, but that's not an excuse.*

Phil Adelman/The Gage Group

So be a grown-up. You owe your agent the courtesy of a personal meeting. Go in and talk to him. Explain that, for whatever reason, it's just not working. No need for long recriminations. No excuses. Not, "my wife thinks," or, "my manager thinks." Simply say, "I've decided that I am going to make a change. I appreciate all the work you have done for me. I will miss seeing you, but it just seems like the time to make a change. I hope we'll see each other again."

Write your own script. No need to be phony. If you don't appreciate what the guy has done and don't think he's done any work, just skip it.

Talk about the fact that you think the relationship is no longer mutually rewarding. Leave your disappointment and anger at home. Be straightforward and honest and you'll both be left with some dignity. You may see this person again, and with some distance between you, you might even remember why you signed with him in the first place. Don't close doors.

If you are leaving because your fortunes have risen, the meeting will

be even more difficult because the agent will be upset to see you and your money leave. Also, your newfound success has probably come from his efforts as well as yours. But if you are really hot and feel only WMA, CAA, or some other star agency can handle you, then leave you must.

Tell him you wish it were another way, but the vicissitudes of the business indicate that, at a certain career level, the conglomerates have more information, clout, and other stars to bargain with, and you want to go for it.

If you handle it well and if he is smart, he will leave the door open. It has happened to him before and it will happen to him again. That doesn't make it hurt less, but this is business. He will probably just shake his head and tell his friends you have gone crazy, "this isn't the same Mary I always knew. Success has gone to her head."

He has to find some way to handle the rejection, just as you would if he were firing you. It will not be easy to begin a new business relationship, but you are hot right now and the world is rosy.

Wrap Up

Questionable Reasons for Leaving

✓ no recent work
✓ manager pressure
✓ agent disinterest

Better Remedies than Leaving Agent

✓ improve communications with your agent
✓ take a class, study with a coach
✓ do a showcase
✓ court casting directors
✓ put your own project together

Clear-Cut Reasons for Leaving

✓ lack of respect
✓ dishonesty
✓ communication didn't help

✓ differing goals
✓ personality differences
✓ sudden career change for better or worse

Speak to Agent

✓ before things get bad
✓ before interviewing new agents

☙ 15 ☙

Researching the Agents

There are various categories of agents and managers: big, small, credible, wannabes, beginning, aggressive, just getting by. Since rep/client relationships are personal, any classifications I make are subjective. I'm presenting the facts as best I can, based upon my research and personal experience both in interviewing these agents and my years in the business. You must digest the information and make your own decisions.

There are new agents building their lists who, like you, will be the stars of tomorrow. You could become a star with the right one-agent office and you could die on the vine at CAA.

There are no guarantees, no matter whom you choose. The most important office in town might sign you even without your union card if your DVD and/or resume excites them. But mostly they don't take developmental clients. They want you when you are further along. Whomever you choose, if you are to have a career of longevity, you can never surrender your own vigilance in the process of your career.

Evaluate Carefully

If you read carefully, you'll make a wise decision using client lists, the agents' own words, and the listing of each agency. Don't write anyone off. In this business no one knows anything. I love my agent, but you might hate him.

There are nice people who are good agents and there are nice people who are not. There are people who are not nice who are good agents and so on. Just because I may think some agent is a jerk doesn't mean he is. And if he is, that might make him a good agent. Who knows?

If you read all the listings, you will have an overview. I've endeavored to present the facts, plus whatever might have struck me about the agent: this one was once known as "The Goat Lady"; that one was an Equity rep.

Some agents have survived for years without ever really representing

their clients. They wait for the phone to ring. Some agents talk a better game than they play. I believe it would be better to have no agent than one who is going to lie to you.

Agent Stereotypes

We all know the stereotypes about agents: they lie, that's their job. While some agents lie, most don't. Most are hard-working, professional, regular people who, like you, want to make it in show business.

Like you, they want to be respected for their work, go to the Academy Awards, and get great tables at Sardi's. And again, like you, they are willing to put up with the toughest, most heartbreaking business in the world because they are mavericks who love the adventure and can't think of a single thing that interests them more.

Many who read this book are just starting out and will be scanning the listings for people who seem to be building their lists. Many of those agents have great potential. Some don't.

Who's Included in This Book?

I went through a real crisis about whom to include. Anybody who would talk to me? Only those agents that I could actually in good conscience, recommend? It seems inappropriate for me to try to play God about who is worthy and who is not.

On the other hand, I don't want my readers to think I would recommend everyone who is in the book. That automatically makes anyone not in the book suspect.

When I began writing these books, with the exception of the conglomerates, I only included agencies whose offices I could personally visit and interview. Today, in the interests of time and geography, there are a few that I have only met on the phone. The majority of the profiles are based on personal interviews.

Most of the time I went to the office because that was most convenient for the agent. Seeing the office also helped refine my thinking about the agency. I didn't meet everyone in every agency, or all the partners, but I did always meet with a partner or an agent who was acting as a spokesman for the company. I could be wrong in my judgments, but at least they are not based on hearsay.

It's a good bet that if an agent is not included in the book then I

didn't know about them, or had no access to information about them.

Number of Clients

The number of clients listed at the end of an agency profile only refer to theatrical clients, unless otherwise specified and, just as the box office receipts reported in *Variety* might be inflated for business reasons, an agency may under report the size of their list. In reality they may have more clients than they can reasonably represent and they would just as soon not publicize that fact.

The general agent-to-client ratio to look for is at least one agent for every twenty to twenty-five clients. Anything over that makes it difficult to imagine a client getting much personal attention.

Most of the profiles in this book list a few clients from the agency's list, but some of the agents would not release any names lest they leave someone out. In those cases they frequently give me a list and invite me to choose names. Sometimes I've gleaned names from trade ads paid for by the agency. Some information comes from trade columns devoted to information on artists and their reps.

Less Is More

Once you feel you actually have something to interest an agent – an audition tape in your bag, a play in production, and/or some swell reviews from decent venues – be discriminating in your quest for representation.

Don't blanket the town with letters. Target three agents that seem right for you and ration your money, time, and energy. It's more likely to pay off than the scattershot approach.

Agents are already inundated with DVDs and reviews and while they are all looking for the next hot actor, there are only so many hours in a day. Don't waste their time or yours.

If you are just starting, don't expect CAA to come knocking at your door. Choose someone who is at your level so you can grow together.

If you have just gotten a job on your own, you will probably have some referrals already. Check them out and see who appeals to you. A job is not an automatic entree. As you have probably noted throughout this book, most agents are not interested in a one shot deal. Many say they are not adding to their client lists at all.

Don't despair. Agents agree that new blood is what keeps the industry going. Even if you have thirty pairs of shoes and swear you will never buy another, if you see shoes that captivate you, you will buy them. The trick is to be captivating, or more importantly, marketable.

Body of Work

In my experience researching agents for actors, writers, and directors, I keep learning that agents are interested in a body of work. They want to see a progression of you and your product. They want to know that they are not squandering their hard won contacts on someone who doesn't have the ability to go the distance. They won't be able to buy a cottage in the south of France on their commissions from one job. Neither will you.

Like attracts like. You will ultimately get just what you want in an agent. I believe you can get a terrific agent if you make yourself a terrific client. There are no shortcuts. And today is not the last day of your life.

In her book, *My Lives*, Roseanne quotes a line from Sun Tzu's *The Art of War*, which she says everyone in Hollywood has read. It basically says: "The one who cares most, wins."

Kevin Bacon/Referrals

As you read the agency listings, you will see that many of the agents, though they will look at query letters, are not open to being contacted by new people who have no one to recommend them.

If you don't know anyone, remember "The Kevin Bacon Game." It's the same concept as the play/movie *Six Degrees of Separation*, which contends that anyone in the world can find an association with anyone else in the world through six associations. In "The Kevin Bacon Game" it only takes three degrees, and in some cases, less.

For example, I have worked with Kyra Sedgewick who is married to Kevin Bacon. Ostensibly, if I had a script I wanted to get to Kevin, I ought to be able to get it to him through Kyra.

If you track all the odds and ends of your life, you should be able to produce somebody who knows somebody who knows somebody who can make an authentic (however tenuous) connection to someone who can make a call for you. Otherwise you are just querying/calling cold.

If you can't come up with a connection, write the best darn letter in the world and knock some agent on his butt. However, if you can score at "The Kevin Bacon Game," it would be best.

Remember

✓ Your first agent is you. You must be your own agent until you attract someone who will care and has more access than you. It's better to keep on being your own agent than to have an agent without access or passion.

✓ Make yourself read all the listings before you make a decision.

✓ Mass mailings are usually a waste of money. There is no use sending William Morris or CAA a letter without entry. It's pointless to query someone you have never heard of. If you have no information about the agent, how do you know you want him? Take the long view. Look for an agent you would want to be with for years. Be selective.

✓ Don't blow your chances of being taken seriously by pursuing an agent before you are ready.

✓ Although rules were made to be broken, presuming on an agent's time by showing up at his office without an appointment or calling to speak to the agent as though you are an old friend, will ultimately backfire. Observe good manners and be sensitive to other people's space and time.

✓ Getting the right agent is not the answer to all your prayers, but it's a start!

* Every effort has been made to provide up to date contact information for all agents but call to check phone numbers and addresses before you mail. People move, computers goof.

16

Agency Listings

Check addresses and names before mailing. Every effort has been made to provide accurate and current addresses and phone numbers, but agents move and computers goof, so call the office and verify information.

They won't know it's you.

≰ About Artists Agency ≱

1650 Broadway, #1406
at 51ˢᵗ Street
New York, NY 10019
212-581-1857

Renee Glicker was an actress for twenty years before she became an agent, so it's safe to say she knows where we are coming from.

While pursuing a double major in art and theatre at the State University of New York, both departments competed for Renee Glicker's time, but lucky for her clients, her love of theatre won out.

Because she'd been told that if you can be happy doing anything other than being an actor, you should (good advice!), Renee worked as an intern in audience development at a theatre in Florida to test herself and found that, yes, she really had to be an actress. She returned to New York and scored a national tour of *They're Playing Our Song*.

Other national tours, cabaret work, commercials and lots of off-Broadway, television, and films followed. Her day job (at night!) during that time was working as a waitress at The Comic Strip, where she began to know all the rising young comics. Sitting on the sidelines watching the careers of Paul Rieser, Jerry Seinfield, and Chris Rock develop, she absorbed so much of the process that up-and-coming comics asked her to critique their work and club booker, Lucien Hold, asked her to help him open The Holding Company, a management business specializing in comics.

In 1995, when Renee heard that Abrams Artists was looking for someone to create a comedy department, Renee knew she was the one to do the job. Accompanied by her stable of comics, she joined the agency and took the place by storm, immediately booking theatre, film and television sitcoms, sketch artists and improv actors.

When she decided it was time to open her own office in 1998, all but three clients came with her and those that didn't soon regretted their decision.

Although Renee made her reputation with comics, she has clients in film, television, and theatre. Working actors have told me that she also works with an extensive free lance list of actors.

The company's list of about fifty includes Ezra Knight (*Hack* and *The Lion King*), Kristine Zbornick (*Man of La Mancha, Bat Boy*), Craig

Schulman (*Jekyll & Hyde, Les Miz*), Eric Nieves (*Storytelling, NYPD Blue*), Dan Naturman (*Letterman, Conan O'Brien, Craig Kilborn*), Tina Giorgi (*Craig Kilborn*), Kevin Hagan (*Sopranos, Sweet Home Alabama, Third Watch*), Joey Vega (*Law & Order*) and Lou Martini, Jr., (*100 Centre Street*), Tricia Jeffrey (*Little Shop of Horrors*), Keith Keaveney (*She House Cinema*), Elaine Kussack (*Sex and the City*), Lori Ann Strunk (*Aida*), and Todd Anderson (*Boy from Oz*).

Renee hosts a stand-up comedy showcase for the industry in January and August. Renee says she never left acting, it's just that one day, she found herself in the middle of a new career and could hardly wait to get to work.

Agents
Renee Glicker
Client List
50 plus free lance

⊿ Abrams Artists Agency ⊾

275 7th Avenue
btwn 25th & 26th Streets
New York, NY 10001
646-486-4600

Harry Abrams has headed or partnered a string of agencies over the years: Abrams-Rubaloff, one of the commercial forces in Manhattan in the late 1960s and 1970s; Abrams Harris & Goldberg, a prestigious theatrical agency in Los Angeles during the early to mid-1980s; and currently Abrams Artists both in New York and Los Angeles.

Through resourcefulness, determination, and an eye for talented agents and actors, Abrams has carved out an impressive bi-coastal agency that is respected in all areas of the business. He is quartered now in Los Angeles, running the motion picture and television department.

New York film/television head Robert Atterman began his career in the mailroom at ICM. The children's film and television division is run by Ellen Gilbert who worked her way through the training program at Abrams Artists.

Paul Reisman, Richard Fisher, and Jill McGrath join Atterman in the theatrical division, while Mark Turner heads a special department for hosting talent.

Clients include Kelly Bishop, Lois Chiles, Judith Ivey, Leroy McClain, Julito McCullum, Daniel McDonald, Chris McKinney, and Marlyne Afflack.

Clients come to this agency through referral, although they do look at all pictures and resumes.

Agents
Robert Atterman, Ellen Gilbert, Richard Fisher, Jill McGrath, Paul Reisman and Mark Turner.
Client List
95-100

⊴ AFA/Agents for the Arts ⊯

203 W 23rd Street, 3rd floor
btwn 7th & 8th Avenues
New York, NY 10011
212-229-2562

Actress/singer/production stage-manager/director Carole Russo arrived in New York ready for work as a performer, but quickly realized she didn't have the emotional stamina for it. She chose the next best thing and uses her background to represent and nurture her list of clients.

Carole represented models at the Paul Wagner Agency and other modeling agencies before realizing that there were more creative ways to use her theatre background. When she switched to the theatrical arena her mentor was Fifi Oscard, for whom she worked for five years.

AFA celebrated its thirtieth birthday this year, so clearly Carole learned her lessons well.

Actors from Carole's list of about forty-five are Paul Jackel, Ann Van Cleave, John D. McNally, Deborah Jean Templin, Amanda Huddleston, Janet Aldrich, Tracy McDowell, Michelle K. Moore, Casey Unterman (*Kid Fitness*), Tod Wilson, James Chip Leonard, Peter Hilton, and Sam Ayers

Although Carole works primarily with her signed clients, she also works with some freelance actors.

Agents
Carole Russo
Client List
45

✉ Andreadis Talent Agency ✉

119 W 57ᵗʰ Street, #711
E of 7ᵗʰ Avenue
New York, NY 10019
212-315-0303

With a father in vaudeville, it's no surprise that Barbara Andreadis joined the family business and became an actress. Like many of us, she left the business when she had children. Her kids are grown now but instead of returning to her acting career, Barbara opted to continue mothering a different group, her family of actors who, of course will always need her.

Barbara trained at The Bonni Kidd Agency, ultimately running that agency for two years before starting her own business in 1983.

Andreadis says she "carries no generic types, only individuals." Her clients include Chance Kelly (*The Departed, Little Children, Generation Kill, Law & Order, The Unit, Burn This*), Jill Nicklaus (*Chicago, Movin' Out, Cats, Fosse*), Greg Butler (*Chicago*), Penny Ayn Maas (*Cabaret, Crazy for You, Damn Yankees*), Karen Lynn Gorney (*Saturday Night Fever, All My Children*), Amanda Gabbard (*Christmas in New York*), Justine Cotsonas (*As the World Turns*), Thomas Ryan (*Hack, Damages, Fort Pit, Tuesdays with Morrie*), Jason Furlani (*Sopranos, Law and Order*), Leif Riddell (*Rescue Me, Oz, One Life to Live*), Tony Devito (*New Amsterdam, One Life to Live*), Mark Manley (*The Boy from Oz, Fiddler on the Roof, Damn Yankees*), Evangelia Kingsley (*Coram Boy*), Renee Bang Allen (*Company, Grand Hotel*), Jim Daly (*Altar Boyz*), Rosalind Brown (*Footloose, One Mo' Time, Law & Order*), Bertrand Buchin (*As The World Turns*), Carolyn Ockert *The Music Man, Annie Get Your Gun*), Billy Hufsey (*Fame*), Lanene Charters (*Mamma Mia*), Catherine Fries Vaughn (*Beauty & the Beast, Cats*), William Mahoney (*One Life to Live*), David White (*The Full Monty*), and Peter Ratray (*Law & Order, Sex and the City, Torch Song Trilogy*).

As you can see from the credits above, Barbara is one of the first people casting directors check for good musical talent. She usually sees people only by referral, but does look at all pictures and resumes.

Agents
Barbara Andreadis
Client List
50

⇗ Ann Steele Agency ⇖

330 W 42nd Street, 18th floor
btwn 8th & 9th, W of Port Authority
New York, NY 10036
212-629-9112

Houston native Ann Steele taught college at Kansas State Teachers College and at a community college in Illinois, was a Girl Scout Executive in Georgia and the Director of the Girl Scouts for the Borough of Queens before showbiz entered her brain via her son's involvement in a program called Acting by Children.

When Ann started raising money for the group, she observed managers checking out kids, picking choice clients and recognized a choice business opportunity. She and a partner started their own business representing young actors like Jason Alexander, Michael E. Knight, Kevin Kilner, Alex Winter, and Christopher Steele.

Ann retired from managing in 1989, reemerging as an agent in 1997 with ASA. She has about 120 signed clients for theatre, film, television and commercials who range in age from twenty-one to seventy plus.

Her eclectic list includes Joe Abraham (*Hairspray*), Peter Kapetan (*Aida*), Orville Mendoza (*Aladdin Live* at California Adventure), Elizabeth Share (*Mamma Mia*), Carole Denise Jones (*Whistle Down the Wind*), Tituss Burgess (*Little Mermaid, Jersey Boys*), Leonard Sullivan (*High School Musical*), Christine Negherbon (*My Fair Lady*), Lainie Munro (*My Fair Lady*), and Gene Jones (*No Country for Old Men*), who is also a featured voice in two Ken Burns' films, *Jack Johnson* and *Horatio's Drive*.

While I was there, a client called and said she was in the neighborhood and would Ann like a nice iced coffee? How can you not love a client like that? And how can you not love an agent who is known in some circles as Ragtime Ann?

Agent
Ann Steele
Client List
120

◢ Ann Wright Representatives ◣

165 W 46ᵗʰ Street, #1105
just E of Broadway, in the Equity Building
New York, NY 10036
212-764-6770

When Ann Wright came to New York after training as an actress at prestigious Boston University, she joined the casting pool at CBS. Like many other actors who have an opportunity to explore other areas of the business, she realized there were other ways to use her creative skills and became the assistant to legendary William Morris agent, Milton Goldman.

Ann cast commercials at an advertising agency and then worked for both Charles Tranum and Bret Adams before opening her own commercial talent agency in 1964.

Still thought of first as a voiceover and commercial talent agency, the legit department continues to thrive with clients working in theatre, film and television.

Her theatrical list includes Billie Allen and Herb Rubens.

Agents
Ann Wright
Clients
20

APA

Agency for the Performing Arts
250 W 57th Street, #1701
New York City, NY 10019
212-657-0092

Founded in the 1960s by expatriates of MCA/ICM, APA is ranked # 10 in agency size with 36 agents working mostly in Los Angeles.

While known more as a hot breeding ground for comics of all kinds and for their music and concert performance base, APA also does a good job with their legit cleints.

Their website *www.apa-agency.com* will give you more detailed information on the agency and their clients, at least in the music and comedy field.

In New York, APA reps theatre talent, music talent, and comedians. Authors, literary talent, composers, hosts, directors, music producers, teens, young adults, and variety artists are repped at their other offices located in Los Angeles, Nashville, Toronto, London and Scandanavia.

Christine Barkley, Fred Hansen, Simon Snow and Christianne Weiss shepherd the theatrical clients while Michael Berkowitz and Avi Gilbert are the cheerleaders for the comics.

Clients include Adam Sandler, Lewis Black, Rita Morena, Clifton Davis, Gail O'Grady, and David Paymer. Endeavor also claims Sandler, so perhaps APA just handles him for stand-up.

Agents
Christine Barkley, Fred Hansen, Simon Snow, Avi Gilbert, Christianne Weiss, and Michael Berkowitz
Clients
Many

✄ Archer King, Ltd. ✄

1650 Broadway, # 407
on 51st Street, btwn 7th & Bdway
New York, NY 10019
212-765-3103

Archer King has been a showbiz fixture forever or at least since he produced *Two Blind Mice* on Broadway with Melvyn Douglas in 1949. At one time or another, I think Archer has either worked with or discovered everyone in the business.

He left producing to agent with the legendary Louis Shurr Agency, repping the big musical stars of the day, as well as Bob Hope. Archer opened his own agency in 1957 and still has files on Jason Robards, James Dean, James Coburn, Martin Sheen, and the three-year-old Ronny Howard, all actors he helped at the beginning of their careers.

From 1963-67, Archer got involved with foreign films importing and distributing such films as Roman Polanski's *Knife in the Water* and Volker Schöndorff's *The Tin Drum*, as well as films from Ingmar Bergman.

While head of theatre for RKO Television, he was responsible for the television productions of *The Gin Game* starring Hume Cronyn and Jessica Tandy, and *Sweeney Todd* starring Angela Lansbury (for which Archer won a Golden Ace Award).

Although some guides list Archer repping actors, comedians, composers, directors, legitimate theatre, lyricists, packaging, producers, screenwriters, and musical theatre, Archer says his main business these days is developing and packaging movies.

He works with a select group of actors, still has a perceptive eye for talent, and is known to give newcomers a helping hand.

Read more about Archer at *www.archerkingltd.com*

Agent
Archer King
Clients
Freelance

⋈ Artists Group East ⋈

1650 Broadway, #711
at 51ˢᵗ Street
New York, NY 10019
212-586-1452

In November of 1996 The Actor's Group (Pat House) and The Artists Group East (Robert Malcolm) merged offices. They could have called themselves The Actors/Artists Group, but decided to just adapt the name that Robert Malcolm adopted when he merged his New York agency (PGA, Inc.) with Artists Group in LA in 1993. In 2007, Robert moved back to New York and closed the LA office. Although his Los Angeles clients were sad, his family and his New York clients are thrilled.

Now Robert and partner Cynthia Katz (Abrams Artists) run the Manhattan office. Clients include Dom Deluise, Jamie Farr, Gary Coleman, Loretta Swit, Nancy Dussault, Tsai Chin, Tony Lo Bianco, Mark Ivanir, Monique Curnen (*Batman*), Tom Hewitt (*The Rocky Horrow Show*), and Judy Kaye (*Mamma Mia*).

Artists Group East looks at all pictures and resumes.

Agents
Cynthia Katz and Robert Malcolm
Client List
65

ᴈ Atlas Talent ᴈ

15 E 32nd Street, 6th fl.
just E of 5th Avenue
New York, NY 10016
212-730-4500

In 2000 Lisa Marber-Rich, Jonn Wasser, John Hossenlopp, and Ian Lesser left Don Buchwald & Associates to create a broadcast agency providing talent for on camera and voice over commercials as well for promotionals, narrations, trailers, books on tape and animation.

Lisa was an Account Manager in advertising at Bates, DMB&B, and Foote Cone Belding, Ian Lesser was in film production at Tribeca Studio, and Jonn Wasser was in marketing at Radio City and worked as a freelance entertainment writer with articles published in Details and other national magazines.

Marilyn McAleer was head of Creative Services at HBO, Lifetime and National Geographic before joining Atlas to head Promos. David Lyerly, Heather Vergo, Nicole Kouveras complete the rest of her team in promos, trailers and documentaries.

Using Integrated Switch Digital Network (SDN), whereby the voice can live in Los Angeles and work in New York via the telephone, has resulted in Atlas' impressive international client list that includes New Yorker Bill Ratner (the voice of Channel 2 in New York and of Channel 7 in Los Angeles), Eartha Kitt, Barry Bostwick, and Rip Torn as well as their list of anonymous celebrity voices that reside all over the world.

For more information about this agency, check out their website at *www.atlastalent.com.*

Agents
Lisa Marber-Rich, Jonn Wasser, John Hossenlopp, Ian Lesser, Marilyn McAleer, David Lyerly, Heather Vergo, and Nicole Kouveras
Client List
120 VO and on camera

⚓ Barry Haft Brown ⚓

Artists Agency
249 E 48th Street, #5J
New York, NY 10019
212-869-9310

Barry Haft Brown is one of the most productive agencies in town. Bob Barry maintained The Barry Agency for 33 years until late 1991, when Bob, whose discerning eye uncovered former clients Gene Hackman, Willem Dafoe, Christopher Walken, Scott Glenn, Maureen Stapleton, and Harvey Kietel, joined colleagues Steven Haft (Ambrosio/Mortimer), and Nanci Brown (The Gersh Agency) to form BHB.

Brown and Haft have moved on, but Bob, now joined by Heather Collis, continues to run the kind of agency that casting directors consult regularly.

One of Bob's actor clients, James Hanlon (*NYPD Blue*) is also a firefighter. Hanlon was in the process of shooting a documentary about rookie firefighters on September 11, 2001. That film became the Emmy and Peabody Award winning film *9/11*.

BHB's clients work in the theatre, films, soaps, and in all areas of television. This agency only works with signed clients.

Please do not visit the agency without an invitation.

Agents
Bob Barry and Heather Collis
Client List
50-60

✠ Bauman, Redanty & Shaul ✠

250 W 57th Street, #2223
at Broadway
New York, NY 10107
212-757-0098

The late Richard Bauman and Wally Hiller created this agency in 1975 and 25 years later (2000), colleagues David Shaul and Mark Redanty became their partners and are now the sole owners. Mark runs the show in New York while David shepherds the Los Angeles clients.

Redanty studied acting/directing at Ithaca College and got a job working as a trainee at Raglyn-Shamsky Agency right out of college. He became an agent while at R-S and then worked for Richard Astor before joining (then) Bauman-Hiller in 1984.

Mark has been running the New York office since 1987, treating the business and clients with the care for which the agency is famous. This comfortable easy style is reflected in Mark's approach to life and to the business.

He and colleagues Charles Bodner (Peter Strain) and Timothy Marshall (who trained at RBA) preside over a list of prestigious clients.

Some from their list include Mark Kudisch (*The Wild Party, Thoroughly Modern Millie*), Donna McKechnie, Glynnis O'Connor, Robert Morse (*Tru*), Sada Thompson, Scott Wise, Dennis Parlato (*Loving*), Justin Deas (*The Guiding Light*), Liz Parkinson (*Movin' Out*), Dennis Christopher (*Breaking Away*), Michael Nouri (*Damages, Victor/Victoria*), and Deirdre Lovejoy (*The Wire*).

Clients are usually referrals who work on a free-lance basis only as a prelude to signing.

Agents
Mark Redanty, Charles Bodner and Timothy Marshall
Client List
80

⚔ Bernard Liebhaber Agency ⚔

352 7th Avenue
btwn 29th & 30th Streets
New York, NY 10001
212-631-7561

Bernard Liebhaber has been in show business in one form or another since before he got out of college.

Originally a dancer, he was a Modern Dance major studying with Martha Graham at Juilliard and was dancing in Broadway shows while still in school.

He worked in wardrobe for ten years after his dancing days were over, then worked as an assistant producer and as a commercial casting director at McCann Ericson.

He was a manager before becoming an agent, working at various agencies including David Drummond. In 1996 Bernard decided it was finally time to open his own agency.

Bernard didn't want to name clients but he did tell me that he has actors working on television series (*Prison Break, The Wire*), on Broadway (*The Color Purple, Avenue Q, The Phantom of the Opera*), and on tour (*My Fair Lady*).

Liebhaber works with no freelance talent and usually finds clients via referral, although he does check out pictures and resumes that come to him.

Agents
Bernard Liebhaber.
Client List
35-40

⩘ bloc ⩗

137 Varick Street
at Spring Street, 6th floor
New York, NY 10013
212 924-6200

Canadian brother and sister Laney and Brendan Filuks moved to Los Angeles with no thought of ever being in the agency business: Laney left home to dance and act; Brendan to work for SONY. But as Laney became the go-to person whenever her agent, Dorothy Day Otis, needed help with the dance clients, she and Brendan hit upon the idea to open an agency with a focus solely on dancers. After all, their Mother had her own dance studio, so they knew about dancers!

They chose the name because bloc means people coming together for a common goal. Today the agency represents actors, singers and choreographers for legit, film, television, and print.

Even though their New York office opened in 2001 shortly after 9/11, bloc NY managed to thrive. Anastasia Miller left bloc LA to run the New York office and heads the talent department for ages five and up for film, legit, television and commercials. She is assisted by Susan Brittle.

Clients from their list include Emily Alpern (*What Just Happened*), Parker Croft (*Were the World Mine*), Dawn Noel (*Normal*), Joe Paparella (*Kiss Me Kate, Hello Dolly*), Jessica Wu (*Paint Your Wagon*), Samantha Jacobs (*Law & Order*), Lisa Ho (*High School Musical*), Oneika Phillips (*West Side Story*), Nicole Gui (*30 Rock*), and Seth Stewart (*Sex & the City*).

Their choreographers include Dan Karaty (*So You Think You Can Dance*), Tanisha Scott (Alicia Keys video), Sho-tyme (*Shoe Carnival* commercial), Rich & Tone Talauega (*Jennifer López*), Tanisha Scott (*Alicia Keys video, Fashion Rocks*), Sho Tyme (*Shoe Time* commercial), and Tyce Diorio (*So You Think You Can Dance* tour). You can find out everything about the agency and who just booked what at their website *www.blocnyc.com*

Agents
Anastasia Miller
Clients
100

✄ Bret Adams ✄

448 W 44th Street
btwn 9th & 10th Avenues
New York, NY 10036
212-765-5630

The late Bret Adams created this agency and ran it with partner Bruce Ostler until January 2003 when he stepped down in favor of Bruce and colleagues Margi Roundtree and Ken Melamed.

Northwestern grad Bruce co-founded the Chicago improv group *Practical Theatre* and then moved it to NY for a successful run. He then sold the tv rights and began a career creating, pitching, producing and writing for theatre, television and films.

Though stimulating and resulting in incredible access, the uncertain life of a freelance producer took a toll. In 1989-90, after a particularly long dry spell, Bruce's wife pointed out that by pitching projects and creating jobs for his friends, he had been honing skills for years. She suggested he take a new career path.

Bruce wasn't convinced, but in 1989 he began interning/assisting Bret Adams to learn the agenting side of the business. He generally hated the whole thing until joining The Fifi Oscard Agency, the first place where he was able to put projects together. At that point Bruce began to really love his new career.

In 1996, after five years at Fifi's, Bret called to offer his old assistant a partnership and a chance to create a new literary department.

Actor clients include Don Stephenson (*The Producers*), Carly Jibson (*Hairspray*), Ron Holgate (*Urinetown*), Noel Harrison, Kier Dullea, Robert Walden, and Matthew Cowles (*Ed*).

This agency sees new clients mainly by referrals but they do check all pictures and resumes. BA also has a respected literary department handling writers, directors, designers, and composers.

Agents
Bruce Ostler, Margi Roundtree and Ken Melamed
Client List
About 100

CAA

Creative Artists Agency
Youth Intelligence Offices
9 W 10th Street
just W of 5th Avenue
New York, NY 10011
212-982-5428

Clearly the most *star* of the star agencies, and #1 in size, Creative Artists Agency has finally opened a New York office. Long resistant to a New York base, CAA began by enticing William Morris theatre heavyweight George Lane onto their team in early 2003, then moved him into offices shared by their newly acquired trendsetting market-research company, Youth Intelligence.

Michael Cardonick, Lane's assistant at William Morris, is now an agent and followed Lane to Gotham's CAA office.

CAA was founded in 1975 by Michael Ovitz, Bill Haber, Rowland Perkins, Ron Meyer, and Michael Rosenfield.

✦ *When these dynamic men left William Morris to start the agency, they ...didn't have any clients. They didn't have any financing. They didn't have any offices. In fact, between the five of them, they only had one car...They couldn't afford to hire a receptionist. So each of their wives filled in one day a week.*
Charles Schreger, *Los Angeles Time*[20]

Though the founding fathers are gone, president Richard Lovett, co-chairs Lee Gabler, Rick Nicita, and senior vice-president Michael Rosenfeld have managed to keep the agency's status in tact, although William Morris, UTA and ICM are nipping ferociously at their heels.

Variety editor Peter Bart recently wrote a love letter to CAA.

✦ *Clients of the agency gladly volunteer their analyses of the CAA work ethic. You feel the whole place is behind you, says one director who asked not to be quoted. You don't feel you're represented by a lone agent, while the guy in the next office is trying to get your job for someone else.*
Peter Bart, *Variety*[21]

While CAA guards client information carefully, the September 14, 2007 issue of *Variety* features an ad from CAA congratulating their

Emmy nominees/winners: Tony Shalhoub, Alec Baldwin, Hugh Laurie, James Gandolfini, Salma Hayek, Jeremy Piven, Jon Avnet, Jim Broadbent, William H. Macy, Matthew Perry, Felicity Huffman, Julia Louis-Dreyfuss, Sally Field, Minnie Driver, Ian McKellen, Stanley Tucci, Giovanni Ribisi, Beau Bridges, Marcia Gay Harden, David Letterman, Tony Bennett, Helen Mirren, Lorne Michaels, Bill Maher, Katie Couric, and Justin Timberlake. Others not represented in that ad include Julia Roberts, Hilary Swank, Gwyneth Paltrow, Helen Hunt, Renee Zellweger, Sandra Bullock, Cameron Diaz, Nicole Kidman, Julianne Moore, Kate Hudson, Sandra Bullock, Tom Hanks, Bonnie Hunt, Arnold Schwarzenegger, Gary Sinise, Robert Redford, Al Pacino, Robert Downey, Jr., Michael J. Fox, Robert Redford, Paul Newman, Tom Cruise, Gene Hackman, Kim Basinger, Barbra Streisand, Chevy Chase, Robert De Niro, Glenn Close, Madonna, Meryl Streep, Oliver Stone, Whoopi Goldberg, Michael Douglas, Sylvester Stallone, Demi Moore, and many, many others.

Ever on the cutting edge, CAA has a large new media department with eight agents dedicated to the Internet and technology clients.

By and large, lists of agents at the big agencies are guarded like Fort Knox, so other than the partners and the tech agents, my agent listings are tentative and based on the trades.

Agents
George Lane and Michael Cardonick
Clients
Many many stars

⋈ Carry Company ⋈

20 W 20th Street, 2th floor
just W of 5th Avenue
New York, NY 10011
212-768-2793

I don't know how I got so mixed up about Sharon Carry but it seems that for years I've been handing out misinformation about her. She was never an actress. She was working at a famous sport establishment in 1990 when she got the idea to send out her well known patrons on the commercial auditions she read about in the trades.

She grew that business to include actors and athletes across the board, and now has clients working on *24, Law & Order, Criminal Intent, NCIS, The Unit, Without a Trace, Monk, Nip/Tuck, CSI, Dirty Sexy Money,* and most of the top nighttime shows. Her clients also work on Broadway and in film.

Carry has so many clients working in Los Angeles that in 2005 she opened a west coast office. She divides her time between the coasts and says she has a terrific assistant in each office.

For more information on Carry and her Company, check out her webpage at *www.carrycompany.com/home.htm*

Sharon concentrates on her signed clients, but also works on a freelance basis. She has a pool of about fifty kids and fifty adults. Don't postcard this agency unless you have something real to say. "Hello, how are you?" doesn't count. They prefer flyers when you are doing something. Sharon says she takes flyers and work very seriously.

Agents
Sharon Carry
Client List
100

◁ The Carson Organization ▷

aka Carson/Kolker
419 Park Avenue South #606
btwn 28th & 29th Streets
New York, NY 10016
212-221-1517

In 1992 Steve Carson and wife Maria Burton-Carson created The Carson Organization (not to be confused with Carson-Adler).

In 2004 Steve retired, passing the reins to colleague-now-owner, Barry Kolker (Henderson Hogan, Fifi Oscard).

This agency is a good choice for actors under age thirty looking for a home. C/K provides the sort of opportunities and nurturing environment that has resulted in an amazing track record for developing clients. Clients include Kristen Alderson (*Starr Manning, One Life to Live*), Desiree Casado (*Sesame Street*), Ilene Kristen (*One Life to Live*), Eddie Alderson (*One Life to Live, Reservation Road*), and Ed Fry. They also have clients performing on Broadway and on tour in *Spring Awakening, Mary Poppins, Wicked, Whistle down the Wind, The Drowsy Chaperone, Grease, How the Grinch Stole Christmas,* etc.

This agency handles children and babies, including infants and twins. Barry says they look at all pictures and resumes and have found some clients on his list from the mail. The legit department does not freelance at all, while the print and commercial dept will freelance with the intent of signing.

The print and commercial department is called About Face and is run by Jenevieve Brewer.

Agents
Barry Kolker
Clients
150 signed clients

✒ Carson-Adler Agency, Inc. ✒

250 W 57th Street, #2030
at Broadway
New York, NY 10107
212-307-1882

One of the most respected children's agencies in New York is run by former showbiz mom Nancy Carson. Being a stage mother showed her a side of the business most agents never experience and inspired her to start an agency where children would be protected.

She trained at prestigious children's agency Jan J. before joining with the late Marion Adler to form C-A in 1982.

Shirley Faison's background in management at the National Black Theatre, plus her experience as the mother of successful child actors make her the perfect advocate to join Nancy in repping their impressive list of child actors.

Their roster includes Julianna Rose Mauriello (*Lazy Town*), Remy Zaken (*Spring Awakening*), Dennis White (*The Brave One*), Betsy Hogg (*Rocket Science*), Maddie Taylor (*The Girl Next Door*), Jamie Nash (*Rush*), Andrew Keenan (*Spelling Bee*), Zack Page (*Rush, The Ten*), Allie Gorenc (*As the World Turns*), Jeanette Bayardelle (*The Color Purple*), Matthew Gumley (*Mary Poppins*), Henry Hodges (*Mary Poppins*), Nicole Bocchi (*Mary Poppins*), Ruby Crawford (*The Color Purple*), Zack Rand (*Les Miz*), Brian D'Addario (*Les Miz*), Kylie Goldstein (*Les Miz*), Matt Wilson (*For Real*), Beth Johnson (*Spamalot*), Donald Faison (*Scrubs*), Frankie J. Grande (*Mamma Mia*), Renee Marino (*High School Musical*), and Olamide Faison (*Sesame Street*).

The agency has seventy-five signed clients for theatre, film, and television. For parents seeking to learn the ins and outs of the business, Nancy's new book *Raising a Star* will answer all your questions. For submission policies, check their website *www.carsonadler.com*

Agents
Nancy Carson and Shirley Faison
Client List
60

◄ CornerStone Talent Agency ►
37 W 20th Street, #1108
just W of 6th Avenue
New York, NY 10011
212-807-8344

Even though he majored in history and planned to become a lawyer, Steve Stone trained to be a general manager upon graduation from college in 1991. He worked two jobs at the same time: full time at Niko Associates as a general manager, plus head of concessions for eight shows a week at Tony Randall's National Actor's Theatre.

In 1993 he met Bob Duva (The Gersh Agency, Duva-Flack) and worked as his assistant at The Gersh Agency. When Bob left Gersh and ran his business out of the office of his friend, the legendary agent Robby Lantz, Steve went along. Robby then became Steve's mentor and role model.

When Duva teamed up with Elin Flack (Duva-Flack), Steve made the move as an assistant, but moved quickly from assistant to sub-agent to being franchised in 1994. In September 1997 he created CornerStone Talent.

Colleague Mark Schlegel was planning to be a banker when he landed a job as a gofer for Mitch Leigh. He worked on *The King and I* as part of his studies as a communications major at Indiana's DePauw University. That taste of showbiz torpedoed his banking career. Who could choose banking over show business?

His background somewhat mirrors Steve's, as both began working for producers and worked with/for Robbie Lantz. Afterwards Mark worked with Bruce Savan at APA, and even returned to banking before Meg Mortimer and Louis Ambrosio (Ambrosio Mortimer) lured him back into show business.

Mark left A/M, joined J. Michael Bloom for ten years until Michael sold the business, then Mark joined APA. A month after APA closed its NYC offices in February 2002, Mark joined Steve at CornerStone.

Their list of impressive clients includes Sara Ramirez (*Spamalot, Grey's Anatomy*), Jefferson Mays (*I Am My Own Wife*), LaChanze (*The Color Purple*), Michael Badalucco (*The Practice*), Molly Ringwald (*Sweet Charity*), Carole Shelley (*Wicked*), Lois Smith (*The Trip to Bountiful*), Lillias White (*The Life, Pieces of April*), Amy Spangler (*The Wedding Singer*), Terrence Mann (*Cats, Les Mis, Lennon*), Cara Buono (*The Ghost Prison*),

Phylicia Rashad (*A Raisin in the Sun*), Dominic Chianese (*The Sopranos*), Anna Belknap (*CSI: New York*), David Harbour (*Revolutionary Road, Who's Afraid of Virginia Woolf?*), and Annaleigh Ashford (*Wicked, Legally Blonde*).

Shannon Kelly is Steve and Mark's associate. All three handle actors, comedians, and seniors for film, soaps, theatre and television. Clients come to CornerStone mostly by referral and at this point, their list is full unless they see anothr talented actor they absolutely cannot resist.

Agents
Steve Stone, Mark Schlegel, and Shannon Kelly
Client List
75

⊠ DDO Artists Agency ⊠

Dorothy Day Otis
81 Franklin Street, 5th floor
btwn Church & Broadway
New York, NY 10013
212-379-6314

DDO has its roots back to 1969 in Los Angeles when Dorothy Day Otis created a top children's agency representing the kids from many hit shows including both *The Brady Bunch* and *Different Strokes*. Today not only has DDO blossomed into a full service agency repping artists in every medium with offices in New York, Las Vegas, Nashville and Miami.

Bill Bohl and Abby Girvin worked for DDO in Los Angeles for years before purchasing the agency in 1995. Marlene Sutton (Sutton Barth Vennari) became their partner in 1996. At that point Bill created one of the first Dance Divisions in LA, while Marlene joined with another commercial powerhouse, Maria Walker, to build the successful commercial division.

In 2007 Maria and her colleague, kid's agent Remy Crane, became partners and moved to New York to run the New York division.

UCLA grad Walker says her one year of law school and her work in film production are great agent assets. She heads the commercial department. Remy's degree in theatre is from NYU, so moving to NY was a homecoming. She heads up the kids division. They hired dance powerhouse Thomas Scott (Clear Talent) to head the dance division. Armed with his degree in musical theatre from the Cincinatti Conservatory of Music, Thomas moved from Chicago to perform at the Paper Mill Playhouse in 1992. He then toured, did regional theatre, and performed at City Center before choreographing and dancing on cruise ships. Tired of living out of a suitcase, he moved back to New York and cast for a while before becoming an agent. Thomas has made DDO the go to place for professional commercial and theatre dancers in New York.

Corey Smith's agency training took place at KSA in Los Angeles. He moved to New York to open this office in 2003 and heads the film and television department.

Clients include Hettie Barnhill (*Fashion Rocks*), Adrienne Fisher (*White Christmas*), Kyra Johanessen (*Captain Morgan's*), Joe Buffa (*Regis*

& Kelly), Anna Kaiser (*Regis & Kelly*), Candace Simpson (*Regis & Kelly*), Emily Alpren (*What Just Happened*), Erynn Dickerson (*The Old Dogs*), Michaela Spague, and Megan Kain (*The Step Up To*).

DDO opens all mail and is constantly looking to fill in gaps. *www.ddoagency.com* for more information.

Agents

Maria Walker, Remy Crane, Thomas Scott, and Corey Smith

Clients

many many

◢ DGRW ◣

Douglas, Gorman, Rothacker & Wilhelm, Inc.
1501 Broadway, #703
btwn 43rd & 44th Streets
New York, NY 10036
212-382-2000

There have been many changes since Flo Rothacker (Ann Wright), Jim Wilhelm (Lionel Larner, Eric Ross, The Barry Douglas Agency), Barry Douglas (ICM), and Fred Gorman (Bret Adams) created this effective, congenial agency in 1988.

Barry and Fred died in 1996 and Flo's life took her to Tennessee in 2006, so Jim is now the sole remaining partner. Not to worry though: Jim says he now has three right hands. Well, actually four, if you count his own, but more about Josh, Nicole and Joel later.

Jim has worn many showbiz hats since he began as a fifteen-year-old actor. He has been a stage manager, public relations director, general manager, and a casting director before he finally became an agent in 1981.

He has a stellar reputation in New York working with diverse and well-respected actors especially in concerts, on network television and in major features. In addition to all his other activities, Jim finds time to to teach master classes at the University of Cincinnati/College Conservatory of Music and has taken on an adjunct position at NYU teaching the Business of Show Business for the young actor.

Josh Pultz moved to the Big Apple from upstate New York in 1998 to major in Psychology, but couldn't resist the lure of the business and found himself interning at DGRW within a week.

Later, thinking he wanted to be a general manager, he left to work with producer Cameron Macintosh and general manager, Alan Wasser, but missing DGRW, he returned to become not only a franchised agent, but a major part of the agency.

Nicole Wichinsky's BS in Communications/Film Business and her BA in Theatre Arts from the University of Miami were great assets when she was still an actress. Now her clients benefit from her combination of artistic and business smarts. Both Nicole and Joel Carton joined DGRW as interns in 2005 and have become agents here. Joel's BFA from Webster University has served him well in a variety of show biz jobs. His history includes his 14 years as a working actor, a

stint as a casting director, a brief run at The Luedtke Agency, and a job at Equity working as a business rep.

Names from the hundred or so actors on DGRW's list include Daniel Dae Kim (*Lost*), Kathleen Chalfant (*Wit*), Reginald Vel Johnson (*Family Matters*), Douglas Sills (*The Scarlet Pimpernel*), Patrick Page (*Lion King, How the Grinch Stole Christmas*), Sierra Bogges (*Little Mermaid*), Lynn Cohen (*Munich, Sex & the City*), Harry Groener (*Crazy for You, Spamalot*) Ron Raines (*Guiding Light*), John Rubenstein (Wicked), Olivia De Havilland, Sandy Duncan, John Davidson, Maureen McGovern, Alice Ripley, Catherine Hickland, Scott Holmes, Lea Salonga, Debby Boone and others.

DGRW also represents writers, directors, fight directors, choreographers, and musical directors. Clients of this office who travel west to work are introduced to several agencies with whom the office has relationships. That way the actor and the agent have a chance to make the most compatible relationship.

DGRW sees new clients through referral only, although they do carefully study pictures and resumes. They are not interested in tapes produced for audition purposes only. While this is an agency of established actors, DGRW also prides itself on its development of new talent.

Agents
Jim Wilhelm, Joel Carlton, Josh Pultz, and Nicole Wichinsky
Client List
100

⚞ Don Buchwald & Associates ⚟

10 E 44th Street
just E of 5th Avenue
New York, NY 10017
212-867-1070

Ex-actor/producer Don Buchwald got his first job agenting with Monty Silver in 1964. He ran his own agency (Don Buchwald) before joining the prestigious commercial agency Abrams-Rubaloff in 1971. When A-R split, Don founded this prestigious NY office. A brilliant negotiator and a shrewd agent, Buchwald has built an impressive list of clients and agents headed by Vice-President of Corporate Affairs, attorney Richard Basch.

Ricki Olshan heads the strong list of agents comprising the theatrical department: Rachel Sheedy, Allan Willig, Joanne Nici, David Lewis, and John Mason

Victoria Kreiss and Hannah Roth handle the Youth Division

Clients from their list include Rosemary Harris (*Spiderman*), Novella Nelson (*Stephanie Delany, The Starter Wife*), Carlo Alban (*Prision Break*), Sasha Allen (*Stick It in Detroit*), Blance Baker (*Sixteen Candles*), Melissa Archer (*One Life to Life*), Fabian Basabe (*Filthy Rich*), Betsy Beutler (*The Black Donnellys*), Baily Chase (*Saving Grace*), Hailey Mills (*The Parent Trap*), and Matt Walton (*All My Children*).

Agents

Don Buchwald, Ricki Olshan, Joanne Nici, Rachel Sheedy, Allan Willig, Hannah Roth, and Victoria Kreiss

Client List

100-150

✒ Dorothy Palmer Talent Agency, Inc. ✑

235 W 56ᵗʰ Street, #24K
btwn 7ᵗʰ & 8ᵗʰ Avenues
New York, NY, 10019
212-765-4280

Dorothy Palmer Talent Agency has 14,000 names in its talent computer and 450 pictures in her annual *Palmer People Book*. Dorothy has about a dozen signed clients.

One would think with all these faces and resumes that the proprietor here would be either out of her mind or totally unapproachable. Neither is true. Dorothy seems to be pretty calm and together about things and she's also friendly.

She trained with Sol Hurok Enterprises and worked with National Concert and Artists Corporation before starting her own agency in 1974.

Dorothy's list includes entertainers, actors, writers, producers, broadcasters, comedians, dancers, singers, models, television hosts and hostesses, and senior citizens, many of whom are hyphenates like actress-impersonator Holly Farris, actor-broadcaster Mike Morris, actor-writer Anthony King, actor-producer Robert Capelli, J. J. Reep, Captain Lou Albano (*The Cannibals*), Michael Sawsett, Michael Caruso, Matthew Lavin, and Michele Muchler.

Dorothy enlarged the agency recently, adding a literary franchise which will possibly benefit her actor clients as well as her screenwriters.

Since Dorothy is seriously committed to the plight of independent filmmakers, she is also always looking for investors and has packaged several independent films.

Agents
Dorothy Palmer
Client List
A dozen plus freelance

◄ Endeavor ►

Carnegie Hall Tower
152 W 57th Street 25th Floor
btwn 6th & 7th Avenues
New York, NY 10036
212-625-2500

The writer-director oriented powerhouse known as Endeavor joined the Los Angeles agency scene in 1995 when key ICM agents David Greenblatt, Tom Strickler, Rick Rosen, and Ariel Emanuel defected and set up business on their own. Since that time the agency has grown to be the fifth largest agency in the business with 75 agents at last count,

Their affiliation with Nashville country music agency Buddy Lee Attractions added a huge list of hot musical clients to their list and a New York office.

Endeavor continues to acquire star actors, writers, directors, comedians, below-the-line talent, and agents to add to their growing riches. Newest partner Patrick Whitesell was co-head of the motion picture talent department at CAA before he defected, bringing along clients Drew Barrymore, Ben Affleck, and Matt Damon.

Children's agent Iris Burton recently formalized a co-representation arrangement for her young agents, opting to share her take in exchange for exposing her young clients to Endeavor's TV packaging deals.

Just to give you a taste of their glittering actors, the list below is only the actors who were Emmy nominees/winners on Endeavors list in 2007: Tina Fey, Jenna Fischer, Ricky Gervais, David Morse, Samantha Morton, Steve Carrell, Toni Collette, America Ferrera, Terry O'Quinn, and Charlie Sheen.

Their list of writers, producers and executive producers is just as impressive. Robert Weitz, Bonnie Bernstein, and Eric Bevans rep the Manhattan legit clients, and Conan Smith reps comics and personal appearances.

Agents
Robert Weitz, Bonnie Bernstein, Eric Bevans, and Conan Smith.
Client List
Large

⚔ FBI ⚔

Frontier Booking International, Inc.
1560 Broadway, #1110
at 46th Street
New York, NY 10036
212-221-0220

When Ian Copeland created FBI in 1979, they were known as one of the largest rock agencies around, ultimately repping Sting, Snoop Doggy Dog, Modern English, and Jane's Addiction, not to mention their very first client, Courtney Cox.

Since 1984, when the theatrical department was born, it has become the dominant presence. FBI reps everyone from Broadway (*Grey Gardens, Rent, etc.*) to the latest hunk carpenter on *Trading Spaces*.

John Shea (SEM&M and Kronick, Kelly & Lauren) heads up the theatrical department representing a hot list of young actors. Clients from that list include Alicia Minshew (*All My Children*), Darien Sills Evans (*On the One, Cosby*), Jacqueline Torres (*FX, Hack*), Sean Nelson (*Fresh, American Buffalo, The Corner*), Jessica Brooks Grant (*What Dreams May Come*), Thad Mills (*Trading Spaces*), Maria Lark (*Medium*), Shelley Hennig (*Days of our Lives*), Justin Johnston (*Rent*), Sarah Hyland (*Grey Gardens, Lipstick Jungle*), Barry Wood (*Hidden Potential*), Carey Evans (*Don't Sweat It*), and Steven Lee Merkel (*Escape from Experiment Island*).

Helping John run herd on this talented bunch are Heather Finn (Abrams Artists) and former children's manager, Marion Falk.

FBI handles all types for all areas. They work with an extensive freelance list in addition to their signed clients. Check out their website: *www.frontierbooking.com/home.htm*

Agents
John Shea, Heather Finn, and Marion Falk
Client List
60 plus freelance

✍ Fifi Oscard Agency, Inc. ✍

110 W 40th Street, #2100
btwn 6th Avenue & Broadway
New York, NY 10018
212-764-1100

The legendary Fifi Oscard died in 2006. A frustrated housewife and mother in 1949 when she began working gratis for Lee Harris Draper, she told me she was inept when she started her job, but quickly became proficient and worked herself up to $15 a week within nine months.

From LHD Fifi moved to The Lucille Phillips Agency, working three days a week. That inauspicious beginning led to Fifi's purchase of LPA in 1959 and the birth of The Fifi Oscard Agency, Inc.

The agency is now in the hands of managing partner, lit agent Peter Sawyer, and theatrical agent and vice-president, Carmen LaVia. When Carmen came to New York from Las Vegas (with wife Arlene Fontana) looking for a job in the business, he began at an amazing level, lucking into a job as an assistant to legendary producer, Leland Hayward.

When Leland became ill, the office cut back and Carmen joined Fifi. Three years later he joined the William Morris Agency, where he stayed for ten years before coming back home to Fifi.

Carmen is joined by Francis Del Duca repping the theatrical clients, while Kevin McShane heads their important voice over and commercial department.

FOA has become an important literary agency representing William Shatner, Art Buchwald, William Claxton, and the like. They rep writers, directors, producers, singers, composers, and actors. In short, they deal with every aspect of showbiz except the variety field.

Check *www.fifioscard.com* for up-to-date lists of agents and submission guidelines.

Agents
Carmen La Via, Peter Sawyer, Francis del Duca, and Kevin McShane
Client List
Large

⚔ The Gage Group ⚔

450 7th Avenue, # 1809
across from Macy's at 34th Street
New York, NY 10036
212-541-5250

The dynamic duo that run the New York office, Phil Adelman and Steve Unger, are not only best friends, but their backgrounds and personalities are synergistic. A theatre major, Steve taught high school after graduation and was pondering what interesting direction his background might take him. When he found The Gage Group, he knew he was home. Phil was an elementary school teacher, quiz show writer, director, screenwriter, director of musicals, and a composer and lyricist. How much better suited could they be?

A successful actor himself, founder Martin Gage worked for Fifi Oscard before opening this agency in 1970. Dynamic, charismatic Martin is headquarted in Los Angeles, but spends enough time in NY that he knows all the clients.

Names from the the GG list include Jessica Molaskey (*Sundays in the Park with George*), Gary Beach (*The Producers*), Paige Davis (*Chicago, Trading Spaces, Sweet Charity*), Jim O'Connor (*The Food Network*), Hunter Foster (*The Producers, Frankenstein*), Paul Benedict, Walter Charles, Dee Hoty, Gavin MacLeod, Debra Monk, John Cunningham, Marcia Lewis, Walter Bobbie, Liz Callaway, Nancy Ringham, Ernie Sabella, Shirley Knight, Harriet Harris, Tovah Feldshuh, Phyllis Newman, Leslie Uggams, Beth Fowler, Chuck Wagner, Sutton Foster, Becky Ann Baker, and B.J. Crosby.

Wendie Relkin Adelman heads the commercial/host department.

Agents
Phil Adelman, Steve Unger, and Martin Gage
Client List
65

⋈ Garber Talent Agency ⋈

2 Pennsylvania Plaza, #1910
7th Avenue btwn 32nd & 33rd Streets
New York, NY 10121
212-292-4910

Karen Garber was in school studying theatre and communications when she got a job as a receptionist with the now defunct Joel Pitts Agency. She left Joel two years later to become an agent with Honey Sanders, where she worked for sixteen years.

In 1995 Karen quit her job with Honey and accepted a job offer in another field. Before even starting the job she missed agenting so much that she changed her plans and set about opening her own agency.

Well-connected in the casting community, Karen hit the ground running and is able to say that of her forty-six clients, at least 90% are currently employed. Not only that, they are loyal: John Mineo (*Chicago*) and Maureen Sadusk have been with her for thirty years!

Karen also sports a strong list of dancers and choreographers. This office works with signed clients theatrically, but does freelance for industrials and commercials. Although Karen does look at pictures and resumes looking for bright new additions to her list, you will need a strong resume to get a call from her.

Jacqueline Knapp, Kurt Ziskie, Elena Ferrante (international company of *West Side Story*), and Birdie Hale (*Blind Faith*) are a few of Karen's other clients.

Agents
Karen Garber
Client List
46

❧ The Gersh Agency New York ❧

41 Madison Ave.
at 26th Street
New York, NY 10010
212-997-1818

GANY was formed when Scott Yoselow, David Guc, Ellen Curren, and Mary Meagher left Don Buchwald & Associates to open a New York office for the legendary Los Angeles agent, Phil Gersh.

Yoselow, the sole remaining partner, heads the literary department. Colleagues who represent GANY's illustrious list of actors are ex-casting executive Lindsay Porter, William Butler (WMA), Stephen Hirsh (Paradigm), Jennifer Konawall, Sally Ware, Rhonda Price, Randi Goldstein, and Kyetay Beckner.

This agency prefers well-trained actors and is meticulous about monitoring new talent by attending showcases and readings. If you don't have a referral, concentrate on doing remarkable work in a showcase and ask them to come and see it.

The client list shared by The Gersh Agency on both coasts is outstanding. Their impressive client list includes: Catherine Keener, Jeffrey Demunn, Mary Kay Place, Mena Suvari, Tobey Maguire, Kelli Martin, Gloria Reuben, David Schwimmer, Jane Krakowski, Roma Downey, Victor Garber, Dan Hedaya, Christopher Lloyd, Robert Prosky, and Kyle Secor.

The Gersh Agency New York continues the top level representation Phil Gersh pioneered for actors, writers, directors, authors, and below-the-line clients.

Agents
Lindsay Porter, William Butler, Stephen Hirsh, Jennifer Konawall, Sally Ware, Rhonda Price, Randi Goldstein, and Kyetay Beckner
Client List
large

≈ Gilla Roos, Ltd. ≈

16 W 22nd Street, 3rd floor
just W of 5th Avenue
New York, NY 10010
212-727-7820

Gilla Roos gives hope to all those women over forty hoping for a career in the business. She was forty when she decided to become an actress/model and ended up with her face plastered all over Grand Central as the Kodak mom.

Her agent, Cy Perkins, persuaded Gilla that she had the people and business skills to become a first-class agent and proceeded to train her. Gilla also worked with legendary commercial agent Ann Wright before she opened her own agency in 1974.

Her son David, who now runs the business, was a chef when his mother first conscripted him to work with her. He kept going back to cooking, but his mom ultimately prevailed. Now, David says, his wife is a better cook than he is.

GR was already a commercial force when they lured Marvin Josephson (APA, Gage Group) away from Hartig-Josephson in 1984 to create what has become a very well-regarded legit department.

Marvin entered the business as an office boy for the great literary agent Audrey Wood where, in addition to reading scripts and running the switchboard, he was able to observe the careers of such literary stars as Tennessee Williams, William Inge, Carson McCullers, and Robert Anderson.

Clients on Marvin's list include Samuel E. Wright (*The Lion King*), Mamie Duncan Gibbs (*Chicago*), Harry Goz (*Fiddler on the Roof*), Diana Pappas (*The Full Monty*), Vince Trani (*Kiss Me Kate, Phantom of the Opera*), Michael Hayward-Jones (*Les Miz*), Sara Pramstaller (*Saturday Night Fever*), Carol Lynley, Polly Adams, David Carradine, and Chuck Stransky.

Agent
Marvin Josephson
Clients
35

⚐ Ginger Dicce Talent Agency ⚑

56 W 45th Street, #1100
just W of 5th Avenue
New York, NY 10036
212-869-9650

Ginger Dicce has a long memory. When I walked into her office she reminded me that early in our careers, when she was a producer at Wells Rich Green, she had cast me in a Tender Vittles commercial.

Though I had a tough time getting her on the phone in the first place, Ms. Dicce couldn't have been nicer when we met. Even though she was very busy that day, she still made time to tell me about her business.

One of the few agents in town who still works exclusively freelance, Dicce says she still gives newcomers a chance and looks at every piece of mail that enters her office.

Starting as a secretary at Wells Rich Green, Ginger moved into production via her smarts and helpful mentors. Once she was producing and casting, she says she fell in love with actors and decided to become an agent.

She started her agency in 1986 and has been busily repping union and non-union actors ever since.

When I asked Ginger what attracted her to an actor she said it was an "inner gut thing," so your guess is as good as mine. Since Ginger suffers no fools, I wouldn't call her unless you are focused, business oriented, and have some idea how you can be marketed.

Agent
Ginger Dicce
Clients
Freelance

◢ Hanns Wolters International ◣

211 E 43rd Street, #505
btwn 2nd & 3rd Avenues
New York, NY 10017
212-714-0100

German talent agent Hanns Wolters finally made it to the US in 1962, after a detour via Israel during WWII, some twenty-five years after his first attempt to escape extermination by Hitler.

Initially specializing in European talent, Hanns soon added a mix of talent. By the seventies HWI was a magnet for commercials.

When his wife, actress Marianne Wolters (Mitzi Bera-Monna), died in the 1990s, one of his German actors, Oliver Mahrdt, became Hanns' unofficial son, helping him not only recover from Marianne's death, but also refocus his business. Oliver, who now owns HWI, ultimately supported Hanns through his own lengthy fatal illness.

The agency is currently experiencing a rebirth of sorts, seeing more actors on Broadway and some of their literary talent represented at Sundance and other film fests.

HWI is still one of the places casting directors call for European actors and is also known for its strong New York character types. Every week you'll see HWI clients on episodic television shot in New York.

Although HWI works with about 300 clients, they say there is a core group of thirty that gets most of the calls. These actors are not only talented but also network and help keep the calls coming in.

This agency doesn't sign contracts with its clients, preferring to work on a handshake basis. One of the "handshakes" belongs to Karen Lynn Gorney from *Saturday Night Fever*.

They also represent German cinema on the East Coast. Amongst HWI's illustrious projects was last year's Academy Award winning Best Foreign Language Film, *Nowhere in Africa*.

Agents
Oliver Mahrdt
Clients
Freelance/union plus non-union

✎ Harden-Curtis Associates ✎

850 7th Avenue, #903
btwn 55th & 56th Streets
New York, NY 10019
212-977-8502

In 1996, after fifteen years at Bret Adams, Ltd., Mary Harden and Nancy Curtis left to open their own agency.

Though Nancy studied acting as a child, her parents felt she should pursue a real job with her MA in advertising from Michigan State University, so her first jobs were at Leo Burnett in Chicago and Ted Bates in New York. When a colleague suggested that Nancy was more addicted to reading plays than *Advertising Age*, she joined Adams, where her acting/marketing background propelled her quickly from assistant to colleague.

Mary's early career was spent problem solving with writers and actors in a variety of jobs at various regional theatres, giving her the perfect background to work with both at HCA.

In addition to Mary and Nancy, HCA clients have three other champions: Diane Riley, who worked in casting at The Roundabout Theatre Company and assisted company management at the Goodspeed Opera House, and ex-actor Michael Kirsten whose theatre degree is from Northwestern. Both have been at HCA since 1997. Recent addition Scott Edwards is a graduate of the Theatrical Design Department of Texas State University.

The fab five represent 150 signed clients including Kathryn Hays (*As the World Turns*), Andrea Anders, (*The Class, Spellbound*), Peter Hermann (*Cashmere Mafia*), Sharon Wilkins (*Maid in Manhattan, Two Weeks Notice*), Bruce Norris (*Sixth Sense, School of Rock*), Kate Shindle (*Stepford Wives, Legally Blonde*), Maggie Siff (*Mad Men)*, Nancy Opel (*Urinetown*), Boris McGiver (*The Wire, Dark Matter*), Alysia Reiner (*Sideways*), and David Alan Basche (*War of the Worlds, Lipstick Jungle*).

Agents
Nancy Curtis, Mary Harden, Diane Riley, Michael Kirsten, and Scott Edwards
Client List
150

⚓ Hartig Hilepo Agency, Ltd. ⚓

54 W 21st Street, #610
just W of 5th Avenue
New York, NY 10010
212-929-1772

The late Michael Hartig established this agency in the early 60s running it for forty years until his death in 2004. Paul Hilepo was a student at NYU when he was first exposed to the agency business as an intern at Don Buchwald Associates.

When he graduated in 1992, he sent out resumes to various talent agencies and says he and Michael clicked. By 1994 Paul was a franchised agent and today he is the new owner.

Helping Paul rep their 100 clients are Ohio-native Nancy Clarkin and Floridian Liz Rosier.

Nancy first came to Hartig as an assistant. She moved on to Harden Curtis before returning to Hartig in 2004 as a franchised agent.

Liz came to HH in 2006 with a big background in theatre management with both ART and Trinity Rep.

HH has a wonderful list of clients that include Ken Leung (*Lost*) and long time client, Jerry Stiller (*Heartbreak Kid, King of Queens,* etc.)

Paul says he does look carefully at every picture and resume that comes in. "We can't afford to leave any stone unturned. We find clients in many ways, we check out plays, television shows shooting here, and referrals from people we respect." He says he has found clients from blind submissions.

Agents
Paul Hilepo, Nancy Clarkin, and Liz Rosier
Clients
100

◄ Henderson-Hogan Agency, Inc. ►

850 7th Avenue, #1003
btwn 56th & 57th Streets
New York, NY 10019
212-765-5190

The late Maggie Henderson formed her first agency with Joan Scott in 1967. Scott soon left to create Writers & Artists while Maggie established The Henderson Agency.

An actor who decided against the instability of the actor's life, Hogan worked as private secretary to actress Margaret Leighton before his first job in the agency business at Dudley, Field & Malone Agency. He was a commercial agent at New York's United Talent before joining Maggie. A year later, Jerry became her partner and Henderson-Hogan was born.

HH became bicoastal in 1974 when Maggie moved west and handed over the New York office to partner Hogan. Maggie died in 1996, and though HH/Los Angeles ceased to exist in 1999, George Lutsch reopened that office in 2005.

David Cash (CESD), Alex Butler (who trained at HH), and Pete Kaiser (The Gage Group) join Jerry representing clients like Dakin Matthews (*The Fighting Temptations*), Christopher Fitzgerald (*Wicked*), Peggy Pope (*Law & Order, Ed*), Earl Hyman (*Euripides*), Peter Jay Fernandez (*Cyrano*), Ron Orbach (*Chicago*), and Terri Garber (*As the World Turns*).

Although HH prefers to work with signed clients, they do occasionally freelance with former clients and/or old friends.

Agents
Jerry Hogan, David Cash, Alex Butler and Pete Kaiser
Client List
60 plus

ICM

International Creative Management
40 W 57th Street
just W of 5th Avenue
New York, NY 10019
212-556-5600

Just like actors, talent agencies have good years and bad years. ICM's stars (both astrological and theatrical) are currently in flux. As discussed in Chapter Nine, ICM's new leader Chris Silberman is more powerful in television than film. There are those who say television is the new film, so perhaps that's not a bad thing.

Chosen by ICM Chairman Jeff Berg in 2006, Silberman is focused on restructuring the agency and building for the future. Berg has led the agency since 1985 and though he denies it, many believe he is preparing the agency for his departure. In 2005 he sold controlling interest in the agency to a private equity group led by Suhail Rizvi and Merrill Lynch, which together own more than 70% of ICM.

Silberman's corporate culture cleanup has resulted in the public sacking of two huge industry ikons. Important television agent and co-president Nancy Josephson, whose father was one of the co-founders of ICM, was fired over the phone while she was recovering from surgery. Josephson is now Endeavor's prize. Talent agent ikon and co-president Ed Limato was first stripped of his title and then fired via e-mail.

✦ *Limato was long the face of ICM's film department, a dealmaker as storied as Swifty Lazar, Stan Kamen, Freddy Fields and Ted Ashley, known for his effectiveness and skills at social networking.*
Michael Fleming, *Variety* [22]

Josephson and Limato were not the only two important agents who left. Some didn't wait to be pushed:

✦ *Filmmaker agent Robert Newman left for Endeavor in January, and Gotham-based Richard Abate left to start a book division for Endeavor shortly after. Rumors circulated for months that Limato felt disrespected and undercut by the reorganization.*

Ibid[23]

While Endeavor's September 14, 2007 ad congratulating its Emmy nominee/winners took three pages, ICM only needed one. The actors cited were James Spader, Edie Falco, Gene Rowlands, Kevin Dillon, Jaime Pressly, Vanessa Williams, Judy Davis, and Elaine Stritch. They have zillions of other visible clients, just not as many as they used to, and not as many as I'm sure the future will bring.

In any event ICM continues as one of the great conglomerate agencies.

Agents

Sam Cohn, Patrick Herald, Thomas Pearson, Paul Martino, Mala Mosher, and Adam Schweitzer

Client List

Large

◁ Independent Artists Agency ▷

330 W 38th Street, # 709
btwn 8th & 9th Avenues
New York, NY 10018
646-486-3332

Jack Menashe started his showbiz career as a child actor working in film, theatre and television. He continued his career until he was twenty-two, at which time he weighed his childhood dreams against his desire for a regular paycheck and began training to be an agent.

In 1992 Jack became an assistant at one of Manhattan's busiest theatrical agencies at the time, Ambrosio Mortimer. The small but visible client list gave the agency credibility and Jack a perfect platform from which to learn the business. Two years later Jack joined APA as assistant to agent David Kolodner and learned even more.

After Jack became an agent, he rejoined AM briefly before taking a break from that side of the business to return to acting. It didn't take long for Jack to re-evaluate his priorities and choose agenting as the path he truly wanted, opening his own one man office in 1997. In 2000 he and Philip Carlson (Susan Smith Agency, Writers & Artists) partnered to become Carlson-Menashe.

When Philip left the business to return to his hometown, Jack renamed the agency and acquired more staff.

Brooke Barnett and Michele Bianculli, formerly of Arcieri & Associates and Innovative Talent, respectively, head the important voice over department. Cyd Levin worked at Don Buchwald before opening her own bicoastal management company (Cyd Levin and Associates), where she developed the careers of Luke Perry, Ian Ziering, Tori Spelling, Kevin Corrigan and others. After taking a break from the business, she joined Jack in 2003.

That same year former University of Florida teacher Clay Smith joined the agency. He and Eric Fabar (Atlas) head the Commercial Department and also handle legit with former vocal coach Rachel Cohen.

Clients include Marisa Ryan (*Riding in Cars with Boys*), Helen Stenborg, Robert Lupone, Timothy Adams (*One Life to Live*), Daniel Von Bargen, Jim Murtaugh (*How to Lose a Guy in 10 Days, The Laramie Project*), Paul Mecurio (*The Daily Show*), Raynor Scheine (*Fried Green Tomatoes*), Kate McKinnon (*The Big Gay Sketch Comedy Show*), Gerry Vichi

(*The Drowsy Chaperone*), Mary Bacon (*Rock 'n Roll*), Mark Price (*Mary Poppins*), David Pittu (*Love Musik*), Charlotte Raye (*Facts of Life*), and Maria Thayer (*The Accepted, Strangers with Candy*),

Jack says his agency is open to developing new young talent and seriously looks at all pictures and resumes. He is not deterred by an actor not having his union card: they have to start someplace.

Agents

Jack Menashe, Cyd Levin, Clay Smith, Eric Faber, Rachel Cohen, Brooke Barnett, and Michele Bianculli

Client List

100

⚔ Ingber & Associates ⚔

274 Madison Avenue
btwn 39th & 40th Streets
New York, NY 10016
212-889-9450

Carole Ingber worked in motion picture advertising before moving to Los Angeles to work in casting with Vicki Rosenberg in 1982. Since returning from the West Coast, she has worked at a succession of high profile commercial talent agencies: J. Michael Bloom, SEM&M and LW2. For a while she ran the commercial arm of Susan Smith's distinguished agency before opening her own office in 1993.

Amy Davidson was a child actor in Los Angeles before attending NYU Tisch School of the Arts, majoring in acting and directing. She knew all along that she wanted to agent, and joined Carole right out of NYU.

Although I&A is a commercial agency, I include them because they specialize in handling commercial careers of working actors. Carole may be the woman to talk to if you are already working good jobs as an actor and are looking for someone to handle the commercial part of your business.

This agency also handles a few industrials and some print jobs for their clients.

Agents
Carole Ingber and Amy Davidson
Client List
160 plus freelance

◄ Innovative Artists ►

235 Park Avenue South
btwn 19th & 20th Streets
New York, NY 10003
212-253-6900

Gersh alums Scott Harris and the late Howard Goldberg opened the New York edition of their prestigious Los Angeles agency, Harris and Goldberg, in 1991. A prestigious boutique agency from the get-go, the agency has now grown into one of the most important independent agencies on either coast.

Partner Richie Jackson heads up the dynamic New York office handling theatre, film, television, literary, voiceovers, beauty, commercials, and broadcasting.

Clients include Adam Storke (*Over There*), Corey Parker (*The End of the Bar*), Emily Loesser (*Law & Order*), Valerie Perrine (*Superman II*), (Frank Langella (*Frost/Nixon*), John Amos (*John Q*), Bryce Dallas Howard (*The Woods*), Kate Nelligan (*Cider House Rules*), Frances Fisher (*The Unforgiven*), Patti LuPone (*Summer of Sam*), Jason Biggs (*American Wedding*), Alicia Silverstone (*Scooby-Doo 2*), Traci Lords (*First Wave*), Alyson Hannigan (*American Wedding*), Katherine Bell (*JAG*), Illeana Douglas (*Missing Brendan*), Kelly Hu (*X-Men 2*), Lorraine Bracco (*The Sopranos*), Jill Clayburgh (*Leap of Faith*), Elliot Gould (*Ocean's Eleven*), Gary Busey (*Quigley*), Jeremy Sisto (*Six Feet Under*), and Andrew McCarthy (*Kingdom Hospital*).

Clients are seen at this agency strictly by referral.

Agents

Shari Hoffman, Michael Shea, Bill Veloric, Kenneth Lee, Gary Gersh, Allison Levy, Lisa Lieberman, Suzette Bazquez, Eddie Mercado, Jana Kogen, Sue King, Jennifer Jackino, Barbara Coleman, Donna Gerbino, Maury DiMauro, and Ross Haime

Client List

Large

⊴ Irvin Arthur Associates ⊵

350 E 79th Street
btwn 1st & 2nd Avenues
New York, NY 10075
212-570-0051

Irvin Arthur's earliest showbiz life in 1952 was as an actor but working part-time in his agent's office, he got a taste for agenting that subsequently turned him into an gourmet agent for standup comics.

IAA represent comedians, musical performers, specialty acts, lecturers, revues and productions.

In 1976 he and his partner of 45 years, wife Sondra, opened Irvin Arthur Associates in Los Angeles, and in 2000 Irvin and Sondra moved back to Manhattan, opening an office to service existing clients.

Irvin says he is good about going to see newcomers the first time they call and invite him, so make sure you are ready; he didn't say anything about the second time.

Agents
Irvin Arthur
Clients

10

✒ Jim Flynn, Inc. ✒

307 W 38ᵗʰ Street, #801
btwn 8ᵗʰ & 9ᵗʰ Avenues
New York, NY 10018
212-868-1068

Jim Flynn entered show business in 1990 answering phones at Susan Smith's agency. His first agenting job was at the New York Agency which merged with Alliance Talent. In 1995 he and Judy Boals came together to create Berman, Boals & Flynn, one of the most effective talent and literary agencies in town. At that time they were partnered with literary icon Lois Berman.

In the spring of 2003, after seven years as partners Judy and Jim mutually decided they wanted their own agencies. Since they were friends, they decided to share space. Even when Judy moved a block west, Jim ended up moving to the same building on the same floor. Old bonds continue.

Somehow Jim has managed to maintain a successful talent/lit agency and attend law school at the same time. In 2003 he earned the right to sign, 'Esq.' after his name. As a lawyer he can add entertainment law to his list of services, a big plus for clients. Flynn's list of actors includes Frank Wood and Enid Graham.

His clients come mostly through referrals. Although this office looks at all pictures and resumes, they rarely call anyone in from them.

Agents
Jim Flynn
Client List
30

✒ Jordon Gill & Dornbaum Agency, Inc. ✑

1133 Broadway, #623
at 26th Street
New York, NY 10010
212-463-8455

Although Robin Dornbaum loved actors and wanted to work with them in some way, she never knew how until she spent six months interning with the legendary Marje Fields while still in school as a communications major. At that point Robin knew she had found her calling. After six months mentor Fields sent her to work in casting at Reed Sweeney Reed, where she worked for free, honed her skills, stored information and grew in the business.

When she graduated, she got a job at The Joe Jordon Agency. Within three years Robin was President and brought in Jeffrey Gill (Bonni Kidd, Fifi Oscard) as her partner. Both under thirty, they now had their own agency.

Their youth, savvy, and industriousness changed this agency into one of the top child and young adult agencies in New York.

Former actor David McDermott (FBI, HWA) reps the eighteen to thirty age group and is interested in special skills (skateboarders, all types of athletes, dancers, Little people, beatboxers, etc.). Jeff heads the legit department, while Robin reps the commercial clients.

Prospective clients can send in snapshots if they don't have professional pictures. Clients include Tyler James Williams (*Everyone Hates Chris*), Aleisha Allen (*Are We There Yet?*), Nick Art (*The Nanny Diaries, Syriana, Taking Chance, Cashmere Mafia*), Olivia Thirlby (*United Flight 93, Juno, The Secret, The Wackness*), Katie Bowden (*30 Rock*), Allie Demecco (*The Naked Brothers Band*), Raven Goodwin (*Just Jordan*), Graham Martin (*The Bill Engvall Show*), Colleen and Suzanne Dengal (*The Devil Wears Prada*), Alex Chando (*As the World Turns*), and many others.

Agents

Robin Dornbaum, Jeffrey Gill, and David McDermott

Client List

50-60

☒ Judy Boals, Inc. ☒
307 W 30th Street, #812
btwn 8th & 9th Avenues
New York, NY 10018
212-500-1424

Judy Boals started in the business as an actor, but a part-time job working in varying capacities with literary legend Lois Berman ultimately led not only to her agenting career, but also to a partnership with Berman and talent/literary agent Jim Flynn (Susan Smith, The New York Agency, Alliance Talent) in 1995

Berman died in January of 2003 and that spring, after seven years as partners, Boals and Flynn mutually decided they wanted their own agencies. But since they were friends, they decided to share space.

This is good news to potential clients who now just have to manage to get one agent to fall in love with them instead of two.

Both agencies continue to represent actors, directors, writers and composers/songwriters who are chosen not only for their talent, but because they are easy to get along with.

Names from Judy's list include Julee Cruise, Peggy Shaw, Dael Orlandersmith, Klea Blackhurst, David Mogentale, David Greenspan, Daren Kelly, and Mary Cleere Haran. Clients come to this agency mainly through referrals.

Although Boals looks at all pictures and resumes, she rarely calls anyone in from them.

There are good quotes from Judy throughout the book.

Agents
Judy Boals
Client List
50

✂ Kazarian/Spencer ✂

162 West 56th Street, Suite 307
btwn 6th & 7th Avenues
New York, NY 10019
212- 582-7572

One of the top commercial agencies in Los Angeles since 1957, K/S opened their NY office in 2002 as a strictly legit agency repping clients for theatre, television and film.

New Yorker Lori Swift runs the New York office. She has the perfect background for an actor's advocate as she was an actress before working with one of the most important casting directors in town, Bernie Telsey.

Clients from her list include Orlagh Cassidy (*The Field, Spinning into Butter, Definitely Maybe*), Stephanie Nava (*Rescue Me, Law & Order*), Cedric Sanders *(The Ten, Law & Order)*, Jason Tam (*Chorus Line, One Life to Life, Beyond the Break*), Chad Allen (*We Married Margo, Shock to the System*), and Jennifer Massoni (*Damages, Law & Order*).

Try to find someone who knows Lori or one of her clients since new clients mostly come to this agency by referral.

Agent
Lori Swift
Clients
15

⚔ Kerin-Goldberg Associates ⚔

155 E 55th Street, #5D
btwn 3rd & Lexington Avenues
New York, NY 10022
212-838-7373

Charles Kerin's interest in the business was so strong that in his first job as a publicist for *Scholastic Magazine*, he convinced management to create a film award just so he could get to see free movies. His first agent job was with the prestigious Coleman-Rosenberg agency.

Charles left C-R to open his own literary agency representing soap writers in 1985. Partner Ellie Goldberg was an actress when old school chum Gary Epstein cajoled her into joining his office and becoming an agent. Goldberg's path has also included stints with Henderson-Hogan, Bonni Allen and ultimately, Coleman-Rosenberg. Although Charles was working at another agency when he was called on to broker a literary deal for one of C-R's theatrical clients, he and Ellie hit it off immediately and spoke often of opening their own agency when the time was right.

1995 turned out to be the magic year when Kerin and Goldberg got together to create this classy agency representing actors, playwrights, directors, composers, choreographers, songwriters, scenic designers, costume designers, and art directors.

Ellie, Charles, and colleagues Ron Ross (Waters Nicolosi), and Chris Nichols (Peggy Hadley) represent an impressive list that features Jean Stapleton, Austin Pendleton, and Donald Sadler, among others. They see new clients only by referral but do look at all pictures and resumes.

There are incisive comments from Ellie elsewhere in the book. Be sure to check them out.

Agents
Charles Kerin, Ellie Goldberg, Ron Ross, and Chris Nichols
Client List
100

⚐ The Krasny Office, Inc. ⚐

1501 Broadway, #1303
btwn 43rd & 44th Streets
New York, NY 10019
212-730-8160

Gary Krasny has a valuable background for an agent. He was an actor, a publicist for Berkeley Books, a story editor for Craig Anderson (after he left the Hudson Theatre Guild), and an assistant to Broadway general manager Norman Rothstein at Theatre Now. In 1985 he decided he was more empathetic with the artist than management and decided to become an agent.

Gary honed his agenting skills at various agencies before opening his own in late 1991. He found office space not only in the same building, but on the same floor where he had worked with Craig Anderson years before.

Gary's background, experience, and taste made him a favorite with the casting community. When he opened his office, he quickly became part of the mainstream.

Gary runs the legit department with B. Lynne Jebens (Michael Hartig) and Tom Kammer. Kammer was in casting and at various agencies before joining Gary and B. Lynne.

Clients from their list include Jennifer Laura Thompson (*Urinetown*), Denny Dillon (*Dream On*), Carl Gordon, Meg Mundy, and Ken Jennings.

The Krasny Office has liaison arrangements with several Los Angeles agents and managers.

Norma Eisenbaum (Sharon Ambrose) runs the highly successful commercial, voiceover, and print department.

Agents
Gary Krasny, B. Lynne Jebens, Norma Eisenbaum, and Tom Kammer
Client List
85

⟆ KTA ⟅

Kolstein Talent
247 W 38th Street, #1001
btwn 7th & 8th Avenues
New York City, NY 10018
212-937-8967

The office of KTA is alive with whimsical original art celebrating New York and the business, and positively reflects Naomi Kolstein and partner Jeremy Zall.

With parents who ran their own at home PR firm repping Jackie Mason, novelist Robert Ludlum, and Pernel Roberts (*Bonanza, Trapper John*, etc.), Naomi has absorbed their talents and melded them into a business both promoting and getting jobs for her clients.

After acquiring her psychology degree, Naomi married. She and her husband had a baby and began "acquiring things," a house, possessions, etc., when it occurred to both of them that they were too young to be so serious. To the horror of both their families, they sold everything and traveled for a year with their three-year-old son. That trip changed their lives as they realized the endless possibilities that life offers. Naomi's husband wrote a book about it, *Everyone Should Quit at Least Once*.

When they returned to Rockland County, Naomi started her own business as the "The Goat Lady," traveling to schools introducing her goat to kids of all ages. Once everyone had seen her goat, her list expanded to include so many different animals and reptiles, that she renamed herself "The Creature Teacher."

After ten years Naomi moved onto *Naomi's World of Entertainment, Inc.* to provide quality entertainment for young people. That led to repping political speakers, look-a-likes, and producing events for large corporations.

Now known as the "go to/can do" lady for everything, people began calling Naomi for more projects involving actors. As she morphed into a talent agent, she began to edge ever closer to Manhattan, moving her operation to an old Episcopal Church in Sufferin, New York. In 2004 she moved the agency into the current art-filled haven on west 38th Street and renamed it KTA.

Partner Jeremy Zall had been a fellow Hebrew student with Naomi's son and came looking for representation as an actor. That

didn't work out, but when Naomi was moving to a new office and growing, she needed help and called Jeremy to see if he and his Business degree from the University of Buffalo were interested. Not just interested, he fell in love with the other side of the desk. He learned the biz at CED, then returned to Naomi as her partner in 2003.

Naomi handles both the theatre and Voice Over actors, while Jeremy herds the film and television actors. Their combined list of signed clients numbers about 100. They both freelance with many more.

Signed clients include Arbender Robinson (*The Little Mermaid*), Polly Baird (*Phantom of the Opera*), Erin Fogel (*27 Dresses*), Paul Calderon (*Marker*), Rebakah Aramini (*Sisterhood of the Traveling Pants*), Frank Vincent (*The Sopranos*), E. Clayton Cornelius (*Chorus Line*), Nitya Vidyasagar (*The Glorious Ones*), Cory Skaggs (*Mary Poppins*), Joe Estevez, Joey Perillo, Jack Fitz, Guillermo Ivan, Don Puglisi, Tony Rossi, and Gene Biscontini.

Although they look at the pictures and resumes that come through the mail, it's more likely they'll find you onstage, film, or television someplace or someone they know will mention your name and that's how you'll get their attention.

Agents
Naomi Kolstein, Jeremy Zall
Clients
100 signed/also work with freelance talent

⩗ The Lantz Office ⩘

200 W 57th Street, #503
at 7th Avenue
New York, NY 10019
212-586-0200

When I quizzed New York agents as to other agents they admire, Robert Lantz was the name most mentioned. One of the class acts in the annals of showbiz, Lantz started in the business as a story editor. On a Los Angeles business trip from his London home in 1950, Phil Berg, of the famous Berg-Allenbery Agency, made him an offer he couldn't refuse: Don't go home. Come open a New York office for us. Mr. Lantz opened their New York office at 3 East 57th Street and represented Clark Gable, Madeleine Carroll, and other illustrious stars until William Morris bought that company a year later.

Lantz worked for smaller agencies for a few years before opening Robert Lantz, Ltd. in 1954. A year later he succumbed to Joe Mankiewicz's pleas to join his efforts producing films. It took three years for Lantz to figure out that he found agenting a much more interesting profession.

In 1958 Lantz reentered the field as a literary agent. Feeling that a mix of actors and directors and writers gave each segment more power, his list soon reflected that.

Mary Ann Anderson is Robby's assistant and runs the office, so she's the one to talk to, although this agency only represents two actors, longtime clients Liv Ullman and Polly Holiday.

The main thrust of the agency continues to be writers and directors.

Agents
Robert Lantz
Client List
20

◁ Leading Artists, Inc. ▷

145 W 45th Street, #1000
btwn 6th & Broadway Avenues
New York, NY 10036
212-391-4545

In 2003, after 43 years agenting, founder Monty Silver (Monty Silver, Silver Massetti & Szatmary) retired. He tossed the keys to longtime colleague Dianne Busch and rode off into the sunset, or at the very least, to East Hampton, to produce.

Happy key-catcher Dianne Busch came to New York from Ohio in 1979 figuring to act, but within three months was stage managing, producing, and ultimately supervising messengers at the TKTS booth on 47th Street. She moved to California to work at Western Stage in Salinas before the Big Apple lured her back two years later. She found a cross-section of showbiz jobs ranging from casting commercials with Joy Weber to legit with Meg Simon and Fran Kumin. A brief managing career led the way to Monty in 1991. In June 2003, Dianne became the owner and changed the agency's name to Leading Artists, Inc.

Diana Doussant (Talentworks) and Michael Kelly Boone, who had agented for Monty earlier and at Starcaster, join Dianne overseeing the careers of clients Chuck Cooper (*The Life*), Paul Guilfoyle (*CSI*), James Rebhorn (*Independence Day*), Zeljko Ivanek (*Damages, 24, Oz*), Celeste Holm (*All About Eve*), Fyvush Finkel (*Picket Fences*), Michael Gross (*Tremors*), Burke Moses (*The Fantastiks*), Daniel Jenkins (*Mary Poppins*), Larry Pine (*Vanya on 42nd Street*), Robert Joy (*CSI NY*), Adriane Lenox (*Doubt*), Jenna Stern (*16 Blocks*), Aasif Mandvi (*The Daily Show*), Tricia Paoluccio (*Debbie Does Dallas*), Zach Quinto (*Heroes, Star Trek*), Hilary Bailey Smith (*One Life to Life*), Skylar Astin (*Spring Awakening*), Van Hansis and Ewa Da Cruz, both on *As the World Turns*, and Bradley Cole, Yvonna Kopacz and Jessica Leccia, all on *The Guiding Light*.

Leading Artists is affiliated with Monty's former partners, Donna Massetti and Marilyn Szatmary of SMS Talent in Los Angeles.

Agents
Dianne Busch, Michael Kelly Boone, and Diana Doussant
Client List
85

⨳ Leudeke Agency ⨲

1674 Broadway, #7A
btwn 52nd & 53rd Streets
New York, NY 10019
212-765-9564

Penny Leudeke is such a born entrepreneur that at the age of twelve, she had a small business: after she designed and made a bag for her violinist-mother's neckrest, other violinists saw the bag and became customers. Never a person to do just one thing at a time, Penny was designing and making gowns for an opera company, and getting jobs for her friends, even as her own opera career was booming.

When Penny determined that she loved agenting more than singing and/or sewing, she approached children's agent Pat Gilchrist in 1996 about starting an adult department at her agency. Penny shared space with Pat for a year before opening her own office.

Penny considers Victor Varnado (*The Adventures of Pluto Nash*), ex-pro football player David Roya (*Law & Order, Third Watch, Billy Jack*), Robin Givens(*Queen of Media, Hollywood Wives, the Next Generation*), Heather Tom (*The Bold and the Beautiful*), John Tartaglia (*Avenue Q, Johnny and the Sprites*), Deidre Goodwin (*Chicago*), composer Anthony Davis (*Angels in America*) and various writers, dancers, and singers are part of her professional family.

Penny looks carefully at all pictures and resumes and has found a couple of her most successful clients that way.

Agent
Penny Leudeke
Client List
50

◢LTA◣

Film Center Building
630 9th Avenue, #800
at 44th Street
New York, NY 10038
212-974-8718

Dale Lally was an actor and personal manager before he crossed the desk to became an agent. He worked for Mary Ellen White and Nobel Talent before partnering with print agents Wallace Rogers and Peter Lerman (Lally Rogers & Lerman).

When Lally, Rogers and Lerman decided to go their separate ways in 1992, Dale opened this office.

Partner Stephen Laviska was a contract lawyer before he joined Dale in representing their strong list of musical performers, interesting young adults, and solid character people.

Actors from their list include James Lally, Angel Caban, Alice Spivak, Jerome Preston Bates, Brenda Denmark, Victor Anthony, Brad Oscar, Kathy Brier, and Chadwick Boseman.

All I ever got was the answering machine, so I'm not sure if this agency is still in business.

Agents
Dale Lally and Stephen Laviska
Client List
45

◢ Nicolosi & Co. Inc. ◣

150 W 25th Street, #1200
btwn 6th & 7th Avenues
New York, NY 10001
212-633-1010

Jeanne Nicolosi is an awesome woman. After getting her B.A. in acting from the University of Massachusetts and Masters in both acting and directing from Emerson College, she headed the theatre department and taught acting at a Boston high school.

Though she moved to New York to act and direct and was successful at both, neither lifestyle appealed to her. She wondered what it would be like to be an agent and her first exposure, as an assistant agent with Beverly Anderson, convinced her she was on the right path.

In 1985 Jeanne became a franchised agent, working briefly at Writers & Artists before joining The Bob Waters Agency where she quickly became a partner. Wanting her own agency from the start, Nicolosi finally realized her dream in 2002.

Nicolosi met all the first year goals she set for herself and now five years later, she continues to grow.

Colleagues Russell Gregory and another former actor, Michael Goddard, join Jeanne repping an amazing list of actors for Broadway, film and television. Among their clients are Johnny Pruitt (*Sponk, Whirly Girl*), Jeff Weiss (*Flesh & Blood*), Jenny Fellner (*Mamma Mia, The Boy Friend*), Jenny Powers (*Grease*), Alex Cranmer (*The Bronx is Burning, Life is Wild*), Chris Heuisler (*As the World Turns*), David Turner (*The Ritz*), Joe Forbrich (*Law & Order,*) and Marcella Roy *(30 Rock).*

Agents
Jeanne Nicolosi, Russell Gregory, and Michael Goddard
Client List
60-65

◢ Nouvelle Talent, Inc. ◣

302A W 12th Street, #237
btwn 7th Avenue & Bank Streets
New York, NY 10014
212-352-2712

You won't find any straight acting jobs through Nouvelle Talent, Inc., but you might find some jobs that will pay the rent while you are looking for your ship to come in.

Toni Sipka was a spokesperson and narrator at trade shows when it occurred to her that she could open her own agency and book others into the same kinds of jobs. In 1987 she did just that in Chicago and subsequently added both New York and Las Vegas to her slate.

Sipka also books cruise ships and corporate promotions, so if you have any musical ability and/or a one person show, or have put together any other kind of entertainment, Toni might be able to find some bookings for you.

Toni manages to run all these offices herself. She has returned to her maiden name, Toni (Antoinette) Sipka, but since she was known for years as Ann Bordalo, she says she answers to either.

Pictures that catch her eye feature a nice smile, are clean, crisp, warm, neat and professional. Toni looks for a sexy wholesomeness in women clients instead of the fresh-scrubbed look and seeks men with a well-groomed look and likes a length shot. Toni is one agent who likes to be called weekly and quizzed as to "what's going on." When talent calls Toni, she says she knows they are interested in working. If they don't call, she tends to forget about them.

Toni has now started a series of workshops for those interested in learning how to enter the modeling/hosting/marketing arena. Check out *www.nouvelletalent.org/* it's pretty interesting.

Nouvelle sounds like an exceptional resource.

Agents
Toni Sipka
Client List
Large

✒ Paradigm ✐

360 Park Avenue South, 16ᵗʰ Floor
at 26ᵗʰ Street
New York, NY 10110
212-897-6400

Paradigm grew from 50 agents to 104 in three years and already has more offices and more agents than United Talent. This baby conglomerate was created from the 1992 merger of two elegant talent agencies, Los Angeles' Gores/Fields and New York's STE (Clifford Stevens), along with heavy-hitting LA lit agencies, Robinson/Weintraub & Gross and Shorr Stille & Associates.

Paradigm recently consolidated their four Manhattan offices into their new Park Avenue South address.

Paradigm guides the careers of an elite roster of actors, musical artists, directors, writers, and producers. Led by chairman Sam Gores, the agency continues to grow and prosper.

New York Paradigm theatrical clients are repped by original partner Clifford Stevens, Sarah Fargo (Writers & Artists), Richard Schmenner (STE), and Rosanne Quezada. Schmenner and Quezeda were both franchised at this agency. Others on the legit team are Scott Metzger, Tim Sage, and Tom O'Donnell.

Names from their prestigious list include Philip Seymour Hoffman, Denis Leary, Neil Patrick Harris, Katherine Heigl, Allan Arkush, William Baldwin, Charles Durning, Andy Garcia, Campbell Scott, Laurence Fishburne, Eli Wallach, Anne Jackson, Dana Ivey, Max Van Sydow, Allison Janney, Chris Cooper, and Dennis Franz.

Offices in Nashville and Monterey rep their music stars.

Agents
Clifford Stevens, Richard Schmenner, Sarah Fargo, Rosanne Quezada, Scott Metzger, Tim Sage, and Tom O'Donnell
Client List
Many many

✒ Peggy Hadley Enterprises, Ltd. ✒

250 W 57th Street, #2317
btwn 7th & 8th Avenues
New York, NY 10107
212-246-2166

Another actor who changed sides of the desk, Peggy Hadley has never missed performing. When she was searching for a new career, fellow performer Fannie Flagg talked Peggy into becoming her manager. Peggy managed Fannie and four others until their careers drew them west. Peggy (a transplanted Kentuckian) felt she couldn't bear leaving the city to go with them to Los Angeles, so she just added more actors to her list and became an agent.

She has about sixty to seventy signed clients and works with many others freelance. She handles only legit, no commercials.

Clients from her list include Lou Meyers, Clifford David, Jason Patrick Sands (*Chorus Line, The Producers*), and Danette Holden (*Laughing Room Only, The Sound of Music*).

Agents
Peggy Hadley
Client List
50

⊿ Peter Strain & Associates ⊾

321 W 44th Street, #805
btwn 8th & 9th Avenues
New York, NY 10036
212-391-0380

Peter Strain moved to Los Angeles in 1995 to provide for bi-coastal clients, leaving the New York office in the capable hands of Bill Timms. Bill Timms' community theatre background in Scranton helped him become a free-lance client at Writers & Artists in 1984. Rejected after four callbacks for a coveted job, Bill quietly presented himself to his agents and told them that he felt he would be more successful on the other side of the desk. From W&A he went to The New York Agency, Sames & Rollnick, and The Tantleff Office, then joined Strain in 2001.

Michelle (Gerard) Arst was a musical theatre actress with an MA in Arts Administration from NYU before she joined the agency training program at DGRW. After 10 years agenting at DGRW, she moved to Peter Strain and now joins Bill repping clients for TV, film and theatre.

This agency is home to Joe Mantegna (*The Starter Wife, Criminal Minds*), Emily Loesser (*By Jeeves*), Lewis J. Stadlen (*The Producers*), Rene Auberjonois (*Boston Legal*), Jonathan Hadary (*Spamalot*), Brent Barrett (*Phantom of the Opera*), Bryan Batt (*Mad Men*), Robert Sella (*Stuff Happens*), Lewis Cleale (*Spamalot*), Ron Bohmer (*Women in White*), Gerry Bamman (*Nixon's Nixon*), Mary Louise Wilson (*Grey Gardens*), Marlo Thomas (*That Girl*), Georgia Engel (*Drowsy Chaperone*), Rebecca Schull (*United 93*), Marylouise Burke (*Fuddy Meers*), Carolee Carmello (*Mamma Mia*), Emily Skinner (*Side Show*), Randy Graff (*City of Angels*), Alma Cuervo (*Wicked*), Catherine Cox (*Footloose, Baby*), Heather Macrae (*A Catered Affair*), David Huddleston (*1776*), Sophina Brown (*Shark*), Stephanie Zimbalist (*A Little Night Music*), Ray Abruzzo (*The Sopranos*), Brenda Wehle (*Stuff Happens*), and John Doman (*The Wire*).

Agents
Bill Timms and Michelle (Gerard)Arst
Client List
100

◢ Phoenix Artists ◣

321 W 44ᵗʰ Street, #401
btwn 8ᵗʰ & 9ᵗʰ Avenues
New York, NY 10036
212-586-9110

Gary Epstein's agency education was at the feet of legendary NY agent Stark Hesseltine. When Stark died in 1986 and Hesseltine Baker dissolved, Gary opened his own office with a few inherited clients and named it Phoenix Artists.

Seeking to be bicoastal, Gary began a long partnership with Los Angeles agent Craig Wyckoff (Epstein/Wyckoff and later Epstein Wyckoff Corsa Ross & Associates) in 1991.

When the partnership dissolved in 2004 Phoenix Artists rose again. Veteran Randi Ross continues with Gary.

Phoenix is primarily a theatrical agency servicing actors in all parts of the business. They have a small literary list of writers and directors, all either old friends or actor clients who became hyphenates and asked Gary to shepherd their careers.

Agents
Gary Epstein and Randy Ross
Client List
20

⚔ The Price Group, LLC ✍

280 Madison Avenue, #705
btwn 39th & 40th Streets
New York, NY 10016
212-725-1980

After graduating SUNY Purchase with a Dramatic Arts Degree and an interest in production, Lisa Price moved to San Diego for three years to intern at San Diego Rep. There she cast, directed, and assisted Josephina Lopez on the first production of *Real Women Have Curves*, and assisted the theatre's founder and Artistic Director, David Woodhouse.

She then moved to Los Angeles where she did some acting and worked in television and film production. When her Mother became ill, Lisa returned home to be with her. Her Mother's death from pancreatic cancer resulted in Lisa's spending three years raising money and awareness for Pancan, the first national patient advocacy organization for the pancreatic cancer community.

After three years producing the *Bidding for a Cure* fundraiser, a friend's suggestion to get back into the business led Lisa to Beverly Anderson's ad on playbill.com looking for an assistant.

Price says she owes a lot to Beverly, who saw herself in Lisa. Anderson recognized Lisa's inherent skills, taught her the history of the business, and encouraged her to be an agent almost immediately.

Price left Anderson in July 2006 and six months later had her paperwork together to open The Price Group, LLC.

Her list includes Bette Midler backup singer, Shayna Steele (*Rent, Hair Spray*), Sidney James (*Lion King*), Jon Masorti (*Law & Order SVU, One Life to Live*), Julie Barnes (*Spamalot*), Rusty Mowrey (*Legally Blonde*), Julia Lindig (The Strokes video, *Juicebox*), Barry Anderson (*Gershwin at Folly*), Michael Ziegfield (*27 Dresses, SNL, Sex & the City*), and Sydney James (*High Five*). Lisa works free lance only as a prelude to signing.

Agent
Lisa Price
Clients
15

☒ Professional Artists ☒

321 W 44th Street, #605
btwn 8th & 9th Avenues
New York, NY 10036
212-247-8770

Sheldon Lubliner is fun, easy to talk to, informed, a good negotiator and he has a good client list. Add charm, taste, ability, access, and his great partner Marilynn Scott Murphy, and you've pretty much got a picture of Professional Artists.

As a director-producer Sheldon enjoyed all the details involved in mounting shows for Al Pacino, Gene Barry, and Vivica Lindfors except for raising the money.

Deciding he could transfer all his skills into agenting and not be a fundraiser, Sheldon changed careers in 1980, translating his contacts and style into an agency called News and Entertainment. PA is an outgrowth of that venture.

Actress/client Marilynn Scott Murphy was commandeered to answer phones in a pinch in 1986, and has since become Sheldon's partner. Sheldon's negotiating skills and Marilynn's people skills – although they are both strong in this department – form the perfect agent.

Both Ashley Williams and Paul Riley are part of the Professional Artists training program. Ashley Williams joined in 2005 and is now a full agent. Paul arrived in 2006 and will be a full agent in 2008.

Their list includes not only actors, news and radio personalities, but also writers, producers, directors, and casting directors.

Agents
Sheldon Lubliner, Marilynn Scott, and Ashley Williams
Client List
100

❧ Schiowitz/Clay/Rose, Inc. ❧

165 W 46th Street, #1210
btwn 6th Avenue and Broadway
New York, NY 10036
212-840-6787

Originally a Los Angeles producer and general manager, Josh Schiowitz took his formidable marketing and organizational skills, his connections to casting directors and talent, and ultimately transformed from buyer to seller when he opened SCR in 1987. Stephen Rose and Josh Clay were his partners for a while, and although the masthead retains their names, Schiowitz is now the sole owner and runs the place with colleague Teresa Wolf (Honey Sanders, Penny Leudeke, Waters Nicolosi).

Wolf was an actor before Honey Sanders hired her to be an agent. She joined SCR's New York office nine months after it opened in February 2000. Wolf says she has lived all over the country, but has been in NYC longer than anywhere else (although she says this still doesn't make her a native).

Clients from SCR's New York list include Marva Hicks (*Caroline or Change*), George McDaniel (*Big River*), Rebecca Wisocky (*36 Views*), James Biberi (*Analyze That*), Colman Domingo (*Henry V*), Elizabeth Stanley (*Company*), Christopher Kale Jones (*Jersey Boys*), J. Salome Martinez, Jr. (*Generation Kill*), Cheryl Lynn Bowers (*Evening*), and Patch Darragh (*Crimes of the Heart*).

SCR says if they specialize in anything, it is in really good actors. Though they review all pictures and resumes, they admit they rarely call anyone in from a mailing. The client list is a combination of referrals and heavy theatre credits.

Agents
Teresa Wolf and Kevin Thompson
Client List
7

⊴ Stanley Kaplan Talent ⊵

139 Fulton Street, #503
btwn Broadway and Nassau
New York, NY 10038
212-385-4400

Stanley Kaplan gets people jobs. Originally a regular employment agent, his son's involvement in acting let him switch gears and start getting jobs for actors. For a while Kaplan represented non-union talent as an agent before becoming a manager.

In 1998 Kaplan got his franchise from SAG and now has access to union actors and union jobs.

When I asked Stanley how big his client list was, he spread his arms and said, "I represent the entire city of New York! I'm the agent for the underdog. Anyone who can't get an agent can come here. I submit everybody. It means something to be able to go into an agent's office. I'm here for actors."

Stanley reps people across the board, any age, any type, any ethnicity, any job, extras, commercials, print, and television. Any medium that might be using actors, Stanley's there.

Agent
Stanley Kaplan
Client List
The City of New York!

⚔ Stone Manners ⚔

900 Broadway, #803
btwn 19th & 20th Streets
New York, NY 10003
212-505-1400

The offspring of a famous British agent, Tim Stone came to Los
Angeles in 1979 to provide services for British actors in this country by
establishing his own agency, UK Management. Although he used his
British list as a base in the beginning, Tim's list quickly expanded to
represent a much broader base.

By 1982 Tim had acquired partner Larry Masser (Stone Masser),
and by April 1986 Scott Manners (Fred Amsel, Richard Dickens
Agency) name was added to the masthead (Stone Manners Masser).

Larry left the following August, but since then, Tim and Scott's
partnership has prevailed.

In January 2003, at a time when many NYC agencies were closing,
Stone Manners was doing so well that they decided to open an East
Coast office. Tim moved to Manhattan and Scott keeps the business
intact in Los Angeles. Erin Grush became franchised at Stone Manners
and now joins him repping a prestigious list of actors, directors,
producers, scriptwriters, young adults, and teens. SM won't let me name
anyone from their list, so you'll have to check SAG's agency files or
scan *www.imdbpro.com* to check out their clients.

Agents
Tim Stone and Erin Grush
Client List
They won't say

⊿ Talent House ⊾

311 W 43rd Street, #602
at 8th Avenue
New York, NY 10036
212-957-5220

The Talent House is one of Canada's premier theatrical agencies, not only doing business in Toronto, but also building a solid relationship with New York theatre casting directors and producers.

When Talent House felt a need for a physical Manhattan presence in 1999, Toronto agent Dave Bennett moved to New York to open this office. His background was in business management, promotions and student recruitment.

Dave took off on a years Sabattical in 2006. He was replaced by Paradigm alum Ari Cohn and by Flora Johnstone who worked at both Gersh LA and at DGRW.

The agency handles actors, directors, choreographers, and writers for theatre and musical theatre. They are building their film and television departments.

TH avoids freelancing and prefer referrals from actors seeking representation. Names from their list include Jeremy Kushnier and Shannon Lewis.

Agents
Ari Cohn and Flora Johnstone
Client List
60

⚔The Talent Mine ⚔

135 W 27th St, 9th floor
btwn 6th & 7th Avenues
New York NY 10001
212-612-3200

Canadian David Crombie's background was in technology before old friends persuaded him to move to Los Angeles to learn the agency business. Once trained, he left Los Angeles to open the New York offices of bloc in 2001.

Though originally conceived as a dance centered agency, Crombie's success with actors convinced him to broaden bloc's focus. He hired legit agent David Krasner (Penny Leudeke) to open a legit department.

The legit division did so well that in 2007 Crombie decided to create The Mine, an agency focused solely on theatrical representation.

The Talent Mine opened in early 2007 with four agents: Crombie, Krasner, Ben Sands, and commercial department head, former manager Erica Amsinger.

Names from the legit list include Kate Wetherhead (*Legally Blonde*), Doug Kreeger (*Les Miz*), and Mark Setlock (*Law & Order*).

You can send pictures and resumes, but clients mostly come to this agency via referral or being spotted performing someplace.

Agents
David Crombie, David Krasner, and Ben Sands
Clients
70

◄ Talent Representatives, Inc. ►

307 E 44th Street, #1F
btwn 1st & 2nd Avenues
New York, NY 10017
212-752-1835

Honey Raider and Steve Kaplan's mutual love of theatre, film, and television led them to create this agency as a way to become involved in show business. The agency formed in 1964 to represent actors, but has now grown to include writers, directors, and producers.

Honey says the changes came about through a natural course of events, as some actors who worked daytime shows decided to write and ended up being staff writers, and those writers became producers, etc.

Talent Representatives is now one of the few agencies that does a real literary business in daytime television.

Honey's list of clients is confidential so you'll need to do some research at SAG or at *www.imdbpro.com* to see who they are.

Agents
Honey Raider
Client List
17 plus freelance

◁ Talentworks New York ▷

220 E 23rd Street, #303
btwn 2nd & 3rd Avenues
New York, NY 10010
212-889-0800

Jay Kane, Patty Woo, Anthony Calamata, and Danielle Ippolito rep the theatrical clients of increasingly powerful Talentworks. Once known as HWA for its founding partners, Barbara Harter and Patty Woo, their merger with LA's Gold/Liedtke has resulted in Talentworks.

Ohio-reared Jay Kane (Select Artists, The Tantleff Office) had stars in his eyes when he arrived to study with Stella Adler at NYU. After graduation, he assessed his acting range and began searching for another theatre career path.

The search took him to New Hampshire's Hampton Playhouse where his career grew from teenage apprentice to perennial summer general company and/or stage manager. In the winter he returned to NY, searching for his "place" in the business. Working as a business manager at the WPA, as an AD on a Broadway show, and several years in ticket sales at the Metropolitan Opera, Kane turned a deaf ear to friends who kept telling him he'd make a great agent.

In 1990 he finally accepted his destiny. He took a receptionist job at Select Artists and started up the ladder. Just three years later he was an agent at The Tantleff Office, before moving to HWA in 1996.

The NY client list includes Joe Morton (*Bounce*), Karen Ziemba (*Contact*), Carolyn McCormick (*Law & Order*), Michael Berresse, Ian Kahn, Peter Riegert (*Damages*), Robert Cuccioli (*Jeckyll & Hyde),* Amy Irving *(Carrie, Coast of Utopia),* and Elie Wallach (*Studio 60 on the Sunset Strip*). The combined Los Angeles/New York list numbers about 250 theatrical clients.

Agents
Jay Kane, Patty Woo, Anthony Calamata, and Danielle Ippolito
Client List
250 combined coasts

◢ WMA ◣

William Morris Agency
1325 Avenue of the Americas
at 54th Street
New York, NY 10019
212-586-5100

Mr. William Morris (yep, there really was one) started this agency in 1898. The IBM of the Big Three, William Morris continually reinvents itself. At one point in history the unchallenged #1, today William Morris, like other star agencies, continues to fluctuate based upon the current client base. Today their fortunes dictate #2.

The big news in 1999 was that ICM co-chief Jim Wiatt defected to William Morris to serve as president and co-CEO. The 2007 headline is that WMA acquired former ICM Motion Picture head, uber-agent Ed Limato after ICM unceremoniously demoted and subsequently fired him. Limato brought along clients Mel Gibson, Denzel Washington, Richard Gere, Sam Neil, and Steve Martin to beef up WMA's movie star list. Not a bad day's work for WMA.

✦ *[Wiatt] oversees an agency that has 235 agents and claims about 4,000 clients worldwide in offices in Beverly Hills, New York, London and Nashville.*
Claudia Eller and James Bates, *Los Angeles Times*[24]

When WMA consolidated the talent portion of the motion picture department in Los Angeles many dyed in the wool New York agents had no intention of relocating to Los Angeles, so there were many changes.

What remains is a sleeker, more powerful, less bureaucratic agency that reps not only actors, writers, directors, and producers, but athletes, newscasters, political figures, corporations and anyone or thing that might need representation at the higher levels.

For an up to the minute list of agent names, check out *The Hollywood Creative Directory* or *imdbpro.com*.

William Morris may or may not be #1 as of this writing, but perennially at Oscar time, when the big agencies run ads in the trades to congratulate their nominees, William Morris has the longest, most impressive client list.

Billy Bob Thornton, Willem Dafoe, Forest Whitaker, Daniel Day-Lewis, Christopher Walken, Emma Thompson, Matthew Modine, Lili Taylor, Ashley Judd, Cary Brokaw, Robert Altman, John Rubinstein, John Travolta, Bruce Willis, Julianne Moore, Tim Burton, Clint Eastwood, Stephen Frears, Diane Keaton, John Malkovich, Alec Baldwin, Danny Aiello, Charlie Sheen, Dean Stockwell, Bill Cosby, Sean Hayes, Ray Romano, Alfre Woodard, Kiefer Sutherland, Mary Louise Parker, Mariska Hargitay, Queen Latifah, Rainn Wilson, Thomas Hayden Church, Rachel Griffiths, Anna Paquin, Forest Whitaker, Laurie Metcalf, Jean Smart, and Candice Bergen are just some of William Morris' amazing list.

Randi Michel heads the motion picture department, David Kolodner and Jeff Hunter heads the film department.

Agents
Randi Michel, Jeff Hunter, David Kalodner, Scott Lanker, Brian Stern, Val Day, Peter Franklin, Biff Liff, Roland Scahill, Jack Tantleff, Susan Weaving, and others

Client List
4,000 worldwide

⚔ 17 ⚔

Glossary

Academy Players Directory — Now known as *Players Directory*

Actors' Equity Membership Requirements — Rules for membership for the union covering actors for work in the theater state you must have a verifiable Equity Contract in order to join, or have been a member in good standing for at least one year in AFTRA or SAG.

Initiation fee is $1100 as of 4/1/07, payable prior to election to membership. Basic dues are $118 annually. Working dues: 2% of gross weekly earnings from employment is deducted from your check just like your income tax.

Actors' Equity Minimum — There are eighteen basic contracts ranging from the low end of the Small Production Contract to the higher Production Contract covering Broadway houses, Jones Beach, tours, etc. Highest is the Business Theater Agreement, for industrial shows produced by large corporations. All monies are discussed online at "contracts" at *www.actorsequity.org*

Actor Unions — There are three: Actors' Equity Association (commonly referred to as Equity, or AEA on resumes) is the union that covers actors' employment in the theater. The American Federation of Television and Radio Artists (commonly referred to as AFTRA) covers television and radio actors, broadcasters and recording artists. Screen Actors Guild (commonly referred to as SAG) covers actors employed in theatrical motion pictures and filmed television. The unions continue discussions about the potential of joining together under one overall labor organization.

AFTRA Membership Requirements — anyone expecting to work in the news and entertainment industries can join. AFTRA's initiation fee is $1300 as of 11/1/04. Minimum dues for the first six-month period are $63.90 After joining, a member's dues are based on earnings in AFTRA

jurisdictions during the prior year. Dues are billed each May and November. For information on contracts, log onto *www.aftra.org*

AFTRA Minimum — Check AFTRA's web page for rates.

AFTRA Nighttime Rates — Check AFTRA's web page for rates.

Atmosphere — another term for background performers, a.k.a. Extras.

Audition Tape — A DVD usually no longer than six minutes, showcasing either one performance or a montage of scenes of an actor's work. Agents and casting directors prefer tapes of professional appearances (film or television), but some will look at a tape produced for audition purposes only.

Background Performers — a.k.a. Atmosphere or Extras.

Breakdown Service — Started in 1971 by Gary Marsh, the Service condenses scripts and lists parts available in films, television and theater. Expensive and available to agents and managers only.

Clear — The unions require that the agent check with a freelance actor (clearing) before submitting him on a particular project.

Equity-Waiver Productions — See Showcases.

Freelance — Term used to describe the relationship between an actor and agent or agents who submit the actor for work without an exclusive contract. New York agents frequently will work on this basis, Los Angeles agents rarely consent to this arrangement.

Going Out — Auditions or meetings with directors and/or casting directors. These are usually set up by your agent but have also been set up by very persistent and courageous actors.

Going to Network — Final process in landing a pilot/series. After the audition process has narrowed the list of choices, actors who have already signed option deals have another callback for network executives, usually at the network. Sometimes this process can include

an extra callback for the heads of whatever studio is involved.

Industry Referral — If you are looking for an agent, the best possible way to access one is if someone with some credibility in the business will call and make a phone call for you. This could be a casting director, writer, producer, or the agent's mother, as long as it's someone whose opinion the agent respects. If someone says, "just use my name," forget it. They need to offer to make a phone call for you.

The Leagues — A now defunct formal collective of prestigious theater schools offering conservatory training for the actor. There is no longer a formal association, but the current "favored" schools are still referred to by this designation. As far as agents are concerned, this is the very best background an actor can have, other than having your father own a studio.

Schools in this collective are The American Conservatory Theater in San Francisco, CA; American Repertory Theater, Harvard University in Cambridge, MA; Boston University in Boston, MA; Carnegie Mellon in Pittsburgh, PA; Catholic University in Washington, DC; The Juilliard School in New York City, NY; New York University in New York City, NY; North Carolina School of the Arts in Winston-Salem, NC; Southern Methodist University in Dallas, TX; The University of California at San Diego in La Jolla, CA; and the Yale School of Drama in New Haven, CT. Addresses are listed in Chapter Four.

Letter of Termination — A legal document dissolving the contract between actor and agent. Send a copy of the letter to your agent via registered mail, return receipt requested, plus a copy to the SAG and all other unions involved. Retain a copy for your files.

Open Call — refers to audition or meeting held by casting directors that are not restricted by agents. No individual appointments are given. Usually the call is made in an advertisement in one of the trade newspapers, by flyers, or in a news story in the popular press. As you can imagine, the number of people that show up is enormous. You will have to wait a long time. Although management's eyes tend to glaze over and see nothing after a certain number of hours, actors do sometimes get jobs this way.

Overexposed — Term used by nervous buyers (producers, casting

directors, networks, etc.) indicating an actor has become too recognizable for their tastes. Frequently he just got off another show after which everyone remembers him as that character and the buyer doesn't want the public thinking of that instead of his project. A thin line exists between not being recognizable and being overexposed.

Packaging — This practice involves a talent agency approaching a buyer with a writer, a star, usually a star director and possibly a producer already attached to it. May include any number of other writers, actors, producers, etc.

Paid Auditions — There's no formal name for the practice of rounding up twenty actors and charging them for the privilege of meeting a casting director, agent, producer, etc. There are agents, casting directors and actors who feel the practice is unethical. It does give some actors who would otherwise not be seen an opportunity to meet casting directors. I feel meeting a casting director under these circumstances is questionable and that there are more productive ways to spend your money.

Per Diem — Negotiated amount of money for expenses on location or on the road per day.

Pictures — The actor's calling card. An 8x10 glossy or matte print color or black and white photograph.

Pilot — The first episode of a proposed television series. Produced so that the network can determine whether there will be additional episodes. There are many pilots made every year. Few get picked up. Fewer stay on the air for more than a single season.

Players Guide — No longer published

Principal — Job designation indicating a part larger than an extra or an Under Five.

Ready to Book — Agent talk for an actor who has been trained and judged mature enough to handle himself well in the audition with material and with buyers. Frequently refers to an actor whose progress in acting class or theater has been monitored by the agent.

Resume — The actor's ID: lists credits, physical description, agent's name, phone contact and special skills.

Right — When someone describes an actor as being right for a part, he is speaking about the essence of an actor. We all associate a particular essence with Brad Pitt and a different essence with Jim Carrey. One would not expect Pitt and Carrey to be up for the same part. Being right also involves credits. The more important the part, the more credits are necessary to support being seen.

Scale — See salary minimums of each union.

Screen Actors Guild Membership Requirements — The most prized union card is that of the Screen Actors Guild. Actors may join upon proof of employment or prospective employment within two weeks or less of start date of a SAG signatory film, television program or commercial.

Proof of employment may be in the form of a signed contract, a payroll check or check stub, or a letter from the company (on company letterhead). The document proving employment must state the applicant's name, Social Security number, name of the production or commercial, the salary paid in dollar amount, and the dates worked.

Another way of joining SAG is by being a paid up member of an affiliated performers' union for a period of at least one year, having worked at least once as a principal performer in that union's jurisdiction.

The SAG initiation fee as of 7-1-07 is $2,211.00, payable in full by cashier's check or money order at the time of application.

The fees may be lower in some branch areas. SAG dues are based on SAG earnings and are billed twice a year. If you are not working, you can go on Honorary Withdrawal which only relieves you of the obligation to pay your dues. You are still in the union and prohibited from accepting non-union work. For up to the minute information on joining, dues, and many other things, *www.sag.org*, search for initiation fee or for recorded information on how to join SAG call 323-549-6772.

Screen Actors Guild Minimum — As of 7-1-07, SAG scale is $757 daily. Overtime in SAG is considerably higher than in AFTRA. Check *www.sag.org* for more detailed info regarding rates. You don't have to be a member to check.

Showcases — Productions in which members of Actors' Equity are allowed by the union to work without compensation are called Showcases in New York and 99-Seat Theater Plan in Los Angeles. Equity members are allowed to perform, as long as the productions conform to certain Equity guidelines: rehearsal conditions, limiting the number of performances and seats, and providing a set number of complimentary tickets for industry people. The producers must provide tickets for franchised agents, casting directors and producers. There is a maximum ticket price of $12.

Sides — The pages of script containing your audition material. Usually not enough information to use as a source to do a good audition. If they won't give you a complete script, go early (or the day before), sit in the office and read it. SAG rules require producers to allow actors access to the script if it's written.

Stage Time — Term used to designate the amount of time a performer has had in front of an audience. Most agents and casting executives believe that an actor can only achieve a certain level of confidence by amassing stage time. They're right.

Submissions — Sending an actor's name to a casting director in hopes of getting the actor an audition or meeting for a part.

Talent — Management's synonym for actors.

Test Option Agreement — Before going to network for a final call back for a pilot/series, actors must routinely sign a contract that negotiates salary for the pilot and for series. The contract is for five years with a option for two more years. All options are at the discretion of management. They can drop you at the end of any season. You are bound by the terms of your contract to stay for the initial five years plus their two one-year options.

Top of the Show/Major Role — A predetermined fee set by producers which is a non-negotiable maximum for guest appearances on television episodes. Also called Major Role Designation.

The Trades — *Back Stage* and *Ross Reports* are newspapers that cover all kinds of show business news. Los Angeles counterpart is *Back Stage*

West. All list information about classes, auditions, casting, etc. These publications are particularly helpful to newcomers. In Los Angeles, this term refers to *Daily Variety* and *Hollywood Reporter.* All are available at good newsstands or by subscription.

Under Five — An AFTRA job in which the actor has five or fewer lines. Paid at a specific rate less than a principal and more than an extra. Sometimes referred to as Five and Under.

Visible/Visibility — Currently on view in film, theater or television. In this business, it's out of sight, out of mind, so visibility is very important.

99-Seat Theater Plan — The Los Angeles version of the Showcase. Originally called waiver. Producers give actors an expense reimbursement of $5-$14 per performance. It's not much, but it adds up; at least you're not working for free.

Producers must also conform to Equity guidelines regarding rehearsal conditions, number of performances, complimentary tickets for industry, etc. If you participate in this plan, be sure to stop by Equity and get a copy of your rights. Fewer stay on the air for more than a single season.

◁ Index to Agents & Agencies ▷

☑ Index to Agencies for Children ☒

☑ Index to Agencies for Young Adults ☒

☑ Index to Agencies for Dancers ☒

☑ Index to Agencies for Stand-Up ☒

⊿ Index to Photographers ⊾

⊿ Index to Resources ⊾

⊿ Index to Teachers ⊾

✑Index to Web Addresses✒

◁ Index to Everything Else ▷

⚔ Endnotes ⚔

1."Backstage at Yale Drama Admissions," October 4, 1996

2."Backstage at Yale Drama admissions," October, 1996

3. "Acting Is One Thing, Getting Hired Another," May 25, 1997

4. "The Early Bird Gets the Audition," March 23, 1995

5. "The Early Bird Gets the Audition," March 23, 1995

6. "The Careerist's Guide to Survival," April 25, 1982

7. "Out from the Shadows," January 13, 2000

8. "Out from the Shadows," January 13, 2000

9. "The Careerist Guide to Survival," April 25, 1982

10. "Out from the Shadows," January 13, 2000

11. "Hiding in Plain Sight," May 1997

12. "Out of the Woods," November, 1994

13. "Out of the Woods," November, 1994

14."Can ICM president restore its glitter?" August 17, 2007

15. Silman-James Press, 2002

16. "Do Re Me Me Me!," November 10, 1997

17.*What You Really Need to Know about Managers and Talent Agents, A Practical Guide,* March, 2001

18. "J. Lo: Ex-manager violated," July 3, 2003

19. "Vardalos' Ex--manager Dealt Lawsuit Setback," September 17, 2003

20. *CAA: Packaging of an Agency,* April 23, 1979

21. Tenacious tenpercenters, April 7, 2003

22. "ICM split causes Hollywood power struggle," July 7, 2007

23. Ibid

24. "The Biz: William Morris Snags Jim Wiatt, Former ICM Exec," August 10, 1999

What Readers Are Saying

"I'm an actress who needed answers to thousands of questions. Other actors didn't know or didn't care to share the information. I found your book at the Drama Book Shop in Manhattan and it is now my bible. I've read it over and over again. Each time I find something new, informative and extremely useful. Whenever I mention something that I've learned from your book to another supposedly more established and experienced actor, I find that they're not as aware of this business as they thought. I'm learning so much from your book that I feel empowered, unstoppable and just great."

Monique Berkley

"K's books make me feel like I'm reading the advice of a mentor who believes in me and my chances. It's very refreshing. It's a shame that her books aren't required reading in training programs. I went to a rather well-regarded conservatory program, and I received almost no education about the business. K's wit and optimism are so pervasive throughout her writing, that she is an absolute joy to read."

David Zack

"I received your book as a gift from a TV producer in Tampa, Florida, my home town. It is the best of the best. You pull no punches. You do not 'tell them what they want to hear'. You are so direct that it sometimes hurts to see the truth in print, AND I LOVE IT!"

Lanny & Sue M Fuettere

"In an industry as competitive as that of entertainment, it is rare that anyone with legitimate experience, talent and wisdom would so unselfishly give others the advice that you so freely give to both struggling and established actors. As a 22 year old actress who has been at this for about 11 years, I greatly appreciate your insights, admonishments, and encouragement. I have a library of industry related books and yours are my favorite."

Jaime Lynn Kalman

"I am an actress is Florida. Your book was very informative and amazing for me. I recommended it and bought it for a lot of fellow actors that I know. I feel like I am in your book club or something. Be blessed in your career. Thank you for all your help."

Jasmine

"Thank you for taking the time to write such a wonderful & resourceful book. I read it from front to back, underlining everything relevant to myself all in one night, I couldn't put it down. I thank you for all the information. It's going to help me a lot."

Dominique

other books by K Callan

How to Sell Yourself as an Actor 6th edition
(From New York to Los Angeles and Everywhere in Between)

The first and last book an actor needs to stay on a successful career track. On any given day, 85-90% of the members of the Screen Actors Guild are out of work. *How to Sell Yourself as an Actor* is filled with nuts and bolts information that can help you be one of the working 15%. The complete actors' marketing tool. Not only a philosophy about acting as a profession, but a guide for actually procuring work.

<div align="right">

ISBN 1-878355-21-X
$20.00 + $5.00 priority mail U. S.
available February 2008

</div>

The Script Is Finished, Now What Do I Do? 4th edition
(A resource book and agent guide for the scriptwriter)

The complete marketing and agent and manager guide for scriptwriters. This book gives you an overview of how the business really is, helps you understand the need to focus in order to succeed, and then teaches you how to do it. The book no scriptwriter should be without. This new edition profiles managers as well as agents.

<div align="right">

ISBN 1-878355-18-8
$20.00 + $5.00 Priority Mail US
available now

</div>

online orders 20% discount

Directing Your Directing Career, 2nd edition
(A resource book and agent guide for directors)

Actress-author K Callan's best-selling directors' resource book and agent guide speaks candidly of the challenges facing directors, stresses the need to focus goals and energy, helps you evaluate whether you can be a working director in your own marketplace or whether it's time to move to New York or Los Angeles. The book features agent profiles, advice on how to agent yourself and attract an agent when you're ready.

ISBN 1-878355-11-2
$18.95 + $5.00 Priority Mail US.

The Los Angeles Agent Book
(How to Get the Agent You Need for the Career You Want)

The west coast companion to *The New York Agent Book*, this book provides profiles of LA's agents including their history, size of client list and names of clients in addition to quotes from the agents themselves. This guide to LA agents will help you make an effective and intelligent decision in your pursuit of the agent that is right for you. In the meantime, Callan gives advice on agenting yourself until an agent is interested.

ISBN 1-878355-20-1
$20.00 + $5.00 Priority Mail US
available January 2008

order autographed copies online
www.swedenpress.com

by mail

Sweden Press

Box 1612

Studio City, CA 91614

✂...

		$	
	The New York Agent Book	$20	
	How To Sell Yourself as an Actor	$20	
	The Script Is Finished, Now What Do I Do?	$20	
	Directing Your Directing Career	$18.95	
	The Los Angeles Agent Book	$20	
	Priority Mail $5 for 1 or 2 books		

Name
Street
City, State, Zip
Phone